LEGAL HANDBOOK
FOR PHOTOGRAPHERS

THE RIGHTS AND LIABILITIES OF MAKING IMAGES, 2ND ED.

Bert P. Krages, Esq.

AMHERST MEDIA, INC. ■ BUFFALO, NY

To my wife
KATHRYN PYLE KRAGES

All rights reserved.
Published by:
Amherst Media®
P.O. Box 586
Buffalo, N.Y. 14226
Fax: 716-874-4508
www.AmherstMedia.com

Publisher: Craig Alesse
Senior Editor/Production Manager: Michelle Perkins
Assistant Editor: Barbara A. Lynch-Johnt

ISBN-13: 978-1-58428-194-8
Library of Congress Control Number: 2006925662
Printed in the United States of America.
10 9 8 7 6 5 4 3 2 1

Notice of Disclaimer: The information contained in this book is based on the author's experience and opinions. The author and publisher will not be held liable for the use or misuse of the information in this book.

TABLE OF CONTENTS

Preface . 6
 Notes on the Second Edition . 6

CHAPTER 1
THE IMPORTANCE OF KNOWING YOUR RIGHTS 7
 What You Should Know about the Law . 7
 How Laws Are Made and Enforced . 8
 The Mulberry Tree Case . 11

CHAPTER 2
ACCESS TO PROPERTY . 12
 Photography in Public Places . 12
 Restraints on Photographers in Public Places . 16
 Access to Private Property . 18
 Photography on Tribal Lands . 22
 Photography from Your Property . 23

CHAPTER 3
PRIVACY ISSUES . 25
 Intrusions on Privacy . 25
 Intentional Infliction of Emotional Distress . 28
 Regulation of Photography to Protect Privacy . 31
 Security Monitoring . 34
 Photography in the Workplace . 35
 The Role of Permission in Photography . 36
 Using a Simple Release Form . 39

CHAPTER 4
RESTRICTIONS ON SUBJECT MATTER . 40
 Federal Statutory Restrictions . 40
 Currency, Stamps, and Securities . 40
 Federal Insignia, Seals, and Trademarks . 42
 Military and Nuclear Installations . 43
 Trade Secrets and Economic Espionage . 45

Copyrighted Material . 46
 The Purpose and Character of Use. 49
 The Nature of the Copyrighted Work. 50
 The Amount and Sustainability of the Work Copied 50
 Effect of Use on the Market or Value of the Copyrighted Work 50
Trademarks . 50
Nudity and Pornography. 53
Animal Photography . 55
Permissible Subjects. 56

CHAPTER 5

CONFRONTATIONS AND REMEDIES . 59
Reducing the Chances of Confrontation 60
Dealing with Confrontations . 62
Seizure of Film, Photographs, and Equipment. 65
Private Seizures . 65
Government Seizures . 67
Subpoenas . 68
Remedies for Photographers . 69
 Writing a Demand Letter . 72

CHAPTER 6

PROTECTING YOUR INTELLECTUAL PROPERTY 74
The Nature of Copyright. 74
An Ultra-Brief History of Copyright Law 76
What You Need to Register Your Images. 77
How to Register Your Images . 77
The Copyright Notice . 81
Enforcing Copyright . 82
Taking Care of Your Property . 88
Patents . 89
Trademarks . 90

CHAPTER 7

PUBLISHING. 92
The Privacy Torts . 92
Misappropriations of Likeness and the Right of Publicity. 94
Publicity Given to Private Life. 96
False Light . 97
Defamation . 98
Licensing Photographs . 99
Licensing Options . 99
Terms and Conditions . 100
Working with Stock Agencies . 105

CHAPTER 8
FORMULATING YOUR ETHICS . 108
Articulating Your Ethical Code . 108
Ethical Issues Associated with Candid Photography. 110
Ethical Issues Associated with Privacy . 111
Ethics of Portraying Things Truthfully . 111
Effect of Images on Natural Subjects. 114
Effects on People . 116
Ethics of Misrepresenting Facts to Take a Photograph. 116

Conclusion . 118

Glossary. 119

About the Author . 122

Index . 123

PREFACE

The material in this book is intended to inform about the general legal principles that apply to taking and publishing photographs within the United States. It cannot substitute for legal advice for specific situations and readers should seek counsel from a competent attorney when they need such advice. Readers should be aware that laws change and the material in this book may become outdated. Since it is impossible to describe every applicable law in a book of this nature, it should not be used as a comprehensive guide to the laws as they apply in individual states.

■ NOTES ON THE SECOND EDITION

The first edition was released on September 1, 2001. A few days later, terrorists hijacked planes that were used to attack the World Trade Center in New York City and the Pentagon building outside of Washington, D.C. Another plane crashed after the crew and passengers attempted to subdue the hijackers. Even though the law affecting photography did not change in response to the attacks, an environment was created in which many photographers have faced suspicion, and even confrontation, as they go about their normal activities. The result is that photographers need to understand the legal aspects of taking images more than ever.

The first edition of *Legal Handbook for Photographers* emphasized the rights regarding the taking of photographs and addressed how to handle confrontations. The second edition expands on these topics, with additional information provided on how to get satisfaction when your rights have been violated. The reason the first edition did not contain a lot of information about protecting copyrights and the legal aspects of publishing images was because I believed, at the time, that the concerns of most

photographers were limited to the making of images. Although the Internet and digital photography were well established when the first edition was released, their continued development and popularity have made publication and copyright issues increasingly important to photographers because of the enhanced opportunities to publish images on the Internet and new venues for representation by stock agencies.

> Photographers can still effectively protect their images in a digital world.

Contrary to what many people assert, the Internet has not made copyright enforcement more difficult—although the amount of infringement has increased dramatically. Considering the potent remedies that copyright law makes available to owners who register their copyrights, and the ease by which digital images can be registered, photographers can still effectively protect their images in a digital world. The second edition thus contains new information about copyright, publishing, and licensing images.

THE IMPORTANCE OF KNOWING YOUR RIGHTS

The purpose of this book is to introduce photographers to the legal principles that govern the making and publishing of images and the practical aspects of dealing with these issues. For the most part, society favors the benefits that photography offers. This is reflected in legal attitudes that are mostly permissive. In cases where photography can infringe on societal interests such as national security or protecting children from sexual exploitation, it may be strictly controlled but in most cases legal regulation is premised on balancing the right of photographers to document the world against the rights of others to enjoy their privacy and property.

While most photographic experiences do not involve confrontation or legal risk, situations do arise where failing to know one's legal rights can mean losing an image or incurring liability. Another issue faced by photographers, irrespective of the legalities, is whether there are some things they should not photograph for ethical reasons. Common ethical issues include the exploitation of subjects and how to deal with the potential to misrepresent apparent truths. Unless photographers understand the basic legal and ethical issues associated with making images, they risk not only running afoul of the law but also violating personal ethics.

■ WHY YOU SHOULD KNOW ABOUT THE LAW

Photographers who do not understand their most basic rights about what, where, and when they can photograph tend to approach legal issues with blissful ignorance, extreme caution, or reckless abandon. A mother who photographs her two-year-old son playing naked by a lawn sprinkler may assume the innocuous nature of the images will keep her out of trouble. An environmental consultant may forgo taking photographs of a hazardous waste site

for fear that it is somehow unlawful to do so. Daring and foolish souls may brazenly cross the lines of propriety to obtain exclusive images of matters such as a celebrity's private activities (attorneys occasionally refer to these photographers as "defendants"). Each of these photographers may suffer as a result of their approach to the legal issues associated with photography.

Insight into the law can make you a more effective photographer.

Insight into the law can make you a more effective photographer because it enables the exercise of judgment that allows you to achieve your objectives—even in difficult or risky situations. For example, people can better handle confrontations when they feel secure about their rights and are knowledgeable about their potential remedies should those rights be violated. Photographers who know the law are also better able to find options that minimize their legal risks, such as composing shots to exclude incidental but legally problematic subjects. An understanding of the practical aspects of the legal system can be used to advantage to get images where other photographers fail. For instance, many people assume that the most common motive behind filing lawsuits is to recover money and are unaware that emotional issues are the root of many kinds of litigation. Showing sensitivity and simple courtesy are not only effective tools for avoiding confrontations and lawsuits; they can be skillfully used to make opportunities denied to the less knowledgeable.

While understanding legal principles can help you deal with the legal aspects of taking photographs more effectively, you should also realize that no book can substitute

Sometimes photographers misunderstand or are unsure of their rights to photograph certain kinds of subjects. There are no laws against the photography of infrastructure such as dams.

for informed advice from counsel in situations that involve significant legal risk. One reason for this is that the law has not always evolved to the point where it is possible to determine clearly how it applies to a particular situation. Furthermore, laws vary among jurisdictions and change over time as legislatures enact new statutes and courts modify legal doctrines to reflect modern sensibilities. These and other factors can make assessing how the law applies to specific facts and locations difficult even for expert practitioners. In cases where the law is unclear or the potential consequences substantial, it is in your best interest to consult with an attorney for advice on the legal risks and how to avoid them.

■ How Laws Are Made and Enforced
A civil procedure professor once commented that learning about the law is similar to eating sausage. If you like it, then don't watch it being made. In other words, the operation of the legal system is not always consistent with the common perception of how it should work. Since photographers must apply legal principles to real situations, an understanding of how laws regulate conduct within our society is an important step to managing the legal aspects of making images. However, it is also important to understand the mechanisms by which laws are created and enforced, because a principle is meaningless if it cannot be put into action.

As a starting point, the legal system's role in society is to define enforceable conduct and to provide mechanisms for resolving disputes. The three basic kinds of laws are statutes, administrative rules, and the common law. Statutes are enacted by legislatures but interpreted by the courts. Administrative rules are promulgated by government agencies pursuant to statutes that give them this authority. The common law has been fashioned by courts based on the enforcement and application of ancient customs and judicial precedents.

The federal government and states have their own legislatures, which means that many different laws are enacted. Federal statutes usually apply to conduct in all the states. For example, the statutes that regulate the photography of currency apply equally to all citizens of the United States regardless of whether they live in Alaska or Wyoming. However, laws enacted by the states generally apply only to conduct within that state. This means that someone who conceals a camera to photograph private activities in Atlanta can be prosecuted under the Georgia statute prohibiting such acts but not under the Hawaii law that prohibits the same.

Administrative rules are generally limited to specific jurisdictions or activities that affect a particular agency. For instance, a city ordinance requiring a permit to photograph a commercial assignment in a city park will be limited to that city and a regulation issued by the U.S.

Postal Service regarding photography inside of post offices will not apply to other government buildings. Sometimes regulations are issued that interpret or define the scope of requirements described in a statute. An example is the regulation issued by the Department of the Army regarding photography of military decorations and service medals.

Although statutory and administrative laws vary substantially across the United States, in many cases it is reasonably easy to look them up. All the states and the federal government have made access to their statutes and regulations available on the Internet where they can be searched electronically. These laws are usually available in local libraries, and if not, can be obtained from the appropriate government office. Typical kinds of laws that can be looked up in this manner include city ordinances that set forth rules that apply to public sidewalks and parks, statutes that regulate concealed cameras, and court rules that govern the photography of judicial proceedings.

The common law encompasses doctrines such as trespass and contract and is applied by state and federal courts. Although the states and the federal government have separate court systems, the federal courts are generally required to apply the law of the state in which they are located when deciding common law issues. For instance, a federal court hearing a right to privacy case in California would apply the California doctrine of privacy rights while a federal court in Virginia would apply the Virginia doctrine. As is the case with legislative law, the common law may be applied differently among the states although the ancient roots of the common law tend to moderate such differences.

Looking up the common law is more difficult than researching statutory requirements because this body of law is set forth in the form of published decisions. However, even though the states have their own versions of the common law, they tend to follow the same general principles for doctrines such as trespass and contract. Some common law doctrines can vary significantly among the states, such as the doctrines that govern privacy rights. In addition, common law doctrines are sometimes modified by statute. Researching common law issues takes a

The common law is set forth in thousands of volumes of published court decisions that require specialized skills to research.

fair amount of knowledge and effort and is not recommended for those who lack the necessary training. However, general knowledge of common law principles should suffice to keep most photographers out of trouble, provided they refrain from photographing subjects under questionable circumstances or seek advice from counsel beforehand.

As an example of how courts apply the common law to specific situations, suppose someone in Oregon is waiting for a flu shot and photographs his children playing in the waiting room at a medical center. The pictures are posted on the family web site and several months later, the photographer is sued for invasion of privacy by a patient of the clinic who claims she appears in the background of one of the photographs. Although such a claim may appear frivolous, arguments can be made that the photographer is liable for invading the other patient's privacy. The Missouri Supreme Court ruled in 1942 that a magazine photographer violated the privacy rights of a patient with a dietary ailment who expressly objected to being photographed in her hospital bed. Similarly, the Maine Supreme Court ruled in 1976 that a physician violated the privacy of a dying man by taking unauthorized photographs of him.

Even simple laws are subject to twists that complicate their enforcement.

Some legal commentators maintain that these cases represent the principle that medical patients cannot be photographed without their consent. However, while Oregon courts would likely consider these cases, they are not required to follow them since they do not establish the law in Oregon. Furthermore, an Oregon court could find that taking an unauthorized photograph of a patient in a waiting room does not violate the kind of privacy interest the legal doctrine is intended to protect. On the other hand, Oregon law does favor some right to privacy and would give serious weight to the fact that other states have decided that the privacy of medical patients warrants more protection from photography than do other subjects. Since the Oregon courts have published no decisions regarding the privacy rights of patients in waiting rooms, an attorney would necessarily have to make an educated guess about how a judge would decide the case.

Laws can be enforced criminally or civilly, depending on how they were enacted. The objective of criminal laws is to deter misconduct by punishing violators. The typical sanctions are monetary penalties and incarceration. Laws that provide for civil remedies are generally intended to compensate victims for their injuries. Criminal laws and some statutes and regulations can only be enforced by the government. For example, a statute that makes it a criminal offense to photograph classified military installations absent authorization can be enforced by the federal government but not by private citizens. Common law actions can be enforced by private citizens but only on their behalf. For example, if someone trespasses onto your neighbor's property to get better access to photograph your family, your neighbor could sue them but you could not. In some cases, conduct can violate criminal and civil laws simultaneously. For example, a photographer who refuses to leave the lobby of a hotel after being told to leave by the management may be prosecuted by the state for criminal trespass and sued by the hotel for private trespass.

■ THE MULBERRY TREE CASE
Even simple laws are subject to twists that complicate their application and enforcement. For example, the law of trespass appears reasonably straightforward in that it prohibits one from entering another's property without permission. However, the substantive aspects are often overwhelmed by the procedural and practical aspects of taking a matter to court. For instance, there is the cost of retaining counsel, the possibility that judges and juries will make serious errors, and the difficulty of making decisions in the face of uncertain outcomes. The following scenario illustrates how a simple trespass case involving trivial conduct can combine with fortuitous circumstances to cause legal trouble for a photographer.

Assume that a suburban naturalist wants to photograph some birds who appear to be building a nest in a mulberry tree next to a house. The photographer asks a young woman (actually, she is the fourteen-year-old daughter of the homeowners but looks much older) if he can set up his tripod next to the house and take some pictures. She tells him he can take pictures whenever he wants and leaves to visit friends. Her mother drives up thirty minutes later and, thinking that the photographer is trying to photograph through her daughter's bedroom

window, starts hitting him. She is not appeased by the photographer's explanations that he only wants to photograph mating rituals and that he has permission to be in the yard whenever he wants. The photographer stomps off—only after vowing to return when the mating process becomes more active. The mother, who has been undergoing psychiatric treatment for severe anxiety, deteriorates after the incident and is hospitalized for several weeks under heavy medication.

The outraged homeowners sue the photographer for trespass and invasion of privacy and seek compensation in the amount of $500,000 for emotional distress and medical bills. The photographer files an answer denying that he trespassed or invaded their privacy and counterclaims for assault in the amount of $100,000. Attempts to settle fail when the homeowners refuse to settle for less than $300,000 and the judge sets the matter for trial. Although in many respects this is a straightforward case, the judge and jury make the kind of errors that typically occur in trials. The most significant error by the judge is an evidentiary ruling where he allows the homeowners to testify about their hospital bills but refuses to let them present a document that summarizes them. Later in the trial he decides to back off a little bit and allows the homeowners to submit one hospital record that reflects an interim charge of $5000. The jury errs in applying the law after misunderstanding the following instruction that was rendered in the judge's most studied monotone: "A trespasser is a person who enters or remains on the premises in possession of another without a privilege to do so and a possessor of the premises has no duty to keep the premises in a safe condition and a trespass occurs when there is an interference with the right of possession. . . ." Having heard this once through and without the opportunity to ask for clarification, the jury deliberates for five hours and finds that the photographer committed a trespass despite getting permission from the daughter and that the homeowners are not liable for assault because they were defending against a trespass. They award the homeowners $5000 mainly because they do not believe the incident contributed greatly to the hospitalization.

The homeowners do not know the basis for the verdict and assume the jury mistakenly believed the hospital record the judge allowed into evidence was a summary of their total expenses. The photographer also disagrees with the judgment because he believes that the mother was

legally required to ask him to leave before assaulting him and that he reasonably relied on the daughter's permission to enter the property. Although both parties are unhappy and have reasonable grounds for appealing the court's judgment, they decide not to appeal because it is too difficult to predict who will win.

A simple trespass case can cause legal trouble for a photographer.

This example shows how a particular set of facts can lead to a middling outcome but, of course, many others are possible. For instance, had the jury believed that the stress of the incident contributed significantly to the hospitalization, they could have awarded a large verdict against the photographer. Similarly, had they understood the judge's instruction better, they may have ruled in favor of the photographer and possibly awarded him a small amount of money. In any case, the moral of the story is that sensitivity to legal and emotional issues can help photographers avoid getting entangled in legal processes. Had this photographer understood the law and the potential consequences better, he could have considered foregoing the opportunity to take the photographs, verifying the age of the daughter and waiting to get permission from a parent, or at the very least treating the mother respectfully when the confrontation began. Arguing with the mother was particularly foolish, and sensitivity to her perspective could have changed the outcome of the incident. With a better grasp of the practical and legal aspects, the photographer could have obtained his images while avoiding much aggravation and expense.

ACCESS TO PROPERTY

Although most photographers understand the basic laws that govern the rights to enter and remain on property, knowing the nuances can greatly assist in gaining lawful access and avoiding erroneous and potentially costly decisions. This knowledge is particularly useful in situations where the legality of being able to take photographs depends on the location. For example, is it lawful to park on the shoulder of an interstate highway to photograph a rainbow? Is it alright to enter and photograph a vacant property that is not posted against trespassing? Does a forklift driver have the authority to let you into a lumberyard to take photographs inside? Being able to answer these kinds of questions can be critical to determining your right to take photographs in specific locations.

■ PHOTOGRAPHY IN PUBLIC PLACES

The role of public places in photography is important to understand because private parties cannot restrict your photography in such areas and the government can restrict photography only if it can show an overriding government interest. In other words, photographers have a qualified right to take photographs when in a public place. Whether or not a particular government interest is sufficiently compelling to override the right to take photographs will depend on the nature of the public place.

There are few reported court decisions that actually describe what constitutes a public place in the context of photography. However, the Supreme Court has established that the constitutionality of government restrictions on free speech activity generally depends on the nature of the forum in which the restriction is applied and on the type of restriction. Under this analysis, the government has very little power to restrict photography in traditional public forums such as city parks and sidewalks. In some, but not all states, large shopping malls are considered traditional public forums when they have common areas that invite the public onto the property for purpos-

City parks and sidewalks are traditional public forum areas where the government must show a compelling reason to restrict expression.

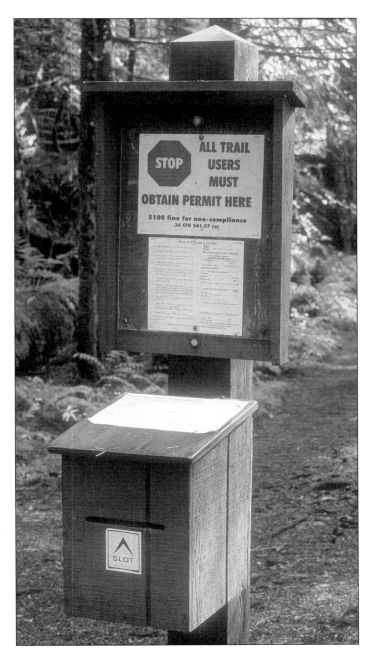

ABOVE—*Although activities in parks can be regulated, photography is almost always allowed.* TOP RIGHT—*No permits are needed to take photographs at national parks and forests except in a few limited situations where professional casts or settings are used or when products and models are photographed for advertising purposes. However, photographers must comply with all other permit requirements.* BOTTOM RIGHT—*The relatively few legal restrictions on photography in public parks means they can be excellent locations from which to make images.*

es other than shopping. As the nature of a place bears a decreasing resemblance to a forum traditionally available for expression, the government may impose enhanced restrictions on activities. Places such as military bases and prisons are well recognized as areas where expression may be severely curtailed and are typically closed to the public altogether.

There are rarely formal rules that prohibit photography while in places of public transit although many photographers have been harassed when photographing in such places. Policies vary considerably around the country and photography in airports, train stations, and similar places incurs the chance of being confronted.

The most common reason for restricting photography on government-owned property is to avoid disruptions to legitimate government functions. For example, judges can prohibit photography in courtrooms to preserve dignity and decorum and building administrators can regulate photography in government buildings to avoid interference with government business. Sometimes governments will regulate only certain types of photography. For example, some agencies and cities require permits for commercial photography when extensive props, crews, or models are used on public properties they administer but do not otherwise restrict photography. For example, the National Park Service requires motion picture photographers to obtain permits if the filming will involve professional casts and settings and requires still photographers to obtain permits before photographing products and models for the purpose of commercial advertising. Neither the National Park Service nor the U.S. Forest Service require permits for general photography even if the images may later be marketed.

The most open public places are those where members of the public have traditionally been accorded the right to express themselves. Established examples of these public forums are city sidewalks and public parks. Some cities have enacted ordinances that encourage the maximum public use of facilities such as parks. While the government can impose restrictions when necessary to protect public welfare, these are typically addressed to the public at large and rarely affect photography specifically. The primary restrictions for activities on public sidewalks are prohibitions against obstructing free passage and access to properties adjoining the sidewalk. The ordinances and rules that apply to city parks typically prohibit things such as littering, unreasonable noise, and vandalism.

Many government-owned or -operated facilities are not governed by formal regulations or ordinances. Areas of public accommodation such as public transit terminals, airports, and train stations are a good example. They are generally not considered to be traditional public forums although some facilities, such as subway systems, have had historical associations as photographic subjects. While many photographers have been harassed in recent years at such places, there are rarely formal regulations in effect that restrict photography at these places.

Some government facilities such as concert halls and convention centers are operated essentially as private enterprises. In such cases, the principles governing access are same as the ones that apply to private property owners which are discussed later in this chapter. When the government operates in a proprietary capacity, it is as free as

any other private entity to restrict photography. For this reason, cities can legally prohibit cameras at concerts held in their auditoriums at the insistence of promoters and artists who want to control images for marketing reasons.

As noted above, photography in public places other than public forums can be restricted if it can substantially disrupt the legitimate function of the facility. Many government agencies have promulgated regulations that govern photography in the publicly accessible spaces under their jurisdiction. Some agencies are very permissive about photography while others impose strict requirements. The tightest restrictions tend to be imposed on military bases, security installations, and concert halls. For example, cameras are prohibited at facilities operated by the National Security Administration unless specially authorized by the Director of Security or a designee. Even activities that are open to the general public may be subject to substantial restrictions even though photography will not jeopardize national security. The Securities and Exchange Commission and the Nuclear Regulatory Commission require advance approval before meetings of their commissioners can be photographed. Other agencies, such as the Tennessee Valley Authority and U.S. Postal Service, are more comfortable with the prospect of unapproved images and

specifically allow photography at their public meetings provided that it is not disruptive.

Some agencies regulate photography depending on whether it is done for personal, news, or commercial reasons. Photography for personal purposes tends to be the least restricted. For example, general visitors to presidential libraries may take photographs in areas open to the public but photographs intended for news, advertising, or commercial purposes can be taken only after a library director approves the request. Some agencies, such as the U.S. Postal Service, take the opposite approach by explicitly allowing news photography in the public areas of post offices but requiring other photographers to seek permission. Commercial and advertising photography at many government properties requires a permit or other permission from an agency. Photographers seeking to do commercial photography at the National Arboretum or commercial aerial photography over national parks must pay a fee and provide advance notice. Advertising and general news photography are prohibited outright at the National Archives Building and the Washington National Record Center.

Although regulations governing photography are not commonly displayed, they are available in administrative

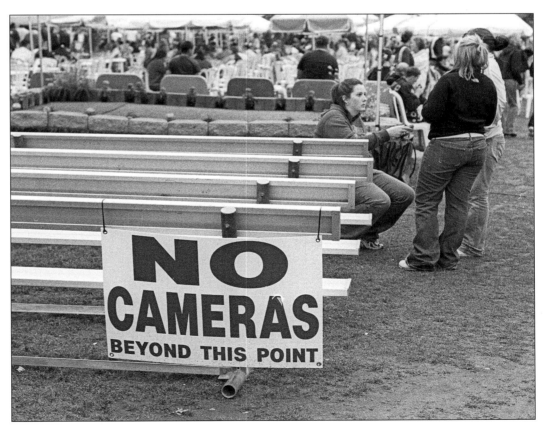

The government can bar cameras when they want to prevent photography at events such as concerts to protect the commercial interests of the performers.

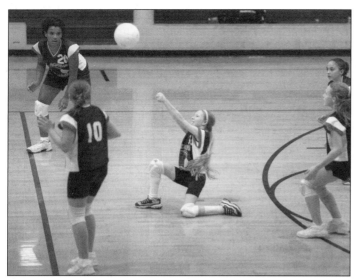

There are no statutes that prohibit photography at schools although schools have the same rights to restrict photography as other property owners.

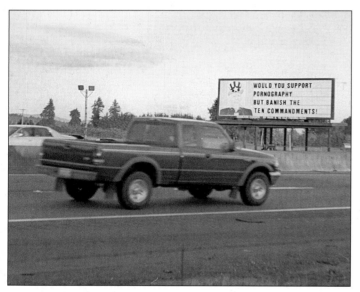

Vehicle codes will generally prohibit stopping on the shoulder of Interstate highways for the purpose of taking photographs but such stopping is allowed on ordinary roads.

compilations such as the Code of Federal Regulations and State administrative codes. Those who are disinclined to look up the regulations can call the public affairs offices of the appropriate agency and ask what requirements apply to photography. However, there are no assurances that you will get the proper information. Government employees are not always familiar with the regulations implemented by their agencies and sometimes dispense advice that is too restrictive or permissive. Furthermore, agencies are rarely bound by erroneous information provided by

their employees which means that you rely on informal advice at your own risk. For these reasons, it is better to review the applicable regulations first hand than to rely on an employee's summary.

Schools present a special issue regarding access because they are often open to the public for some activities but closed for others. Most schools strictly limit access while in session to avoid disrupting classrooms and to protect students. Any photography done on school grounds while classes are in session will require permission from school officials. Sometimes school officials assert that they cannot allow photographers onto school grounds because of the Family Educational Rights and Privacy Act. While this act prohibits schools from releasing educational records without a parent's permission, it does not regulate photography. Extracurricular activities, such as sporting events and performances, are generally open to the public and schools usually allow photography although they are within their rights to impose restrictions such as the use of flash. Many schools make the exterior grounds open for public use after school hours for purposes such as recreational activities and public events. These activities are open to photography.

Streets and highways are open to the general public but are regulated by vehicle and traffic codes. The laws regulating the use of streets and adjacent shoulders vary by state and locality but can be determined easily enough by looking them up in the appropriate vehicle code. Not surprisingly, vehicle codes generally prohibit pedestrians from positioning themselves in the portion of roads traveled by vehicles. Most vehicle codes prohibit parking on shoulders of throughways such as Interstate highways, freeways, and expressways except during emergencies such as a vehicle breakdown. However, it is usually permissible to park and take photographs from the shoulders of other roads and highways, provided you do not obstruct fire hydrants, crosswalks, or driveways.

■ **RESTRAINTS ON PHOTOGRAPHERS IN PUBLIC PLACES**
Although normal photographic activities should not cause problems in public forum areas, extreme or suspicious behavior could expose a photographer to prosecution under disorderly conduct and loitering laws. Disorderly conduct laws prohibit people from engaging in behavior that causes inconvenience, annoyance, or alarm through disruptive behavior. These statutes usually require a sub-

stantial level of interference with another person's activities to be actionable. For example, taking a few photographs of someone in a public place will not constitute disorderly conduct even if the person is annoyed. Extreme behavior, such as repeatedly taking closeups over someone's objections, could constitute disorderly conduct depending on how the statute is written. Photographers have also been held liable for disorderly conduct by refusing to obey reasonable orders from police officers at accident and crime scenes.

Normal photography is unlikely to result in a prosecution for loitering, although in some circumstances you might be questioned by police about why you are hanging around a particular location. The intent behind these laws is to give the police an enforcement tool to prevent crime before it happens. Because crimes such as prostitution, drug dealing, burglary, and pedophilia are typically characterized by persons standing or wandering about with no apparent purpose, some states and many municipalities have enacted laws that attempt to make it a crime to be present in an area for no legitimate reason. Courts have declared many of these laws unconstitutional because they fail to distinguish between unlawful and constitutionally-protected activities and thus give the police the discretion to arrest almost anyone on the streets. The ordinances that have withstood judicial challenge usually describe the prohibited conduct more specifically by requiring an explicit connection to unlawful activities such as prostitution or drug dealing.

As a practical matter, photographers are unlikely to run into problems with loitering ordinances unless they are present in places at unusual times. However, there is nothing illegal about being present in public places at any time except when specific areas have been declared closed to the public, such as city parks after hours. Keep in mind that the enforcement of these ordinances is usually motivated by concerns over street crime, drug dealing, and prostitution and a credible explanation for your presence (i.e., photog-

raphy) can alleviate police concerns. In many cases, the police will be responding to complaints filed by residents or workers concerned about suspicious activity. If you are in a place at unusual hours and see a police officer approaching, it is best to remain where you are because leaving the scene will make you look more suspicious. Once you have explained that you have legitimate purpose in being present, most police officers will leave you alone.

Police, firefighters, and emergency technicians do not have the general power to order you not to take photographs but they can order you to not to interfere with

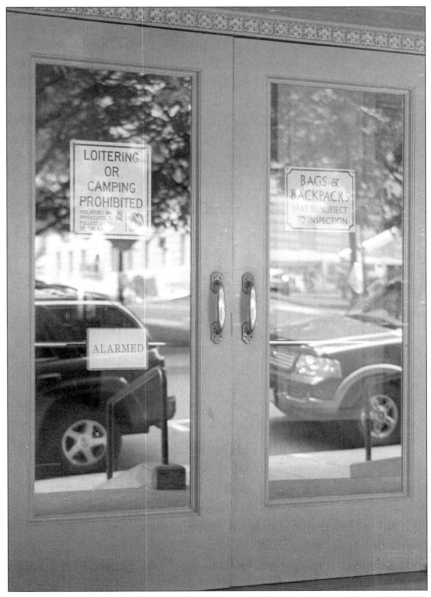

Private persons have no legal authority to prohibit loitering on the public sidewalks adjoining their properties. Although signs that purport to prohibit loitering may not have legal effect, they can indicate that the property owner may be more prone than most to summoning the police.

their lawful activities. In other words, they can instruct photographers to maintain a sufficient distance so as to avoid interfering with their operations but otherwise they cannot restrict photography of events such as arrests, fires, and accident scenes that take place in public view.

Police rarely have the authority to ask you leave an area because of concerns about national security. Although there has been a significant increase in the number of confrontations between police and photographers following the aftermath of the terrorist attacks of September 11, 2001, there were no laws enacted in the aftermath that authorize police or other law enforcement agents to order people away from particular areas. California has a long-standing statute that prohibits loitering near industrial facilities and infrastructure that have been posted against trespassing such as tank farms, refineries, pipelines, reservoirs, dams, power plants, radio and television stations, telephone poles, transmission towers, water and waste-water plants, and railroad facilities and railroad bridges. It is not uncommon for cities to have ordinances that prohibit loitering on places such as bridges and overpasses. The constitutionality of these kinds of laws are suspect because they generally fail to distinguish between unlawful and lawful activities and the inherently vague meaning of loitering. These kinds of laws are rarely, if ever, directed against photographers.

■ ACCESS TO PRIVATE PROPERTY
There is no general legal right of access to private property for the purpose of taking photographs, which means that photographers must obey the same laws that apply to the general public. Because private property owners have the right to exclude others from their property and to limit the activities of those they allow to enter, photogra-

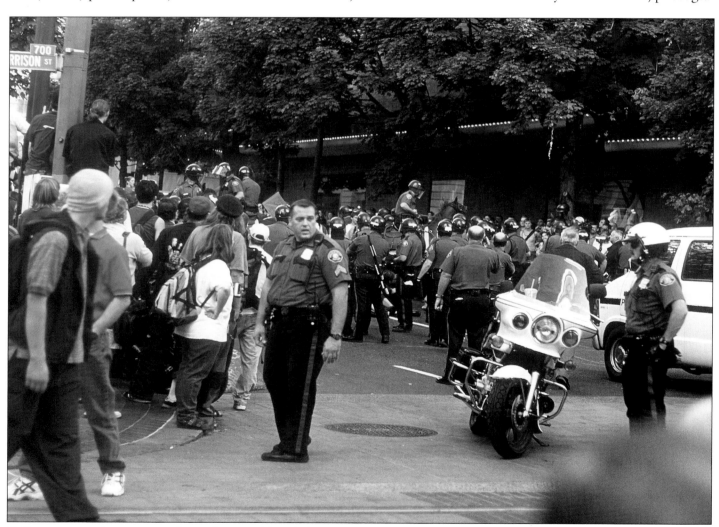

Police cannot order you away from photographing their activities but can order that you not get so close that you interfere with their operations.

Entering fenced and posted property without permission is trespassing. Even sticking a lens through a chain link fence will violate the rights of landowners to exclude others from their property.

phers face liability for trespass if they enter another person's property without permission or disobey the conditions of that permission. The law recognizes that in many cases people may rely on the customs of the community that establish when they have implicit permission to enter someone else's property. It is a universal custom that the public is allowed to enter the public spaces of commercial establishments such as restaurants and stores. It is likewise a universal custom that members of the public may not enter places such as residential units or industrial properties without explicit permission to do so.

In some cases, it is difficult to determine whether the owner allows the public onto a property and some judgment must be exercised. For example, undeveloped properties sometimes show signs of public access such as paths or recreational structures. Although such activities may indicate that the owner allows the general public to enter the property, there is no legal presumption that landowners have given such consent. Furthermore, owners are not required to post signs prohibiting trespassing if they do not want the public entering their property. Where the custom in an area is that people may use privately owned open space for general recreation such as hiking, then you may reasonably assume that you may enter to take photographs unless informed otherwise. However, such deci-

sions must be made at your risk because many communities do not have clearly defined customs in this regard. Even a good faith but mistaken belief that you have permission will not protect you from a charge of trespass unless the mistake is the fault of the property owner. For example, you are still trespassing if you enter onto the wrong property because your client gave bad directions. Furthermore, the fact that you do not intend to cause harm does not excuse a trespass.

Photographers should be aware that the law of trespass is not limited to bodily entries. Extending a camera over and across a fence will constitute a trespass even though the photographer is standing outside the fenceline. Passing over a property for the purpose of aerial photography can constitute a trespass when it infringes the immediate reaches of the airspace above the property and annoys the occupants. Similarly, for those of you who are willing to crawl through sewers, a subterranean entry onto someone else's property is also a trespass. However, you are free to photograph anything on someone's property that is in public view even though you may be prohibited from entering the property itself.

There are a few legally recognized instances where you may enter or pass over property even without permission. Using a navigable stream in a reasonable manner is not a

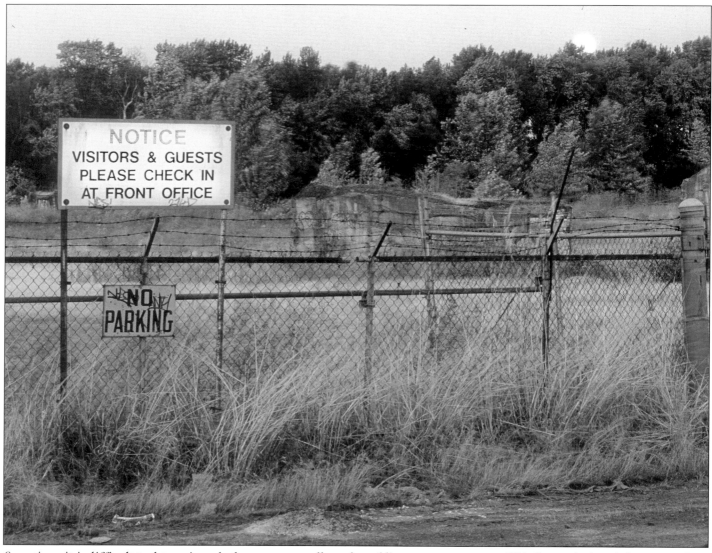

Sometimes it is difficult to determine whether an owner allows the public to enter a property. This former industrial property shows signs of public use and the entrance is not posted against trespassing. While fences can often be construed to mean that public entry is prohibited, the gate to this property is unlocked and has been left wide open.

trespass even if the streambed is privately owned. Although what constitutes reasonable conduct is a factual issue, most courts would hold that taking photographs of private property from a boat is not trespassing. Another instance where permission to enter private property is not necessary is when the photography is necessary to mitigate a public disaster or serious harm to another person. This justification is limited to exceptional situations such as when taking photographs will facilitate the apprehension of a criminal. It does not extend to photography that is not necessary to prevent a serious harm even if it relates to a beneficial purpose such as news coverage. For example, a photographer who sees a child struck by a hit-and-run driver would be legally justified in entering private

property to photograph the fleeing vehicle because this evidence might identify the guilty driver. However, the photographer would not be justified in entering private property if the purpose was to get a better photograph of the victim to publish in a newspaper.

Photographers who enter property with permission should also be aware that owners are free to place express or implied limits on photography. Determining the limits of implied consent to take photographs often requires judgment even when consent has been granted for other purposes. For example, one can lawfully enter a restaurant to dine but whether one has implicit permission to take photographs will depend on the nature of the establishment. One could reasonably assume that a fast food

restaurant will not mind patrons taking a few photographs of their family because this activity is compatible with informal dining oriented to families. However, it would be unreasonable to assume that a formal restaurant will allow you to photograph celebrity patrons unless you have explicit permission.

Photographers are sometimes tempted to misrepresent why they want to enter a property in order to get permission. Irrespective of the ethical ramifications, falsely representing one's purpose for entering a property may invalidate the consent and expose you to liability for trespass. Most jurisdictions hold that one cannot even misrepresent the reason for wanting to take photographs in order to obtain consent from the owner. For example, a photographer would still be trespassing if he or she tells the property owner that the photographs would be used to illustrate an article on tourism when the real purpose is to gather evidence to be used in a lawsuit filed against the owner. A few courts have held that fraudulently inducing consent by misrepresenting how the photographs will be used does not constitute trespass but that the photographer can still be sued for other torts such as fraud.

Mistaken consent may constitute no consent at all. For example, a property owner may wrongly believe that the photographers accompanying police are there for the purpose of recording evidence as part of an investigation. If the photographers are actually working for the media and did not obtain permission from the owner, they can be liable for committing trespass. Therefore, photographers should be careful not to assume that the absence of objections implies consent if the circumstances are such that the property owner could reasonably be expected to misunderstand why the photographer is present.

Another limit on permission to enter a property is the time period for which it is effective. The implied consent to enter a restaurant is obviously limited to the hours during which the restaurant is open to the public. In other circumstances, exact time limits may not be specified but are assumed to be for the time reasonably needed to accomplish the purpose underlying the entry. Unless specifically granted, permission to enter a property does not extend to future entries. This means that if an owner agrees to let you onto his or her property to photograph something, you should not assume that you may enter at other times.

It is important to ensure that the person giving permission to enter a property has the legal capacity to do so. Whether a person has the capacity to allow you onto a property will depend on his or her relationship to the owner and the ability to appreciate the nature, extent, and consequences of the consent. Some people are presumed not to have the legal capacity to give permission such as very young children and severely mentally-impaired persons. Even older children and less impaired persons may be deemed not to have the capacity to consent, depending on the circumstances. When seeking entry to a prop-

Some places that have reputations for prohibiting photography may not always have objections. For example, photographers visiting casinos have had varied experiences ranging from openly tolerant to actively confrontational.

erty, it is better to seek consent from persons who are competent adults and bear an appropriate relationship to the owner.

The authority to grant consent can be critical when the photographer is seeking permission to enter a property from someone other than the owner. When seeking permission, you should establish whether the person has authority to allow other people access to the property. In many cases, one may reasonably infer that people such as the managers of commercial establishments have such authority. Among the factors to consider in determining whether someone has the apparent authority to allow an entry are the stature of the parties, the nature of the property, and the general customs that apply. It is important to understand that not all employees have the authority to allow you onto the premises. For instance, cafeteria workers at a nuclear power plant are not authorized to let visitors enter the control room. When in doubt whether someone is authorized to allow access, seek permission from someone who is more certain to have authority.

They are not entitled to seize a photographer's film or equipment.

Another issue is whether public officials, such as police and fire officers, can allow media photographers onto private property to cover searches, fire fighting, and similar activities without the permission from the owner. Although inviting the media to cover police activities has been customary in parts of the country, government officials do not have the authority to allow the media or independent photographers to enter private property without the owner's permission. This means that a photographer could be liable for trespass, even when a government official said they could enter. Most attempts to argue that traditional practices constitute implied consent have failed. A notable exception occurred in 1976 when the Florida Supreme Court ruled that a newspaper photographer reasonably relied on permission given by fire officials when he entered a private residence and photographed the outline of a deceased teenager. However, most if not all other courts that have faced this issue have ruled the other way.

Sometimes photographers encounter situations where the person who objects to an entry may not have the authority to exclude others from the property. Because the scope of authority to refuse entry is the same as the authority to grant it, third parties have no right to order you off a property unless the owner has given them authority to do so. Among the more common situations are businesses who attempt to ban parking on streets that abut their properties and tenants at complexes such as shopping malls who attempt to expel persons from common areas. In some cases, whether the owner has given implicit authority to a tenant regarding control over activities in common areas is unclear because such matters are not always addressed in lease agreements. Likewise, cities and counties sometimes restrict parking in front of businesses at the request of the owner. It is often prudent to contact the property owner or government agency directly when seeking permission to photograph in common areas or where a private entity has posted signs that limit public use of public properties.

Although owners and their agents may use force to evict trespassers, they must first ask the offending person to leave unless the circumstances indicate that the request would be futile. Once a photographer has indicated they will not honor a request to vacate the property, the owner and his agents are legally entitled to use whatever level of force is reasonably necessary to remove the trespasser. However, they are not entitled to seize a photographer's film or equipment. Even when photographers agree to vacate premises after trespassing, they can still be sued for damages. Although photographers rarely damage property when they trespass, courts may allow property owners to recover for the discomfort, inconvenience, and emotional distress caused by an unauthorized entry. Photographers who enter properties posted against trespassing or who disregard an owner's request to leave may be liable for criminal trespass as well. In addition, using force to resist a lawful eviction can result in liability for assault.

■ PHOTOGRAPHY ON TRIBAL LANDS
Federal law treats Indian tribes as dependent nations and recognizes their legal authority to govern themselves. As sovereign governments, tribes may generally deny access to non-tribal members although the usual practice is not to require visitors to obtain permission before entering tribal lands. However, some tribal governments require permits to visit areas such as archaeological sites, scenic parks, and ceremonial places. They may also impose fees on photography in such areas. Many tribal lands are not

Photography done on your own property will rarely constitute a nuisance irrespective of what the neighbors think.

posted with signs and the responsibility for determining the appropriate boundaries lies with the visitor.

Some tribal governments ban the photography of homes and ceremonies, and even prohibit subsequent publication of a visitor's observations without prior consent from the tribal government. Such practices raise questions about how free expression rights apply on Indian reservations. Although the Bill of Rights embodied in the U.S. Constitution does not apply on tribal lands, the Indian Civil Rights Act of 1968 nominally prohibits tribes from infringing on freedom of speech and of the press. However, parties who might want to challenge such infringements will generally have to try their claims in a tribal court which might adopt a narrower interpretation of free speech rights than that provided under the U.S. Constitution. Furthermore, judicial review by federal and state courts is generally unavailable except in a few states where Congress has shifted civil and criminal jurisdiction over tribal lands to state courts. The jurisdic-tional aspects of applying the Indian Civil Rights Acts has to date impeded the ability of aggrieved parties to test the extent to which tribal governments can lawfully restrict photography.

■ **PHOTOGRAPHY FROM YOUR PROPERTY**

The same property rights that allow others to restrict photography on their property give you the right to conduct it on yours. You are generally free to take photographs while standing on your property, even if the subject matter is located elsewhere. The notable exception that sometimes applies to commercial photography is where zoning and business laws prohibit operating a business such as a portrait or product studio in a residential neighborhood. However, even these regulations often provide for variances if few customers are expected to visit the property at any given time.

Although the doctrine of nuisance has seldom been applied to regulating photography, there is no legal reason

why it cannot be used to curtail photography that unreasonably affects nearby properties. A nuisance is legally defined as an activity that unreasonably interferes with another person's use of their property or a right common to the public affecting morals, comfort, or health. To be a nuisance, the activity must be of a kind that would cause a normal person to suffer significant harm, discomfort, or offense. Activities that affect only hypersensitive persons are not nuisances. In addition, the gravity of the harm caused by the activity must be balanced against its social

Activities that affect only hypersensitive persons are not nuisances.

utility. Photography is the kind of activity that will generally be considered to have some degree of social utility unless it is done intentionally to annoy or injure someone. Quietly conducting astrophotography in your backyard would not constitute a nuisance even if the neighbors preferred that you were not outside with a camera at 2:00AM. Boisterous and drunken astrophotography at that hour would constitute a nuisance if it bothered those neighbors who chose not to participate. From a practical perspective, most situations involving photography will constitute a nuisance only because the ancillary activity offends or annoys others. For example, photographing squirrels in your front yard would not be deemed a nuisance even if your hypersensitive animal-rights activist neighbor is appalled by the stress it might induce. On the other hand, photographing unclothed models in the same setting could be construed as a nuisance if the neighbors are offended by public nudity.

If you are faced with a situation where photography may cause a nuisance, attempting to minimize the annoyance or disruptions experienced by others will work to your legal benefit because courts consider efforts at mitigation when determining whether a particular activity constitutes a nuisance. Efforts to limit photography to reasonable hours or otherwise minimizing the annoyance to others can tip the balance from gravity of harm to social utility. In such cases, a little sensitivity to neighbors and reasonable efforts at accommodation can avoid disputes altogether.

PRIVACY ISSUES

Although the law of property rights governs where you can take photographs, laws that protect personal privacy affect the circumstances in which you may photograph people. The underpinning for privacy law in the United States is the right to be left alone but in most cases the protection is limited to situations where persons take measures to seclude themselves from public view. Nonetheless, photographers need to be aware of when they can photograph people and when they are legally required to refrain. They also need to understand the role of consent in reducing their exposure to liability and how best to document whether a subject has consented in situations where the nature of the image or its use could expose the photographer to liability.

■ INTRUSIONS ON PRIVACY

Despite the importance that society places on personal privacy, the law imposes relatively few restrictions on photographing people. Even the most sensitive aspects of people's lives, including extreme tragedy and embarrassing moments, may be photographed freely unless the subjects have secluded themselves in a place or manner where they can reasonably expect privacy. Much confusion over the right to photograph people comes from failing to distinguish between the legal aspects of taking photographs and those of publishing them.

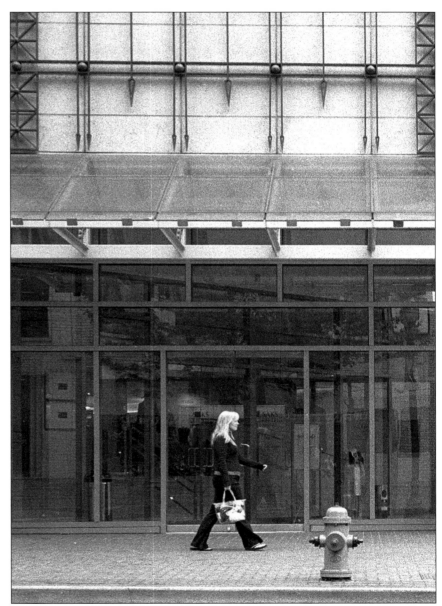

City sidewalks are a classic example of the kind of public place in which people are not considered to have a reasonable expectation to keep their activities or property secluded from public view.

The laws that protect against unauthorized publication are much broader than those that apply to taking photographs. For example, you would not violate a celebrity's legal right to privacy by photographing him walking in public view but would violate his rights if you used the photograph to illustrate an advertisement without his permission. The privacy rights associated with publishing images are covered in more detail in chapter seven.

You can usually take a photograph of someone in a public place.

The privacy right that is most relevant to the taking of photographs is called the tort of intrusion upon seclusion. This is a fairly limited right that allows people to recover damages when someone intentionally intrudes on their seclusion or private affairs in a way that an ordinary person would find highly offensive. Photography is but one of many ways in which this privacy right may be violated; others include opening private mail, viewing financial records, and wiretapping. Liability for this tort is incurred by the act of the intrusion and does not require any distribution of the images.

You can usually take a photograph of someone in a public place irrespective of whether it concerns a matter the subject or even whether it records a matter most members of the public would prefer not to have recorded. For example, courts have held that photographs of a couple caressing at a public market, a fan standing up at a football game with an open zipper, and postal employees standing next to a senator at their workplace did not constitute actionable invasions of privacy. Even though the subjects resented having their personal moments, embarrassing situations, or unwanted implied associations photographed, the photographs were taken in public places and thus did not involve the kind of private facts encompassed by the tort of intrusion.

A key principle in these cases involves whether the subjects have a reasonable expectation of privacy at the time they are photographed. In most cases, people have no such expectations when they are in an area subject to public view. Furthermore, whatever measures are taken to seclude themselves from public view must be of the kind that society generally recognizes as reasonable. For example, courts have held that photographers may stand in places open to the public and record the interior spaces of adjoining businesses without incurring liability but that photographing people who are inside of residences is generally actionable as an invasion of privacy.

One exception to the right to photograph people in public view is that one cannot photograph something that the person has a reasonable expectation of keeping private, even when the person is in a public area. The best known case involving photography, *Daily Times Democrat* v. Graham, was decided in 1964 by the Alabama Supreme Court. There a woman filed suit against a newspaper that published a photograph of her leaving a fun house at a county fair while an air jet in the floor blew her dress above her waist. In some respects, this case can be looked at as a 1960's version of upskirting because the woman's undergarments were involuntarily exposed and then photographed without her consent. Although the newspaper argued that it did not violate the woman's privacy because its photographer recorded an event that occurred in public view, the court ruled that the woman had no reason to believe she would be exposed in public and therefore did not waive any of her rights to be free from an indecent and vulgar intrusion. It also held that the newspaper had no privilege to publish the photograph because the matter was not newsworthy. The holding in this case can be criticized because courts generally give publishers a wide latitude when it comes to determining whether material is newsworthy. The newspaper had published the photograph as humor but if it had been used to illustrate a feature article on how scurrilous carnival operators were invading the privacy of the good women of Cullman County, then perhaps the court would have viewed it as serious reporting. Furthermore, the court blurred the distinction between taking photographs and publishing them with respect to the intrusion tort.

Although the holding in *Daily Times Democrat* v. Graham may be questionable, courts have made clear that other kinds of private matters are protected even when in public view provided the subject takes reasonable care not to reveal private details to casual observers. For instance, a person is entitled to privacy with regard to the amount of money withdrawn from a bank so long as the person is reasonably discrete when standing at a teller's window or banking machine. However, if someone fails to act reasonably in protecting their privacy, they can be freely photographed. For example, a woman who stands over a ven-

tilation grate knowing that the draft from passing subway trains will raise her skirt cannot complain that her privacy has been intruded upon by being photographed.

The exception to private activities revealed in public for reasons outside one's control does not apply to matters of legitimate public concern such as newsworthy events. For example, a court held that photographing a woman covered only by a dish towel while she was fleeing from a hostage situation did not violate her privacy rights because the event had legitimate news value. Similarly, another court held that photographing the disfigured corpse of a teenager killed in an automobile accident did not violate the privacy rights of her family, even though the photographer must have known that doing so would cause them extreme anguish. Although hard news stories involving crimes, disasters, and other serious events certainly quali-

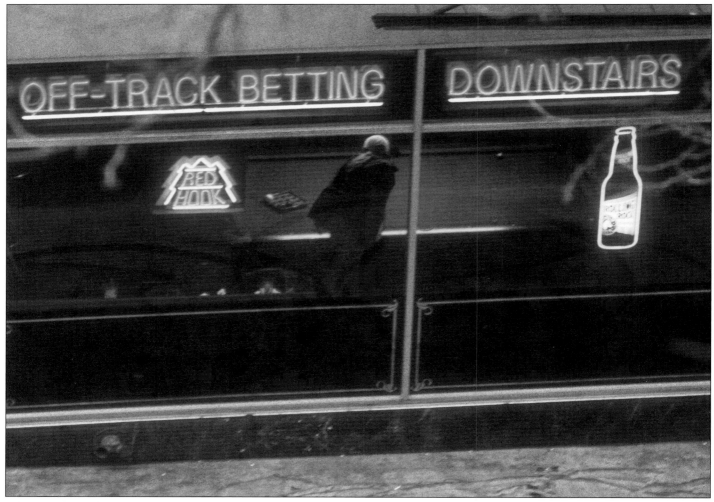

Photographing the interiors of businesses that are open to the public view is not an invasion of privacy.

fy as newsworthy events, the threshold of whether a matter is one of legitimate public concern is not very high. Even matters whose primary function is to entertain the public or satisfy their curiosity may be considered as newsworthy if they are not excessively indecent or offensive.

While courts have generally sanctioned the photography of newsworthy events that are exposed to public view, they have traditionally considered certain subject matter to be private affairs that warrant protection from intrusion. Courts have been very protective of patients who are being treated at medical facilities or in their homes. For this reason, it is standard practice in the medical community to obtain written consent before photographing patients. Similarly, people inside their homes or in the private areas of their businesses have heightened protection under the right to privacy. Courts have also ruled that news and documentary photography can violate the privacy rights of inmates who do not consent to being pho-

tographed while they are in parts of prisons or jails that are generally secluded from the view of outsiders.

■ **INTENTIONAL INFLICTION OF EMOTIONAL DISTRESS**
Although the law allows for most photography in public places regardless of its emotional effect on others, photographers can be liable if they actually intend to cause their subjects to suffer emotional distress. This kind of claim is most commonly called the tort of intentional infliction of emotional distress or outrageous conduct. To be liable a person must act intentionally or recklessly in a way that exceeds the bounds of public decency and that causes someone to suffer emotional distress so severe that a reasonable person would not be expected to bear it. A great deal of rudeness or inappropriate behavior is required before a claim for outrageous conduct can be expected to succeed. Not only must a plaintiff prove that the conduct was intended to cause emotional distress, he or she must

show that the emotional distress was severe. Insults, annoyance, and indignities are not sufficient to support a claim.

The case of Muratore v. M/S Scotia Prince is a good illustration of how photographers can be liable for boorish and unnecessary behavior. The plaintiff was a passenger on a cruise ship sailing from Maine to Nova Scotia. The voyage started off ominously when the two photographers working for the cruise line refused to honor the plaintiff's request that she not be photographed. The photographers took pictures anyway and posted one after doctoring it by pasting a gorilla's head over her head.

The photographers continued to take pictures of her throughout the cruise despite her objections. During one confrontation, one photographer told the other to "Take the back of her—she likes things from the back," which the plaintiff (and later the court) construed to be highly offensive.

Needless to say, being harassed and embarrassed over being photographed made for an unpleasant trip. During much of the cruise, the plaintiff stayed in her cabin to avoid the photographers. After the cruise, she filed a lawsuit alleging that the photographers invaded her privacy and intentionally inflicted emotional distress. The court ruled against her on the invasion of privacy claim, noting that all the photography took place in the public areas of the ship. However, the court ruled in her favor on the outrageous conduct claim, finding that the photographers had deliberately tried to upset the plaintiff by playing on her sensitivity about being photographed.

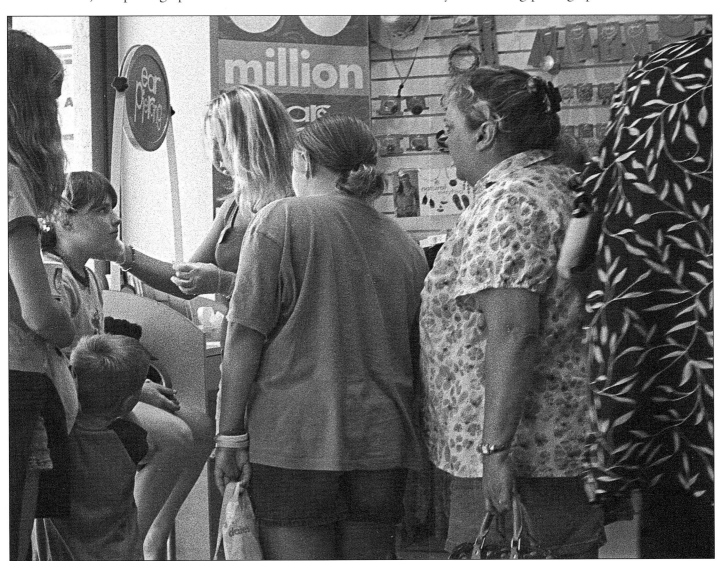

The protection of privacy accorded to medical treatments does not extend to activities that occur in public and does not extend to procedures intended to adorn the body such as ear piercing.

The Muratore case is a good lesson regarding the importance of mature and respectful conduct when taking photographs. The photographers were supposedly employed on the Scotia Prince to provide a service to the passengers and not to harass them. Any reasonable person could have deduced that neither the plaintiff nor other passengers were likely to purchase photographs of the plaintiff and that there was little if any business justification to take them. More mature photographers could have easily avoided liability by honoring the plaintiff's wishes or at the very least by not insulting her. Showing courtesy and respect to subjects can be very effective at avoiding liability for outrageous conduct because hard feelings often provide a stronger motive to pursue legal claims than the prospect of monetary compensation.

The tort of intentional infliction of emotional distress requires conduct that one knows will be so severe that a reasonable person cannot be expected to endure it.

When photographing residential structures, one should be careful not to inadvertently record the private activities of the occupants.

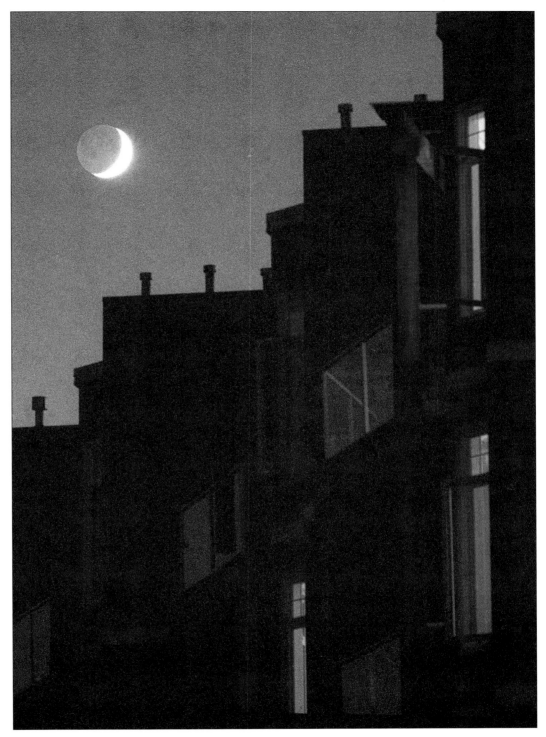

■ REGULATION OF PHOTOGRAPHY TO PROTECT PRIVACY

Although the common law doctrines have traditionally played the dominant role with respect to privacy issues, legislation is increasingly coming into play to protect people from very intrusive forms of photography. These laws tend to mirror the common law elements by prohibiting photography of people in private places without their consent, but they differ in that violations constitute crimes that can result in fines or even incarceration.

One kind of privacy statute generally prohibits people from looking into dwellings with the intent to interfere with privacy. Although these ordinances do not apply to inadvertent glances through windows and doors, they do make taking photographs of private activities in dwelling units unlawful. Examples of the kinds of dwelling units

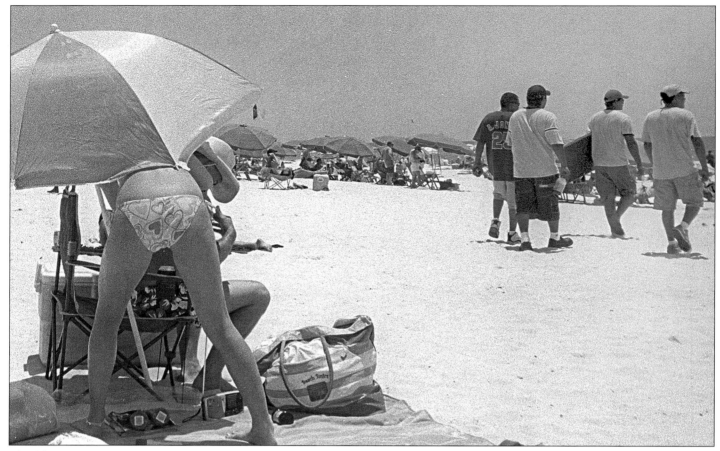

Would a photographer be liable for taking this kind of image in Texas if she had feelings for men walking around in baggy shorts?

that are covered by these laws are houses, apartments, hotel rooms, and motor homes. These laws can be interpreted to protect any activity within the confines of a residential structure and arguably extend liability beyond what is encompassed by the tort of intrusion.

Some states have enacted laws that specifically prohibit installing or using devices to photograph people in a private place without their consent. These statutes vary widely in their specificity. For instance, some legislatures prefer general language such as contained in a New Hampshire statute that defines a private place to be "a place where one may reasonably expect to be safe from surveillance but does not include a place to which the public or a substantial group thereof has access." Other legislatures make their statutes more specific, such as the Oregon statute that expands the definition of private place to include " a bathroom, dressing room, locker room that includes an area for dressing or showering, tanning booth and any area where a person undresses in an enclosed space that is not open to public view." Such specificity can be helpful in defining the limits of lawful conduct. For example, one

can discern with certainty that a locker room associated with a community swimming pool qualifies as a private place in Oregon whereas the legal status of such areas in New Hampshire is more open to interpretation. State privacy statutes also vary with respect to the activities they protect. For instance, the New Hampshire statute applies to any event occurring in a private place while the Oregon statute applies only to persons in a state of nudity.

Concerns that advancements in imaging and computer technology have resulted in the enactment or amendment of statutes that seek to protect privacy based on a person's reasonable expectations and do not require that the person be in a private place. Most of these statutes have been enacted in response to "upskirting" where small or concealed cameras are used to take pictures of women's undergarments. Some of these laws provide victims with civil remedies in addition to ensuring that individuals taking such pictures can be criminally prosecuted. Most of these statutes limit their application to where intimate areas of a person are photographed without their consent and define intimate areas as pubic areas, female breasts,

and undergarments when covered by clothing and intended to be protected from being seen. As such, photographers can avoid liability under privacy statutes by respecting commonly-recognized expectations of privacy.

However, privacy laws can be pitfalls when they are drafted in ways that fail to consider the reasonable interests of the subjects and the photographers. Texas can claim credit for what may very well be the worst-drafted privacy law in the United States. Section 21.15 of the Texas Penal Code makes it illegal to photograph another person without their consent if the intent of the photographer is to arouse or gratify the sexual desire of any other person. The problems with this law are that it is vague and it makes liability dependent solely upon the intent of the photographer rather than the injury suffered by the subject. The statute does not require that the person being photographed be undressed nor have any reasonable expectation of privacy. Likewise, the intent requirement is too broad in some circumstances and too narrow in others and it is unclear what exactly is meant by the phrase "arouse or gratify sexual desire." For example, does a man who photographs a woman wearing a Nicole Miller dress violate the statute because he finds her attire sexy? Could a woman be liable for photographing football players because she likes the way their uniforms fit over their buttocks? Liability under these circumstances seems unfair considering that the subjects are voluntarily attired in public places and in ways that are considered socially appropriate. Conversely, could a high school principal escape liability if he installed hidden cameras in student locker rooms to investigate whether cheerleaders are using illegal drugs while getting dressed for games? Even though this intrusion would be highly offensive to the cheerleaders, and be socially reprehensible, the principal's lack of intent to gratify a sexual desire would seem to keep the act outside the scope of the statute.

California has another kind of statute intended to protect the privacy of persons engaged in personal or family activities. This statute makes it a tort to violate the privacy of persons who are engaged in personal or family activities either by (1) physically trespassing onto someone's property in order to make a visual image or sound recording if the trespass occurs in a way that would offend a reasonable person, (2) make an image or recording with a visual or auditory enhancing device if the image or recording could not have been made without the device, or (3) commit an assault with the intent to capture any type of visual image, sound recording, or other physical impression of the person. In theory, photographers in California could be liable for taking photographs with telephoto lenses or night vision devices. Likewise, a photographer who inflicted or intended to inflict a harmful or offensive contact against a person in order to obtain images would be liable. However, conduct that might be annoying but does not involve contact would not be actionable. For example, asking questions of persons who do not want to be interviewed or photographing an event where a celebrity objects to the photographer's presence would not violate the statute. If found liable under the statute, defendants can be required to pay plaintiffs up to three times the damages suffered and also to disgorge any profit made from the image or recording. Although this law applies to all persons within California, the primary motive behind its passage was to provide more privacy to celebrities and protect their physical safety from overzealous paparazzi. This law has been criticized both for its vagueness and its potential to hinder news coverage. The statute does not apply to photographs of a celebrity's property. When the actress Barbara Streisand sued a photographer who had photographed her Malibu mansion while documenting the California coastline as part of an environmental archive, the court dismissed the case as frivolous and ordered her to pay the legal fees incurred by the photographer to defend the case.

Many states prohibit the recording of conversations.

Photographers who use video or digital cameras that simultaneously record sound should be mindful that many states prohibit the recording of conversations where all the parties are not informed that their conversations are being recorded. The audio portions are treated under wiretapping laws, and in some instances police have arrested photographers on the grounds that the associated sound recordings violated these statutes. Although the laws of most states allow for the recording of conversations in public areas that are loud enough to be heard by others, or in which the speakers have no reasonable expectation of privacy, the laws of some states are unclear as to whether they apply to such conversations.

Security monitoring in places such as the public areas of banks is rarely resented because it deters crime and makes patrons and employees feel more secure.

A particularly sensitive issue is the monitoring of dressing rooms at retail establishments to detect shoplifters. Most retailers who sell clothing make dressing rooms available to customers to try on clothing before deciding whether to make a purchase. Because the purpose of these rooms is to shield partially dressed customers from public view, retailers in effect are creating an atmosphere where privacy is expected.

Unfortunately, some retailers have resorted to surveillance monitoring to detect shoplifters who use dressing rooms to conceal merchandise. Some but not all courts have shown considerable tolerance to this practice although most of the decided cases have involved prosecutions of accused shoplifters.

Another potential source of liability for photographers who follow or repeatedly photograph particular subjects are stalking statutes, although they are generally enforced in contexts that do not involve photography. Many states have passed such statutes which make it a crime to repeatedly engage in activities such as following, surveillance, and harassment with an intent to either harm a person or cause a material level of fear or emotional distress. The act of photography, by itself, is unlikely to violate a stalking statute. Nonetheless, furtive or persistent behavior that alarms a subject could result in being reported to the police for investigation. Some stalking statutes could be construed to make it a crime to persist in taking photographs of a person for no legitimate purpose after being requested to stop.

■ SECURITY MONITORING

Security monitoring is widely used to deter crime and protect patrons and employees at commercial establishments such as banks and office buildings. Irrespective of how people feel about security monitoring, anyone may legally set up a camera to monitor areas in public view. Security monitoring is rarely resented when it makes people feel safer and reasonable applications will not result in claims. However, when security monitoring extends into areas where people legitimately expect privacy, the chances of incurring legal liability greatly increase.

For instance, appellate decisions in several states have held that the posting of warnings that such facilities were under surveillance by store personnel constituted consent on the part of customers who chose to use them. Some courts have also held that openings in or around doors and curtains reduce the expectation of privacy that patrons may have.

This does not mean that courts necessarily favor the monitoring of dressing rooms and some have awarded damages to the innocent victims of such surveillance. Furthermore, as other technologies to deter shoplifting become more available, judicial acquiescence of such monitoring should decrease. In addition, some states have statutes that explicitly prohibit viewing or photographing anyone in dressing rooms without their consent.

Restrooms are another area where surveillance presents legal problems. The most common reason for surveillance is to deter drug transactions, sexual activity, and vandalism. Whether surveillance in a restroom will invade a right to privacy depends on the circumstances.

Although there is no general expectation of privacy in the common or open areas of restrooms, many courts have held that intentional surveillance of toilet stalls is a privacy invasion. Surveillance of somewhat exposed areas such as urinals may also invade privacy depending on factors such as camera location and angle. Courts are less likely to protect privacy within toilet stalls when the cir-

cumstances indicate the stall is not being used for its normal purpose. Examples of such conduct are the presence of two or more people in a stall, spending an inordinate amount of time in the stall, and making noises consistent with illicit drug use.

Although cases involving the surveillance of restrooms have varied results, courts tend to rule in favor of innocent parties even when they were photographed by parties who only intended to curtail improper activities.

■ PHOTOGRAPHY IN THE WORKPLACE

As a general rule, employers are free to photograph employees in most areas of the workplace because they are not in seclusion. Employers may also require that employees submit to being photographed for the purposes of identification and work-related activities such as time-motion studies. Nonetheless, resentment against monitoring can make workplace photography a sensitive legal area.

Employers who want to minimize the prospect of being sued and reduce employee objections about workplace monitoring should implement it as part of a carefully considered program. An important issue to address in developing a program is to ascertain that the monitoring addresses legitimate business purposes and does not unduly intrude on the affairs of employees. It is likewise important to clearly define the limits of what can be mon-

itored to avoid abusive or unnecessary practices that are likely to result in lawsuits.

Excessive or abusive monitoring can violate employee protection laws. For example, monitoring of restrooms and dressing areas could lead to the creation of a hostile work environment and constitute sexual harassment. In some cases, business concerns can be addressed effectively by finding an alternative to visual monitoring. Employers who use workplace surveillance can often reduce employee objections by explaining the scope and purpose of the monitoring to their employees.

Employers sometimes resort to secret or concealed photography to monitor employees who are suspected of improper activities. Such monitoring is usually lawful so long as the employer avoids monitoring intensely private activities. One exception is that monitoring to identify employees who may be informing the government about violations of defense contracts or environmental laws could violate whistleblower laws.

Another exception to the rule that employees may generally be photographed by employers applies to union activities such as picketing, accepting handbills, and attending union meetings. Under the National Labor Relations Act, employees have the right to engage in concerted action for collective bargaining and mutual aid or protection. Any action by an employer that coerces employees from participating in concerted actions is an unfair

While most people are free to photograph union activities, employers cannot if doing so might intimidate employees from participating in concerted action.

labor practice and thus unlawful. The National Labor Relations Board has issued decisions holding employers liable for having initiated photography of union activities because it might have intimidated employees. In a few cases, courts and the Board ruled that photography is lawful when done solely to record evidence of unlawful acts by employees. Employers who want more latitude to photograph union employees may want to address such issues in their collective bargaining agreements.

Employers sometimes resort to secret or concealed photography.

Employees may generally presume they can take photographs in the workplace unless the employer has explicitly prohibited photography or where it could damage the employer's interests such as by disclosing trade secrets. Legally, employees owe a duty to avoid acting contrary to the best interests of their employers while they are on the payroll. This means that employees cannot take photographs that may harm the employer except in the special case when such activities are covered by laws that protect employee disclosures to government agencies such as whistleblower statutes.

■ THE ROLE OF PERMISSION IN PHOTOGRAPHY
The best way to protect oneself from being sued for invading someone's privacy is to obtain his or her permission to be photographed. A person can consent to be photographed either implicitly by their actions under the circumstances or they can expressly give their permission in speech or writing. Written consent provides the best legal protection because it provides a permanent record that permission was given. Although implied and oral consent are theoretically as effective as written consent, it can be difficult to prove them in court which makes them less desirable. Photographers who choose to rely on implied or oral consent run the very real risk of having the subject either forget about giving permission or outright lying about having done so.

Sometimes it is a good idea to get a release even when permission is not legally required to take a photograph. One reason is that most advertisers and some publishers require releases before they will purchase the rights to use photographs of identifiable persons. Without releases, it can be difficult to market some kinds of photographs. Even when there is no intent to profit from an image, releases may be warranted when the circumstances give the appearance that the subject's privacy rights may have been violated. For example, taking a photograph that shows an exterior window that frames a couple caressing inside a bedroom could give the impression that the photographer has violated laws against voyeurism. Absent a written release, the photographer could face a difficult situation if he is accused of voyeurism and cannot locate the models to corroborate that permission had been given.

Implied consent may be assumed when subjects know that they are being photographed and their reactions would be understood by a reasonable person to indicate consent. For example, when people apparently welcome being photographed or do not appear to object, one may assume they have consented to be photographed. However, implied consent to be photographed will not necessarily be construed as consent to publication unless the subject has reason to believe that the photographer intends to have the work published. In one case, a man sued the publisher of *Sports Illustrated* after it took and published a photograph of him standing up at a football game with his pants unzipped. The court observed that it had some misgivings about the editorial judgment in singling out a person in an embarrassing situation, but noted also that the photograph was taken in a public place, was newsworthy, and the fan had given implied consent because he was aware that the photographer was working for *Sports Illustrated* and was part of a group of fans that had asked to be photographed.

For consent to be effective, it must be granted by someone who is capable of understanding the nature and consequences associated with the photography and who has the authority to give the consent. When photographing mentally competent adults, it is usually necessary to get permission from the person being photographed. For example, people cannot consent on behalf of their spouses to allow them to be photographed surreptitiously in private activities. The possible exception is when the subject has clearly given someone else the authority to consent on his or her behalf such as might be the case for a publicist working for a celebrity. When photographing minors and persons suffering from significant mental disabilities, you need to get permission from an appropriate party such as a parent or guardian.

Consent obtained through misrepresentation is invalid if the subject misunderstands the nature of what is being photographed or how the photographs may be used. For example, someone who agrees to model without clothes after being told the images will be used solely to illustrate a medical text would likely have a cause of action should the photographs be mass-marketed as pin-up posters. However, consent that is based on the photographer representing a subjective opinion will be effective even if the subject's opinion ultimately differs. For example, models who are assured that they will be portrayed attractively or artistically cannot argue that their consent is invalid merely because the photographs fail to meet their expectations.

The standard document that most photographers use to record written consent is the model release. At a bare minimum, the release should state that model has agreed to be photographed and has given permission for the photographs to be published. Many releases, including most of those available as preprinted forms, address more issues but do not necessarily provide better legal protection to the photographer. As noted above, consent is ineffective if the subject misunderstands the nature of what is being photographed and the intended scope of use. In addition, courts sometimes refuse to enforce provisions they consider unconscionable. Using complex release forms that express simple concepts in obtuse legal terms increases the chance that a court will find that the subject misunderstood the scope of their consent. In such cases, a court may rule the consent is ineffective.

To better understand how releases work, it is helpful to evaluate the most common clauses and their legal effect. All model releases identify the subject who is granting consent and provide for his or her signature (or one from a parent or guardian). Surprisingly, because the scope of consent is a critical legal issue, few preprinted release forms provide spaces for identifying the general subject matter or the dates on which the photographs are taken. Nonetheless, it is a good idea to describe the general nature of the photographs and the period in which they were taken on the release before it is signed. By doing so, photographers can avoid disputes over what the release is intended to cover.

Many model release forms recite that the subject has received consideration. Consideration is the legal term for payment for property, services, or the waiver of a legal right. In my opinion, consideration clauses are usually unnecessary in a release and may even be counterproductive. When the primary purpose of the release is to protect the photographer and subsequent publishers of the photographs from claims that privacy rights have been violated, all the release needs to do is to document that the subject has given permission to be photographed and to have the subsequent images published. There is no need for a release to constitute a contract to be effective.

Because the concept of consideration relates to contract law, releases that contain consideration clauses can create doubt regarding whether the consent is a condition of the contract or is an independent statement. Because consent by itself is sufficient to negate a claim that a model's privacy rights have been violated, adding a consideration clause to a release can weaken the legal protection because a court could find the consent invalid if for some reason it finds the contract to be unenforceable.

The release should state that model has agreed to be photographed.

Consideration clauses can be particularly problematic when the photographer does not actually pay the subject. Not only does the failure to pay create an issue regarding whether the release fails without an actual payment, it may open the door to claims that the subject is owed money. Courts traditionally have been hostile to enforcing contracts when the nominal nature of the consideration indicates that it was a mere formality and not the result of a bargained transaction. In addition, most courts will disregard recitals in which the subject acknowledges receiving consideration and allow evidence to be admitted regarding whether payment was actually made. If the release form fails to quantify the consideration, the photographer may face the quandary of having to defend alternative claims that either the consent is invalid or that the model is owed a fee. Furthermore, if the publisher relied on the photographer's assertion that the image had a proper release, then the publisher could sue the photographer to be indemnified for whatever costs and damages were incurred as a result of having to defend a lawsuit filed by the model.

One useful purpose consideration clauses can serve is to preclude models from revoking their consent in the future. Without a binding contract, parties are normally

free to revoke their consent and thus prevent subsequent publication of the images. If irrevocable consent is in fact a condition of the contract, the photographer should ensure this is clearly expressed. The best way to do this is to use separate contract and release forms in which the contract form requires the model to sign the release and states that the consent cannot be revoked. In addition, the consideration should be commensurate with the services rendered. The amount paid does not necessarily have to be great, but it should more than a mere token. Photographers who do not pay their subjects will probably be better off forgoing the use of consideration clauses because the practical aspects of revoking consent reduce the potential for hardship. For one thing, a revocation is not be effective until it has been expressed to the parties protected by the release. In many cases, models will not know how to contact the photographer and thus will be unable to effect a revocation until after the photographs are published. Also, courts typically allow those who rely on another's consent to act in a reasonable manner to protect their interests. This means that it is unlikely that a court would prevent a publisher from selling books with photographs of a particular model if the consent was revoked after the publication was printed. In fact, a court might rule that a model is barred from revoking consent altogether provided the release clearly communicated the prospect of future publication at the time the photograph was taken.

A court might rule that a model is barred from revoking consent.

Many release forms contain recitals that describe the potential ways the photographs might be used, although they are usually written in verbose and legally-bloated text. A release is sufficient if it documents the model's consent that the photographs may be published for any purpose including advertising and promotions. Although there is some merit to addressing issues such as altering photographs or the use of accompanying text, photographers should be careful not to impair the ability of the subject to comprehend a release form by making it too complex. Also, introducing too much specific language opens the door to a court ruling that the specific nature of the release implies that matters not specifically

described are beyond its scope. For example, a court could decide that a release that allows a photograph to be used in any "book, journal, magazine, pamphlet, newspaper, or other printed document" does not extend to fine art prints or publication on the Internet because these uses are not described in the specific text used in the release. Conversely, a court would likely find that fine art prints and Internet use were adequately described in straightforward text such as "published in any form and for any purpose."

One exception to using general text to describe how photographs may be published may apply when the photographer knows that an image is likely to be used in a sensitive or controversial context. For example, a general release signed by a mother of a teenage girl may be acceptable when a photographer is taking photographs for general stock use but would be less prudent if the photographer is on assignment to illustrate an article about teens infected with sexually-transmitted diseases. In such cases, photographers are better off legally if they first explain how the photograph will likely be used and document the model's consent to that particular use.

Releases are often cluttered with irrelevant provisions that do nothing to alter the legal rights of photographers or subjects. For example, releases sometimes state that the subject warrants having the capacity to sign the release. The problem with such clauses is that people who lack the capacity to consent also lack the capacity to warrant they have the capacity to consent. Clauses that state the subject acknowledges reading the release prior to signing it are similarly illogical because subjects who do not read the release cannot knowingly acknowledge having done so. Although these kinds of clauses probably won't hurt the photographer, they provide little practical protection and are better omitted for the sake of clarity.

Photographers can also make their releases clearer by omitting provisions that merely document the legal rights the photographer and subject have anyway. For example, permission from a model has no bearing on who owns the copyright and such recitals in releases are unnecessary. Furthermore, consenting to be photographed cannot be construed to transfer the copyright to the subject because such transfers must be expressed in writing. In short, copyright clauses are unnecessary in releases.

Photographers should also be careful to avoid releases that contain clauses that are invalid because they are

unconscionable. While courts give considerable leeway in allowing the parties to negotiate the extent of a release, they will not enforce provisions that are so one-sided as to shock the conscience. One type of unconscionable provision commonly found in release forms is the indemnity clause. These clauses usually are drafted with terms such as "indemnify," "hold harmless," or "save harmless" and purport to require the model to pay or reimburse the photographer for any legal expenses and damages suffered should the photographer be sued because of the photograph. Such terms are clearly overreaching and courts will not enforce them. In fact, they present some degree of risk to photographers, because a court may be sufficiently offended by the overreaching clauses to rule that the entire release is invalid.

■ USING A SIMPLE RELEASE FORM

When reviewing a release to determine whether it records an effective consent, courts will consider the clarity of the text, the sophistication of the subject, and the overall fairness of the agreement if the release purports to be a contract. In such cases, a complex release form may work against the photographer. Because they are easier to understand, simple releases are more ethical and in my opinion better protect the photographer than lengthy and complex releases. Another advantage of simple release forms is that they can be printed on small pieces of paper while still maintaining a legible type size. This allows photographers to carry them in convenient places such as wallets or even attached to photographic equipment.

The following is an example of a simple form.

CONSENT TO BE
PHOTOGRAPHED AND PUBLISHED

I, _____, consent to be photographed on [insert dates] by [name of photographer] while [describe context or subject matter]. I further authorize that the photographs may be published for any purpose and in any form.

Signature

Date

Some models may wish to limit the scope of their consent. For instance, they may object to using the photographs to advertise products they find objectionable. When this occurs the photographer can avoid having to draft a entirely new release incorporating the model's restrictions by writing in the limitations at the bottom of the standard release form and having them initialed by the model and the photographer to confirm the revision.

When photographing minors or other persons who lack the legal capacity to consent, the release can be altered to indicate that a parent or guardian is signing on the model's behalf. Alternatively, a form such as the one below can be used.

PARENTAL OR GUARDIAN'S CONSENT
TO BE PHOTOGRAPHED AND PUBLISHED

I, _____, as parent or legal guardian, authorize [name of photographer] to photograph [name of model] on [insert dates] while [describe context or subject matter]. I further authorize that the photographs may be published for any purpose and in any form.

Signature

Date

RESTRICTIONS ON SUBJECT MATTER

While there are few subjects that cannot be legally photographed, there is a lot of confusion and many misconceptions about legal restrictions regarding what can and cannot be photographed. Knowing the law regarding subject-matter restrictions can help keep you from being misled by people who misunderstand what can and cannot be legally photographed. In any case, it is important to understand the legal limits because the sanctions for violating laws that prohibit photography can often be severe.

■ **FEDERAL STATUTORY RESTRICTIONS**

Several federal statutes prohibit the photography of certain subjects except when authorized by a designated official or by regulation. Some of these statutes promote a significant government interest such as the prevention of counterfeiting, while others border on the absurd, such as criminalizing the commercial appropriation of the Woodsy Owl character. Many of the federal laws that restrict photography are vaguely drafted, spottily enforced, and difficult to find. In addition, Congress sometimes drafts statutes that provide regulatory authority to agencies in ways that are so broad as to make it difficult to determine

> Relying on the good sense of the government provides little comfort.

the boundary between lawful and unlawful conduct. The government often justifies this approach to regulation by arguing that it needs the flexibility to enforce against conduct that was not contemplated during the legislative process. It likewise claims that the harshness of unclear laws can be alleviated by not enforcing them when it

would be unjust to do so. Unfortunately, relying on the graciousness and good sense of the government provides little comfort to photographers who need to know where the line is between lawful and unlawful conduct.

Restrictions based on how photographs will be used are disfavored from a constitutional perspective because the First Amendment limits the power of the government to restrict expression based on its content. Some federal statutes and regulations purport to limit photography of some subjects to particular purposes, such as education or news coverage, and a few prohibit photography that may demean a national symbol or a cast aspersions on a particular agency. Although there is an extensive body of law regarding the government's ability to regulate expression, few cases have interpreted the statutes and regulations that restrict photography based on subject matter. This further aggravates the already difficult problem of determining whether and how a particular law applies to a photographer's activities. When faced with a situation where the plain language of a statute or regulation prohibits what appears to be constitutionally protected expression, it is wise to consult with counsel before proceeding with what may or may not be lawful photography.

The government's power to regulate what may be photographed depends on whether it has a legitimate interest in restricting some forms of expression. Although courts have found many social objectives to be compelling, they tend to be suspicious of restrictions that are based on the content of the expression and examine them with more scrutiny than they do for restrictions on the time and manner of expression. Political expression, particularly that which criticizes the government, is subject to the highest level of scrutiny and the government has a high burden to establish that its interest in restricting such

expression is in fact compelling. The evaluation of restrictions on photography that is to be used for news, art, and educational purposes likewise receives a heightened level of scrutiny. Commercial speech, such as advertising, is subject to a much lower level of scrutiny. This means that the government has considerably more latitude to restrict photography used to promote commercial interests than it does when it is used for political or news purposes. For example, one federal court ruled that the U.S. Forest Service can restrict the reproduction of the Smokey Bear character for commercial purposes but not when used to illustrate political criticism of that agency.

Constitutional issues aside, a few federal statutes and several regulations that regulate the photography of certain subjects require government officials to either specifically authorize what may be photographed or to promulgate regulations that define specifically how photography is to be restricted. This presents photographers with a practical problem when the government fails to respond to requests for permission to photograph something or fails to promulgate the required regulations. The most common reason offered by government officials for ignoring requests or not drafting rules is a lack of resources, but in many cases the real reason is there is little interest to do so. Because few cases warrant the expense or effort needed to file a lawsuit demanding government action, the vacuums caused by agencies failing to follow statutory mandates can be expected to persist. As a practical matter, photographers who face situations where permission is required should submit their requests as early as possible and be prepared to follow up zealously when necessary.

■ CURRENCY, STAMPS, AND SECURITIES

Concerns over photography as a counterfeiting tool have been addressed by federal statutes that substantially restrict the ways currency, postage stamps, and securities can be illustrated. The use of photography to make illustrations was formerly limited by federal statutes to historical, educational, newsworthy, and collector purposes, but in 2001 the anticounterfeiting statutes were amended to make clear that making images of currency and government obligations such as stamps, bonds, and notes is legal provided that they are made with no intent to defraud anyone or aid counterfeiting.

The federal government has issued guidelines that describe how currency may be illustrated without violat-

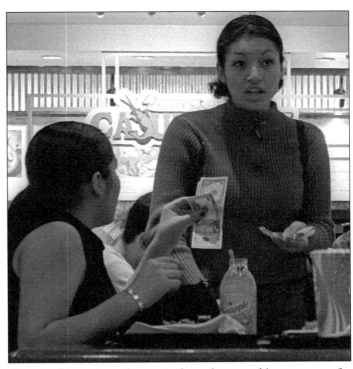

Counterfeiting laws do not apply to photographing currency for nonfraudulent purposes but do restrict how the currency is depicted. Ordinary scenes involving currency pose little risk to photographers.

ing the law. To comply with these guidelines, illustrations of U.S. currency must be in black & white except when the illustration is less than three-fourths or greater than one and one-half the actual size of the item illustrated. Photographs of other U.S. obligations such as bonds and of foreign currencies can only be reproduced in black & white and must also be less than three-fourths or greater than one and one-half the actual size of the item. All illustrations of currency must be one-sided. Coins may be freely photographed and illustrated for any nonfraudulent purpose. Postage stamps may be illustrated in either color or black & white and in any size if they have been canceled. Uncancelled stamps can be reproduced in black & white in any size but if reproduced in color must be less than three-fourths or greater than one and one-half the size of the actual stamp. Postage meter stamps are considered postage stamps under this law. Illustrations of revenue stamps can only be reproduced in black & white. Another requirement is that the negatives and plates used to make the illustrations must be destroyed after their final use. In addition, while it is lawful to make motion pictures, videos, and slides of currency so long as the purpose is for projection or telecasting, no prints can be made

from these unless they conform to the size and color restrictions described above.

Photographing any currency, stamp, or security obligation to facilitate counterfeiting or forgery is also illegal under many state laws. These laws apply more broadly than the restrictions regarding how currency and stamps may be illustrated. For example, the term security obligation may encompass stock certificates, corporate bonds, certificates of deposit, checks, money orders, bills of lading, and automobile titles.

■ FEDERAL INSIGNIA, SEALS, AND TRADEMARKS
Congress has enacted several statutes that limit the reproduction of agency insignia, military decorations, and some trademarks. These statutes appear to promote three kinds of federal interests. The first is to prevent unauthorized persons from using agency insignia and identification to falsely convey that their activities are sanctioned or endorsed by the U.S. Government. The second is to establish government control over the commercial use of these items. The third interest is to prevent private citizens from using federal marks and insignia in ways that demean or offend the U.S. Government. Courts would undoubtedly uphold the power of the government to regulate the reproduction of these items for fraudulent or commercial uses but the constitutionality of preventing their use to express political opinion is highly questionable.

Federal law restricts the photography of agency insignia without authorization.

Although the federal statutes regarding seals and insignia address commercial appropriation and deceptive practices issues, they often fail to address photography in other contexts such as news, art, and personal use. This is unfortunate because drafting statutes in a way that protects the legitimate government interests yet avoids overbroad restrictions is not that difficult. For example, the statute that prohibits reproducing the Golden Eagle insignia (the symbol of federal recreational fee areas) is written to clearly state that as long as people do not intend to use a reproduction of the insignia for some kind of fraudulent purpose, they are free to photograph it. Unfortunately, most statutes that regulate the photography of government symbols are less clear, because, while

they apparently intend to prevent deceptive uses, they could theoretically be construed to prohibit any photography of symbols that has not been authorized by regulation or a senior official.

One such federal statute could be interpreted to make it unlawful to make images of the seals of the United States president, vice-president, Senate, or House of Representatives except as authorized by regulations. Although the statute seems intended to limit commercial uses of these seals, a literal interpretation would prohibit taking photographs of politicians standing next to presidential and congressional seals unless properly authorized. The government has provided little guidance regarding when these seals may be included in photographs although an executive order does make it lawful to photograph the presidential and vice-presidential seals for bona fide news or educational purposes without prior permission. In other cases involving exceptional historical, educational, or newsworthy purposes, permission to reproduce the seals may be obtained in writing from the Counsel to the President or the clerks of the Senate and House of Representatives.

Federal law also restricts the photography of agency insignia without authorization. The general statute that governs the reproduction and use of most agency insignia provides that whoever photographs an insignia, badge, identification cards, or tolerable imitations thereof except as authorized by regulations is guilty of a misdemeanor. Because most agencies have not promulgated regulations that authorize the photography of their insignia, the legal aspects of photographing them are not entirely clear. Furthermore, the few regulations that have been promulgated tend not to address issues concerning general photography. For example, the U.S. Forest Service restricts the use of its insignia to official use except when specifically authorized for public service or commercial uses that contribute to the public recognition of the forest service. Although its regulations do not prohibit photography of the insignia for news, educational, or personal use, they fail to explicitly authorize it.

Similar statutes encompass the reproduction of military decorations and badges and medals of veterans' organizations incorporated by act of Congress. For example, the Department of the Army authorizes the photographic reproduction of insignia so long as no discredit is brought on the military and the reproductions are not used for

deceptive purposes. While the Army certainly has the power to prohibit reproductions for deceptive purposes, its authority to restrict on the basis of whether the use portrays the government favorably or unfavorably is constitutionally suspect.

While it is generally lawful to photograph private trademarks, the federal government has the power to increase the legal protection associated with government trademarks and has done just this with respect to the Smokey Bear and Woodsy Owl characters. The two statutes that protect these marks prohibit anyone from reproducing them for profit except as authorized by the U.S. Department of Agriculture. In addition, a third statute gives the Attorney General the authority to enjoin any reproduction of Smokey Bear or Woodsy Owl irrespective of how the image is used unless such use has been authorized by the U.S. Forest Service. At least one court has ruled that these statutes do not apply to photography done for noncommercial purposes. This means that citizens may photograph Smokey Bear and his likeness without fear of prosecution so long as the photographs are used for editorial or personal purposes.

Despite the government's interest in preserving the value of the Smokey Bear character to the campaign against forest fires, it cannot prohibit unauthorized photography for editorial or personal purposes.

■ MILITARY AND NUCLEAR INSTALLATIONS

Two types of laws regulate the photography of defense-related materials, equipment and installations. Espionage laws prohibit anyone from gathering information respecting the national defense who knows or should know that the information will be used in a way that injures the United States or benefits a foreign government. Another set of laws prohibits the unauthorized photography of military installations and equipment that have been classified as top secret, secret, confidential, or restricted, irrespective of whether the photographer intends to disclose information to foreign governments.

Photographers who work around defense and intelligence facilities should be aware that the laws against espionage reach beyond classic spying. The mere act of taking photographs that depict national security material can expose photographers to criminal liability if they know

they will be disseminated by the media. Absent special access to sensitive facilities, photographers are unlikely to violate these laws but government and contractor employees should be careful not to photograph sensitive materials if unauthorized persons are likely to view the images.

The laws against photographing classified equipment and facilities do not require any intent to harm the United States and are easier to enforce than the laws against espionage. They require photographers to obtain permission from the commanding officer of a facility or a higher authority before photographing classified materials and to agree to submit their images for censorship. In general, areas that have been designated as classified are not readily visible outside of military installations so this is usually not an issue with respect to photography done from outside the installation except for aerial photography. When photography is done on a military installation, permission

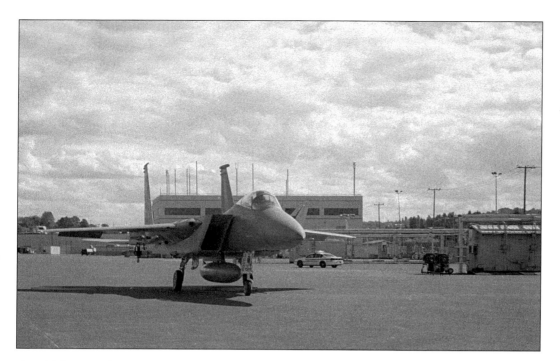

Not all areas at military installations are necessarily off limits to photography. However, it is a good to check first with the appropriate officials when in doubt.

should be sought except when the circumstances make it clear that photography is not restricted. For example, it would be a good idea to seek permission to photograph inside an aircraft maintenance shop but permission would not be needed to photograph a sporting event at a school located on the installation. Most facilities have a public information officer who should be familiar with the issues associated with photography on the installation. Consulting with this person can help avoid problems and confrontations when photographing at a defense facility.

Restrictions on photography are not limited to military installations. Federal law authorizes the military to regulate photography at sensitive defense manufacturing and research facilities. Military authorities can also restrict photography of experimental equipment and aircraft and also at crash sites, if necessary, to prevent the disclosure of classified information. In such cases, however, regulations require the military to seek the assistance of civilian authorities to actually seize equipment. Note that these restrictions do not apply once the classified material has been covered or removed from the scene.

The photography of nuclear facilities that have been designated by the government as requiring protection from general dissemination of information is prohibited unless previously authorized by the U.S. Department of Energy. These requirements apply to photography that occurs either on designated property administered by the U.S. Department of Energy or from the air. Photo-

graphing nuclear facilities from outside their property lines is permissible.

One problem when photographing defense or nuclear subjects is that the degree of zeal with which these laws are enforced varies greatly. Part of the difficulty is that security personnel have different priorities and perspectives with regard to photography. Some tend to be very protective, some are lax, and there are quite a few that enjoy asserting their self-perceived authority. In some instances, attitudes within the services may conflict. For instance, a high-level official at the Pentagon may spend hours arranging access for film producers in order to gain positive publicity for the military services while low-level security staff may evict casual amateurs because of fear about how the photographs may be used. Considering the firepower and egos that some security staff have, photographers should exercise restraint and good judgment when confronted by overbearing or unreasonably suspicious personnel. When such personnel act inappropriately, your chances of prevailing in the field are remote. In most cases, photographers will be better off by acquiescing and then diplomatically resolving matters with more senior officials in the public affairs office. People who anticipate that they may be photographing sensitive facilities or equipment should consult with the public information office at the facility to obtain permission ahead of time. Not only does obtaining explicit permission obviate concerns about the legality of the photography, in many cases

it will lead to better access and cooperation from security personnel.

■ TRADE SECRETS AND ECONOMIC ESPIONAGE

The protection of trade secrets has traditionally been the domain of state law and every state has passed legislation that provides some form of trade secret protection. Trade secrets are typically defined as information that derives independent economic value from not being generally known or readily ascertainable by other persons and is subject to reasonable efforts to keep it secret. Although there is considerable variation in how trade secret law has developed among the states, most statutes require that the trade secrets be acquired by improper means and subsequently disclosed or used to the owner's detriment. Persons who misappropriate trade secrets may be liable for civil damages and injunctions, and might also be ordered by courts to pay the legal expenses incurred by the owner to address the misappropriation.

Courts generally do not require the owner to employ absolute measures to protect secrecy but instead require them to act commensurately with respect to the information being protected. For example, two aerial photographers were found liable in a 1970 case for photographing a chemical plant that was under construction in the hope of discerning a secret manufacturing process. Although aerial photography of industrial facilities is normally legal, the court held that it would be unreasonable to require the chemical company to build a roof over their unfinished plant because the process would be shielded from the air after the construction was finished. However, in cases where trade-secret owners fail to take appropriate measures to protect secrecy, they lose the right to legal protection.

In 1996, Congress enacted the Economic Espionage Act which makes misappropriation of trade secrets a federal crime if they relate to a product that is produced for or placed in interstate or foreign commerce. The consequences of being convicted under the Act are severe with fines ranging up to $500,000 and imprisonment of up to 15 years for individuals and fines of up to $5,000,000 for private organizations and $10,000,000 for foreign instrumentalities. In addition, any property used in the process of violating the Act may be forfeited to the United States. For example, a photographer convicted under the Act could very well lose the camera, computers, and other devices used to commit the offense.

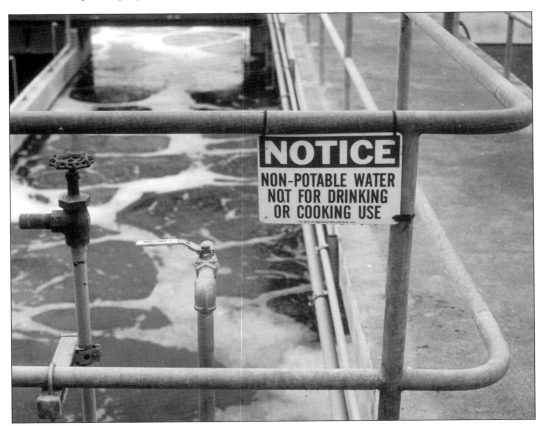

Owners of industrial facilities are sometimes leery about taking photographs for fear that trade secrets may be inadvertently disclosed.

The profuse amount of copyrighted work on public display would cripple photography if permission were always required from every owner. While the obvious intent underlying this photograph is to depict a bowler, there is a lot of copyrighted artwork depicted in the background.

■ COPYRIGHTED MATERIAL

Copyright law in theory could impose substantial potential restrictions on photography although the legal issues go mostly unnoticed. While many photographers are aware that their images are protected from unauthorized use and copying, few consider the vast extent of copyrighted material that is routinely reproduced in photographs. For example, copyright protection covers more than written materials and art, it can extend to patterned fabrics, jewelry, toys, and sculptural ornamentation. Common kinds of copyrighted materials that are unwittingly incorporated into photographs include newspapers, billboards, and sculptures in public places. Taken to an extreme, copyright considerations would place enormous restraints on photography because it is impossible to avoid including copyrighted elements in many photographs.

Fortunately, copyright law has not crippled photography because of the practical limits on its reach. Unfortunately, determining where those limits lie is not always easy because copyright law is a messy area with regard to determining the point at which copying subjects someone to liability. In its basic essence, copyright law prohibits the copying of protected materials unless one obtains permission from the owner of the copyright.

Violators who infringe a copyright are liable for the actual damages they cause and in some cases can be required to pay statutorily prescribed damages and the legal expenses of the copyright owner. What keeps copyright law from crippling general photography is that courts apply the doctrines of fair use and *de minimis* use to allow unauthorized copying under circumstances where the interest in fostering free expression or avoiding litigation over trivial matters is more compelling than the interest in protecting intellectual property rights. However, applying these doctrines requires courts to decide each case on its own facts, which means that one's rights and liabilities cannot always be assessed with certainty ahead of time. The dearth of published court decisions involving infringement of copyrights by photography further increases the difficulty of assessing whether taking a photograph will infringe a copyright.

From a practical perspective, the potential for infringement can be analyzed by asking three questions. First, will the photograph encompass an object that is protected by copyright? Second, will taking a photograph actually constitute making a copy? Third, will taking the photograph constitute the kind of infringement that will allow a copyright owner to recover damages? In many cases, the deter-

mination will depend on how the photograph is ultimately used. To avoid being liable for contributing to an infringement, photographers should be careful about how their photographs may be used.

Copyright law protects a variety of created material including literary works, motion pictures, sculpture, choreography, dramatic works, architecture, and graphical works such as drawings and photographs. Under current law, works are protected once they are expressed in fixed form. The former requirement to register the work with the Library of Congress was lifted in 1978 and the requirement to display a copyright symbol was lifted in 1989. However, registration and providing copyright notices on works can greatly enhance the ability of the copyright owner to recover for infringement. While abolishing the need to register works and display the symbol has made copyright protection more practical for photographers, it also increases the risk of inadvertently infringing copyrights.

The type of work can affect the extent to which taking a photograph may infringe a copyright. Literary works, graphical works, and sculpture are protected from any copying that is not authorized by the copyright owner or otherwise permitted by an exception from copyright protection. Choreographical works and pantomime are protected only if the movements and patterns are first recorded in a tangible form such as diagrams or video. This means that the dance sequences in a choreographed stage play can be protected, while spontaneous dancing and simple dance routines cannot. Architectural works are protected by copyright to some degree but the copyright statutes specifically allow anyone to take and distribute photographs of buildings that are ordinarily visible from a public place. However, artistic elements associated with buildings such as sculptural ornaments may receive independent copyright protection as visual art. The actual plans and written specifications are protected as visual and literary works.

Sometimes parties claim that they have a copyright in objects that are not eligible for copyright protection. For example, colleges and sports franchises cannot copyright the performances of their athletic teams, although they may acquire the copyright to the televised footage. Similarly, owners of natural things such as trees and manufacturers of utilitarian items such as automobiles and toasters cannot claim copyright protection for their natu-

ral or industrial designs. Certain kinds of expression cannot be copyrighted, even when they have been fixed in a tangible form. Names, titles, and short ordinary phrases are one example, and type fonts and familiar symbols such as those on playing cards are another. Because these items cannot be copyrighted, they may be freely photographed. In addition, works that are in the public domain are not protected by copyright. Such works include text prepared by the federal government and materials for which the copyrights have expired due to time. The laws regarding expiration of copyrights are complex and it can be risky to assume that particular materials are in the public domain. Additional information about the expiration and renewal of copyrights can be found in texts on copyright law.

The issue of whether a photograph actually copies a copyrighted work is critical when determining whether it infringes the copyright. To constitute a copy, it is not nec-

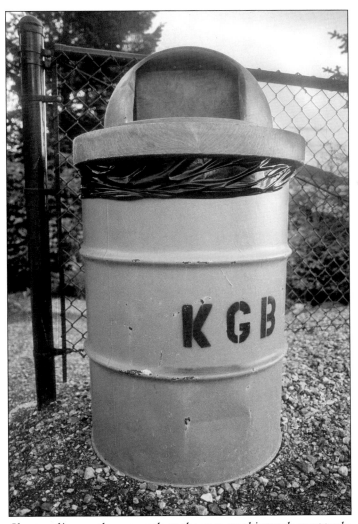

Short ordinary phrases, such as the ones on this trash receptacle, cannot be copyrighted.

 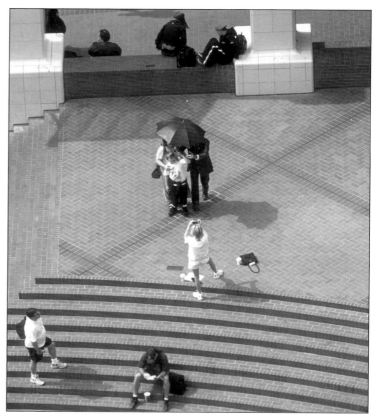

LEFT—*A derivative work is one that is based on a preexisting copyrighted work. A straightforward photograph of a sculpture would be a derivative work whereas a photograph of the shadow cast by sculpture might be considered a transformative work.* RIGHT—*Some courts have suggested that private copying would constitute a de minimis use, such as taking photographs for personal use of family standing around a public sculpture.*

essary to copy something exactly or completely to be liable under copyright law. The legal test is whether the copy is substantially similar to the original work. One of the relevant considerations is the amount of the work that is included in the photograph. For example, a photograph that includes such a small portion of an artwork as to render it unrecognizable to the average layperson would not be considered copying.

However, it is important not to confuse this principle with the amount of space that the copyrighted work occupies within the photograph. The relevant issue is the amount of the infringed work that is copied and not the amount of new material added. In other words, a photograph in which a painting takes up a minor area would still be copying if the painting is recognizable.

The qualitative aspects of how the copyrighted work appears in a photograph will also affect whether a work is considered to have been copied. If the work is sufficiently blurred or shaded to be unrecognizable to the average layperson, then it will not be considered to be copied

under copyright law. However, copyright law does not require perfect focus and exposure before a court can find that a work has been infringed.

The fact that a photograph expresses something in a different medium does not mean that the photograph will not infringe the copyright because derivative works are covered by copyright law. Any work that is based on a preexisting work is a derivative work. This means that taking photographs of works such as choreographed dance or sculptures can constitute copying and thus have the potential to infringe copyrights. To the extent that a photograph is "transformative" because its adds something new to the expression or significantly alters the character of the underlying work, a court would be less likely to find that the work was sufficiently derivative to violate the rights of the copyright owner.

Copyright law protects the way that an idea is expressed but does not protect the ideas themselves. The fact that someone else has used a particular idea regarding subject matter or technique does not preclude others

from doing so later. For example, taking a photograph of Half Dome in Yosemite National Park does not infringe any copyrights despite the fact that other photographers and painters have made works depicting the mountain. Even the duplication of the major elements such as lighting, perspective, subject, and background will not infringe a copyrighted pictorial work if the photograph was created independently. However, deliberately replicating a particular photograph by incorporating its dominant elements can infringe a copyright if the resulting image is substantially similar. Unfortunately, there are no clear boundaries for how similar a work must be before it infringes another. For example, one court ruled that a jury would have to decide whether a set of photographs of a statue in a cemetery infringed a prior photograph of the same statue in the same cemetery because they used the same subject and similar camera angles, lighting, and composition. In another case, a court ruled that a jury could find that a photograph of a saxophone player infringed one made of a concertina player where both photographs were taken in the same corner of a nightclub with similar lighting, angle, and camera position.

Considering the extent of copyright-protected work that is visible in everyday life and the difficulty of excluding it from photographs, the law provides two exceptions from liability for infringement. One of these doctrines is known as the *de minimis* use doctrine, under which courts refuse to waste their time on trivial matters. However, as is the case with much of copyright law, it is not always easy to determine whether a particular use is *de minimis*. The few published decisions that have discussed this issue suggest that purely private copying may qualify as *de minimis* use, but neither the courts nor Congress have made this an explicit doctrine. For example, one court ruled that a company's internal use of a competitor's product photograph in a mock-up of a package design was too trivial to warrant damages. The same court alluded that private copying, such as making a photocopy of a *New Yorker* cartoon to post on one's refrigerator, would also be a *de minimis* use. Nonetheless, when evaluating whether an infringement would be *de minimis*, it is important to remember that infringement is ultimately in the eye of the courts and that one's subjective opinion that a copy is trivial will not be controlling.

The most important exception to copyright infringement is the fair use doctrine. This doctrine is intended to balance society's need to protect intellectual property against the benefits of being able to use copyrighted materials for some purposes without having to compensate the copyright owner. Applying the fair use doctrine always requires consideration of the facts at hand, although courts generally evaluate the use against four factors. Because courts are required to consider the totality of the circumstances, they will not necessarily give each of the factors equal weight when determining whether a particular instance of copying constitutes fair use. This means a party need not prevail on every factor to be entitled to make fair use of a copyrighted work. The four factors are:

The Purpose and Character of the Use. Using copyrighted material for noncommercial purposes such as news reporting, commentary, and education is more likely to be considered fair use than using it for commercial gain. Fair use is rarely found when the purpose of the copying is to exploit the material for commercial gain in situations where the customary practice is to pay a licensing fee.

An important exception to copyright infringement is the fair use doctrine.

With respect to photography, the nature of the use is typically an important factor in determining whether incorporating copyrighted objects into an image is fair use. Photographs of copyrighted objects used for commercial purposes such as advertising are less likely to be construed as fair use than those used to illustrate news, commentary, and criticism. Fair use is particularly disfavored when the copy serves essentially the same function as the original. For example, a photograph used in a newspaper to illustrate a riot that incidentally contains a copyright-protected sculpture would be accorded fair use because the sculpture adds little if any significance to the dominant subject matter. On the other hand, an artistic photograph of the sculpture that was marketed as fine art might not be considered fair use.

However, highly transformative copying that alters the original work by adding a new expression or meaning can be fair use. For example, Paramount Pictures parodied a photograph of Demi Moore taken by Annie Leibovitz in its marketing campaign for the film *Naked Gun 33⅓: The Final Insult*. The Leibovitz photograph showed the then-pregnant actress in the nude with a serious expression

whereas the Paramount Pictures version showed a pregnant female body with the smirking face of the actor Leslie Nielsen superimposed. Although the photographs used almost identical poses, the court ruled that no infringement occurred because it perceived the Paramount Pictures photograph as commentary on the Leibovitz photograph. Absent this implied commentary, Paramount Pictures likely would have been found liable for infringement.

The Nature of the Copyrighted Work. Photographs that incorporate informational works are more likely to be construed as fair use than those incorporating creative works. For example, a photograph that incorporates text written on a classroom chalkboard is less likely to infringe a copyright than one that includes a work of fine art. Courts sometimes give parties more latitude to copy published or publicly visible works. For example, courts would be more likely to find fair use associated with photography of public art works than those in an artist's private collection.

The Amount and Substantiality of the Work Copied. This factor may be less relevant to photography than to other media because photography tends to copy all or most of a work. What a court will evaluate is whether the amount copied from a copyrighted work was excessive in relation to the legitimate use of the copy. This factor can be very important when evaluating whether a literary work has gone beyond fair use in quoting or borrowing from other works, but is seldom given much weight in cases involving photography because the other factors tend to be more relevant.

> Be objective when deciding whether it is safe to copy someone else's work.

The Effect of Use on the Market or Value of the Copyrighted Work. Courts seem to weigh the fourth factor more heavily than the others, irrespective of the medium in which the work is copied. Photographs that do not materially impair the marketability of the works they copy are far more likely to be accorded the benefit of fair use than those that will cause the copyright owner to lose sales. For example, one court ruled that illustrations of fine-art postcards in reduced size and quality in a magazine would not serve as a substitute for someone wishing to collect art or send postcards. Another court ruled that a film company did not infringe the copyright of artwork on a mobile that was portrayed sporadically in a motion picture because the film was no substitute for the artwork. However, it is important to consider the potential for derivative works in evaluating the effect on marketability. For example, if a photograph would diminish the potential markets of the copied work in the form of posters, cards, and books, this factor would dictate against fair use.

As noted earlier, assessing whether a photograph may violate a copyright is often a judgment call and photographers are sometimes tempted to view the factors in the light that favors the outcome they desire. Because courts and jurors ultimately make these decisions, it is important to be objective when deciding whether it is safe to copy someone else's work. Also, photographers should not rely on the rationalization that copyright owners will not pursue their remedies because they benefit from the publicity generated by the photographs. Many copyright owners zealously protect their intellectual property and do not attach much value to the publicity. There are others who are not only grateful for the publicity but also for the opportunity to extract some money from the infringer. In other words, the fact that you think you are paying someone a compliment may not protect you from having to pay them damages and legal fees.

■ **TRADEMARKS**

Trademarks are the names, symbols, and advertising slogans used by sellers to distinguish their goods and services from others in the marketplace. The legal protection given to trademarks is not limited to just names and logos but also extends to trade dress, which is the distinctive, nonfunctional features used to distinguish goods or services such as the color and shape of packaging or the configuration of a retail establishment.

Many sellers zealously defend their trademarks because of the important role they play in marketing and their association with the reputation of the seller. Because most companies are uncomfortable with not having control over how their trademarks are used, the inclusion of trademarks in photographs can be a sensitive issue. In recent years, a trend has developed where owners are claiming they hold trademarks in the shape of famous properties such as classic buildings and that images of these properties infringe their marks. The primary motive of such

owners is to obtain licensing fees from persons who market the images, although they have not been successful in court. Nonetheless, because trademarks are everywhere, photographers should be generally aware of the legal issues associated with taking photographs that include trademarks.

The good news is that, unlike copyright law, trademark law does not restrict the copying of marks by means such as photography. This means that there is no liability for taking photographs that are used for editorial or private purposes. What trademark law does prohibit is using a likeness of a trademark in a way that can cause confusion over the sponsorship of goods or services. The bad news about trademark law is that determining whether an image will cause confusion can be subject to the same level of uncertainty associated with determining fair use under copyright law. Photographers should also be mindful that the graphic elements used in trademarks are sometimes protected by copyright law and take this into account when photographing a trademark.

One of the threshold elements when analyzing whether a photograph could infringe a trademark is whether the subject in the photograph is in fact a trademark. For a trademark to be a property right, it must be used in connection with an established business or trade. Private symbols and text that are not connected with commerce cannot be trademarks. Trademark owners must also be able to prove that the mark is sufficiently distinct to make a commercial impression. In other words, the mark must be recognized as a symbol of a product or commercial enterprise. For example, the Rock and Roll Hall of Fame sued a photographer for selling photographs of its building in the form of posters. Although the building shape had been registered as a trademark, the court ruled for the photographer on the grounds that the Rock and Roll Hall of Fame failed to prove that it had used the building design shape in a manner that was sufficiently consistent and repetitive to make the images of the building into one of its trademarks. This does not mean that it is impossible for a building shape to be a trademark but it takes more than the owner declaring it to be one.

Claims of trademark infringement involving the reproduction of trademarks in images are usually decided based on whether the image is used in a way that is likely to cause confusion regarding the affiliation of the trademark owner to the image. If there is a reasonable possibility that

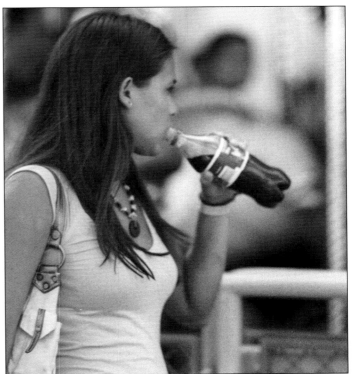

Trade dress can encompass features such as the look and feel of a retail establishment or the distinctive shape of the packaging associated with a specific brand of goods.

a person of reasonable intelligence will believe that an image was sponsored or endorsed by the trademark owner then a court will find that the mark has been infringed. However, courts have been inconsistent in how they evaluate the possibility of confusion, which makes it difficult to discern clearly what uses are permissible. For example,

Trademarks are everywhere and photographers should not worry about liability for making images that depict trademarks in ways that do not call attention to themselves.

one court ruled that wearing a uniform similar to the one associated with Dallas Cowboys Cheerleaders in a pornographic movie constituted infringement because a reasonable person might assume the cheerleader's organization approved the use of the uniform in the film. However, another court ruled that a poster portraying a pregnant girl in a Girl Scout uniform did not infringe a trademark because no one would believe that the Girl Scouts organization would sponsor such a poster.

Among the factors courts consider in assessing the possibility of confusion are whether the products compete with each other and whether consumers will mistakenly believe the product is associated with the owner of the trademark. For example, if a trademark owner sells articles that depict its trademark such as shirts, posters, and coffee mugs in addition to its primary products, a court would be more likely to find infringement by products with similar images. Conversely, a court is not likely to find infringement from an image used to illustrate a magazine article comparing product brands because consumers are unlikely to construe sponsorship in such articles.

There are also laws that protect trademarks from being tarnished or diminished in value even if there is no possibility of confusion on the part of consumers. These antidilution statutes are intended to protect against abuse that diminishes the positive associations with a mark. However, liability under such statutes requires that the mark be used in a commercial context such as on posters or clothing. For example, one court enjoined sales of a poster that displayed the text "Enjoy Cocaine" in a logo stylized to resemble the Coca-Cola logo. Purely editorial uses, such as in news reporting and commentary, are protected by the First Amendment provisions allowing for free speech. However, using someone's trademark in your products or in advertisements could result in liability if a court believes you are trying to appropriate some of the goodwill associated with the mark.

■ NUDITY AND PORNOGRAPHY

With certain exceptions discussed later in this section, the First Amendment makes it lawful to photograph nude adults and adult pornographic activities provided the resulting images are not obscene. In popular usage, nudity means the unclothed body, pornography means materials that are intended to arouse sexual desire, and obscenity means language or images that are lewd and disgusting. The legal criteria for determining obscenity were set by the United States Supreme Court as a three-factor test in *Miller* v. *California*. Under the *Miller* test, an image is obscene if (1) the average person applying contemporary community standards would find that the work taken as whole appeals to the prurient interest, (2) the work depicts specifically defined sexual conduct in a patently offensive way, and (3) taken as a whole the work lacks serious artistic, political, or scientific value. Under this test, two key elements for finding that material is obscene are the wording of the state or local laws governing obscenity and the standards of the community where the images are made or exhibited.

With the exception of child pornography, federal law does not prohibit the making of obscene images but only their distribution. This means that the liability of photographers for making obscene images will be determined by state or local law. As noted in the second part of the *Miller* test, states cannot make obscenity illegal unless they first define by a statute or ordinance the kind of conduct that may be obscene if depicted in a patently offensive way. There is a great deal of variation in how states and localities define obscenity and individual statutes and ordinances should be consulted for specific details. For example, some states narrowly limit their definitions to sexual activities whereas others encompass some forms of nudity and excretory functions. States may also define obscenity in different ways depending on the context. For example, a state might choose to define obscenity in the context of making images of sexual conduct or sado-masochistic abuse but extend the definition to encompass any postpubescent nudity with respect to materials that are furnished to minors.

Irrespective of obscenity, a practical issue for those who photograph nudes or pornography is how the law governs where persons can legally be nude or engage in sexual activities. Governments have flexibility in regulating nudity and sexual activity in public places and may freely pro-hibit them where they are likely to be in public view. Statutes and local ordinances vary significantly throughout the country and it is necessary to consult the requirements that apply to the particular jurisdiction for specific information. Many states and localities have laws that make it a criminal offense to photograph people nude without their consent in places where they have a reasonable expectation of privacy such as bathrooms and locker rooms. Because the unauthorized photography of persons where they reasonably expect privacy will violate their privacy rights, photographers should be careful not to photograph people without their consent in such places.

The federal government and most states have taken strong measures to eradicate child pornography and anyone who photographs minors in any situation that could be construed as erotic should be fully aware of the legal aspects. The government has far more latitude to regulate pornography that involves minors than it does for adult pornography. For example, there is no constitutional requirement that the images be obscene before one can be prosecuted. Because minors are affected, the reach of child pornography laws encompasses a broader range of government interests than is the case with adult pornography. One concern is the welfare of minors used to produce pornography because they lack the legal capacity to consent to acts that result in psychological harm. Legislatures have also expressed concern that pornographic materials depicting minors are used by pedophiles to seduce minors into sexual activity. Because the concerns prompting the legislation consider both the effect of making images on the minor participants and the making of images that will be used as tools to prey on minors, child pornography laws involve comprehensive restrictions on the creation, distribution, and possession of materials deemed to be child pornography.

> There is a great deal of variation in how states define obscenity.

The federal Child Pornography Prevention Act is a very far-reaching statute. This act not only prohibits the distribution of child pornography, it makes photographing a minor engaged in sexually-explicit conduct a federal crime if the materials are intended to be or otherwise become distributed in interstate commerce. The distribu-

tion requirement is applied broadly to encompass transportation between states by any means including the Internet and mail. The act defines explicit sexual conduct as sexual intercourse of any kind, bestiality, masturbation, sadistic or masochistic abuse, and lascivious exhibition of the genitals or pubic area. "Lascivious exhibition" has been interpreted by courts to encompass visual depictions of a child's genitals or pubic area even when covered by clothing if the image is sufficiently sexually suggestive and unnaturally emphasizes the genital region.

Those who are convicted of violating the Child Pornography Prevention Act face severe penalties and photographers who make unlawful visual depictions of minors can be incarcerated for up to ten years and fined up to $100,000. Although courts have discretion in sentencing persons convicted under the act, even modest offenders can expect to serve at least fifteen months in prison. In addition to incarceration and fines, convicted defendants can be required to forfeit the equipment used to make and distribute the images. The act also provides victims the right to sue violators in federal court. Although the statute is phrased in terms of actual damages, there is a presumption that a minor who is a victim will have sustained damages of no less than $50,000.

The child pornography laws in many states go beyond the federal legislation.

The act also imposes a recordkeeping requirement on everyone who make images of sexually-explicit conduct that applies irrespective of whether the performers are adults or minors. The intent behind this provision is to deprive child pornographers access to commercial markets by requiring secondary producers of pornographic material to verify the age of the performers in the images. Persons who produce film, videotape, and other matter such as books or magazines that contain visual depictions of actual sexually explicit conduct made after November 1, 1990 must keep records identifying the persons who appear in the depictions if the matter either incorporates material that has been or will be shipped in interstate commerce or mailed. Under this requirement, producers of images that depict sexual intercourse of any kind, bestiality, masturbation, or sadistic or masochistic abuse must establish the performers' date of birth from an identifica-

tion document such a driver's license or passport, make a copy of the identification document that contains a recent and recognizable picture of the performer, and ascertain and record all names used by the performers including their current legal names, maiden names, aliases, nicknames, and stage names. They are also required to categorize the records so they can be retrieved by all the names used by the performers and maintain them for as long as the producer stays in business and for five years thereafter.

States also have strict laws against child pornography. Most of these laws are analogous to the federal act, although they do not require any relationship to distribution in interstate commerce. The child pornography laws in many states go beyond the federal legislation by requiring film processors who have reason to believe that a minor has been depicted in a sexually explicit manner to report that fact to an appropriate law-enforcement agency. This has created concerns among many photographers that photo-processing labs have become the arbiters for determining which images constitute child pornography. This concern overstates the role of processors because their opinion is legally irrelevant to determining guilt or innocence. Nonetheless, the fact that processors have a statutory duty to report child pornography to authorities means that one may want to use judgment to assure that film is not sent to a processor that misunderstands the reporting requirement or overcautiously construes the child pornography laws.

There are reasonable measures photographers can take to ensure that they do not run afoul of child pornography laws. Liability under the federal laws is predicated on images that depict sexual conduct or lascivious exhibition of genital or pubic areas. Some states may extend liability to lewd exhibitions of other parts of the anatomy. Photographers can avoid the risk of the images being construed as pornography by not taking photographs of the conduct and anatomical parts described in the statutory definitions. However, photographs that show a child's intimate areas are not unlawful so long as they are not lascivious. The factors considered by courts in determining whether an exhibition is lascivious include whether the focal point of the depiction is on an intimate area, whether the setting is sexually suggestive, whether the pose is sexually suggestive or inappropriate considering the age of the child, and whether the depiction is designed to elicit a sexual response from the viewer.

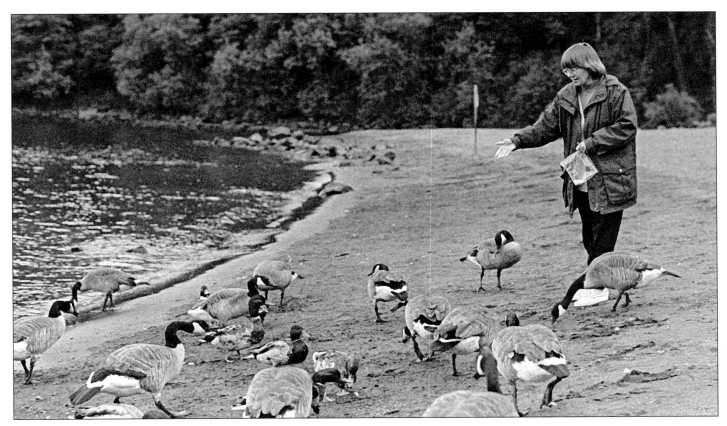

ABOVE—*State laws against harassing wildlife generally require causing a significant level of stress to be actionable. Feeding geese at a public park is lawful as is photographing them provided that no undue distress is caused. Federal laws that protect endangered species and marine mammals can be much more stringent.* RIGHT—*State and federal laws do not prevent geese from biting people who feed them at public parks. Judgment must be exercised when discerning whether and when a wild animal is displaying signs of stress.*

■ ANIMAL PHOTOGRAPHY

Nature photographers should be aware that the Marine Mammal Protection Act and the Endangered Species Act prohibit, among other things, the harassment of protected species. The agencies that enforce these acts give the term "harassment" a broad interpretation and have assessed fines for conduct such as feeding wild dolphins and releasing captive dolphins into the wild before they were capable of surviving on their own. Practices to avoid when photographing protected species are touching, approaching too close, following, and blocking escape routes. Nature photographers should also be aware that actions that individually would not stress protected animals can constitute harassment if their cumulative effect

Neither the Patriot Act nor any other federal laws prohibit the photography of bridges, industrial facilities, or power plants.

causes stress. For instance, a pod of whales might be comfortable in the presence of a single boat but become annoyed when followed by five or six. The National Marine Fisheries Service and U.S. Fish and Wildlife Service have published guidelines that can help photographers avoid charges of harassment.

States also have laws that prohibit the harassment of wildlife although they tend not to interpret harassment as broadly as the federal statutes. For example, these laws tend to be enforced against more egregious offenses such as actively chasing animals or tampering with nests. However, they protect a broader range of species than the federal laws. Some states provide for the protection of wild plants as well. Although the dominant thrust of these statutes is to prohibit the removal of protected species for commercial or ornamental purposes, many statutes and rules are broad enough to apply to any damage such as pruning or crushing. Lists of protected species can usually be obtained from state resource agencies.

■ **PERMISSIBLE SUBJECTS**

There exists a considerable body of informal photographic lore that certain subjects are off-limits to photographers although in fact they are not subject to legal restrictions. In some cases, the belief that something cannot be photographed originates from misunderstanding a requirement about how a photograph may be published. For example, you will violate the rights of celebrities if you use photographs of them in advertisements without their permission but you do not violate their rights by photographing them in public places.

Another source of erroneous lore comes from the people assuming that photography of certain subjects is prohibited because it might tread on a possibly sensitive subject. Some of the sillier assertions include beliefs that it is unlawful to photograph criminal acts on the grounds that it might get the criminals in trouble or that it violates a privacy right to photograph couples in public places because they might be engaged in a licentious affair. The reality is that the law does not shield people who choose

to display improper conduct to the public and that such people should confine such activities to private places if they do not want them recorded.

The most common misconception about supposedly-impermissible subjects is that legislation such as the Patriot Act and the Homeland Security Act have imposed restrictions on subjects that can be photographed. Although many government initiatives took place after September 11, 2001 to address the threat of terrorism, no statutory or regulatory changes were made that enhanced the preexisting limits of what is legal to photograph. Structures such as bridges, industrial facilities, and trains remain perfectly legal to photograph. While there have been many instances of security guards and law enforcement officers confronting photographers for taking pho-

tographs of such subjects, and sometimes telling them that laws such as the Patriot Act prohibit photographs, in the vast majority of cases they have been acting on a erroneous understanding of the law. More information on

It may be unlawful to interfere with law enforcement officers who are involved in exercising their duties but it is not unlawful to photograph them while performing such duties.

There are no legal restrictions against taking photographs of Superfund sites.

how to handle these kinds of confrontations is provided in the next chapter.

A common misconception is that it is unlawful to take photographs of accidents, crime scenes, or places where emergency personnel are rendering medical attention. While police and medical personnel often disapprove of such scenes being photographed and victims and their family members may intensely resent such photographs, photographers are within their legal rights to record these scenes when in public view provided they avoid interfering with emergency operations and obey the reasonable orders of police. When photographers have been convicted for activities associated with the photography of accident or crime scenes, it is usually because they actively interfered with police or medical activities or disregarded orders lawfully issued to protect public safety.

Many photographers are uncertain about their rights to take photographs of children without authorization from parents or guardians. There are no general legal restrictions that prohibit photographing children, although unauthorized photography can arouse suspicions. For example, it is not unusual for people to summon the police when they see a stranger taking photographs of children at a school or public park. For this reason, many photographers refrain from photographing children they do not know unless they have permission from a parent or school officials. Another misconception on the part of some school administrators is that schools may not allow children to be photographed on school premises without a parent's permission. This belief seems to have its origins in the Family Educational Rights and Privacy Act, which limits the disclosure of student records by schools without the parent's written consent. However, the act does not prohibit the photography of students. The use of children as paid models may be restricted by federal and state child labor laws. These requirements vary among the states but generally limit the time and hours that minors are allowed to work. The State of California requires photographers to obtain permits before they employ a minor as an advertising or photographic model.

Buildings are another kind of subject that some photographers believe cannot be photographed without permission of the owner but there are few inherent restrictions. Some, but not all, jurisdictions have enacted incidental restrictions such as laws that prohibit viewing through windows with the intent to invade the occupant's privacy. Similarly, there are laws that authorize the government to restrict the photography of sensitive areas at military and nuclear facilities. Nonetheless, absent a specific legal prohibition, you are free to photograph buildings in public view irrespective of whether they are industrial, commercial, or residential. Except for certain defense and nuclear facilities, it is legal to photograph the exteriors of government office buildings and post offices. A variation on this theme is the erroneous belief that the unauthorized photography of Superfund sites is prohibited. Although the parties responsible for the contamination and cleanup may dislike such photography and even object to it, they have no legal right to prohibit photographers from making images so long as they do not trespass. Likewise, misconceptions sometimes circulate among photographers that it is illegal to photograph power plants, water treatment plants, and law-enforcement facilities. As with Superfund sites, there are no special restrictions against photographing these kinds of facilities.

CONFRONTATIONS AND REMEDIES

Following the terrorist attacks of September 11, 2001, many photographers found themselves being stopped, harassed, and even intimidated into handing over their personal property simply because they were taking photographs of subjects that made other people feel uncomfortable or anxious. Examples of subjects that have led to confrontation include industrial plants, bridges, and bus stations. For the most part, attempts to restrict photography are based on misguided fears about the supposed dangers that unrestricted photography presents to society. Although the federal government enacted several laws in the aftermath of the attacks that enhanced the ability of the government to monitor and detain suspected terrorists, none of these laws place any restrictions on photography nor do they give law enforcement officials additional powers to direct how photographers may go about their business. Unfortunately, the lack of legal authority has not restrained many officers and security guards from engaging in overzealous and unnecessary harassment of photographers.

 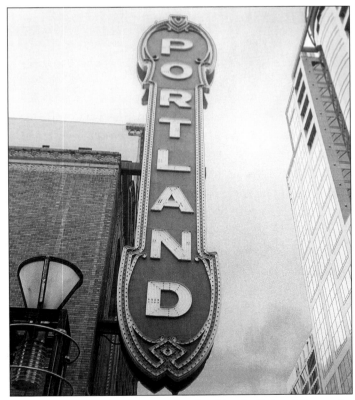

Concerns about security can lead to confrontations over frivolous matters. One photographer was detained by the Federal Protective Service for about twenty minutes after photographing handrails at a former Federal courthouse. The security guards even attempted to prohibit him from photographing the Portland sign at a city-owned auditorium across the street.

Taking photographs of children without a parent's permission in public areas can invite confrontation because people are sensitive about any behavior on the part of a stranger that is directed towards children.

Ironically, unrestricted photography by private citizens has not contributed to a decline in public safety or economic vitality in the United States. When people think back on the acts of terrorism that have occurred over the last forty years, none have depended on or even involved photography. Restrictions on photography would not have prevented any of these acts. Similarly, some corporations have a history of abusing the rights of photographers under the guise of protecting their trade secrets. These claims are almost always without merit because entities are required to keep trade secrets from public view if they want to protect them. Trade secret laws do not give anyone the right to restrain photographers from taking photographs in public places.

Some situations obviously invite confrontation. For example, taking photographs of gang members selling drugs from the porch of an abandoned residence could reasonably be expected to elicit an unfavorable reaction. However, even apparently noncontroversial activities such as nature photography have resulted in confrontations with National Park Service employees who misunderstood the permitting requirements for professional photography in national parks. Considering the wide range of situations in which confrontation can occur, photographers can benefit from knowing how to conduct themselves appropriately and understanding what they can do if they are wronged.

■ REDUCING THE CHANCES OF CONFRONTATION
The easiest way to deal with confrontation is to avoid it altogether. A useful starting point is to consider how other people are likely to perceive a photographer's intentions when shooting a scene. People who act furtive, even without a camera, arouse suspicion and make others uncomfortable. Shy photographers are particularly prone to slinking around the margins while hiding a camera and ironically may call more attention to themselves. Even standing in the open while quietly sneaking shots with a

camera held at waist level can make people act guarded or even hostile. People are particularly sensitive about unusual behavior when it occurs near vulnerable populations such as children and it is not uncommon for people to summon the police when they observe strangers taking photographs at playgrounds. Because being sought by the police surely will not reduce the chance of confrontation, approaches to photography that appear suspicious should be avoided.

When feasible or appropriate, asking permission to photograph a subject can be an effective way to avoid confrontation. At worst, the subject may refuse but this seldom happens. In many cases, you will gain cooperation that enables making a better image than would have resulted otherwise. The most common problem with this approach is that some subjects pose unnaturally and destroy the ambiance wanted by the photographer. However, many subjects revert to their natural appearance if asked to relax or when given sufficient time to become comfortable with the photographer's presence. It is not always necessary to ask permission verbally. Letting people see you have a camera and smiling indicates your intent to take a photograph and gives them an opportunity to express their comfort by smiling back.

Conflicts with property owners and similar parties can be avoided by using common sense. In some situations, such as when photographing residential structures, it is a good idea to get the owner's consent to avoid causing undue concern. Questions regarding taking photographs at places such as museums can often be asked ahead of time about objections or restrictions to photography. This applies to events such as concerts as well.

Two other approaches to reducing the chance of confrontation are to either blend in with the environment or to affirmatively stand out. Although these approaches use opposite methodologies, they are based on the common premise that people are more comfortable with behavior that does not seem inappropriate under the circumstances. Which approach to use will depend on factors such as the setting, type of images desired, and the temperament of the photographer. Experience will indicate the circumstances where one approach works better than another.

Blending in requires photographers to do as little as possible to draw attention to themselves. Casual behavior that suggests there is no pressing purpose behind the photography will tend to be ignored by people even though they are aware of the photographer's presence. As noted above, furtive behavior tends to alarm people and is antithetical to minimizing attention. Instead of concealing their activities, photographers who use the blending in approach merely try to avoid attracting interest by making their activities seem mundane as possible. One aspect of doing this is to be attired in a manner consistent with the setting. Wearing a suit at the beach or swim trunks in the lobby of a courthouse are counterproductive to blending in. Another aspect is to use minimal equipment of a type that does not necessarily imply serious photography. Point and shoot cameras and even older rangefinders tend to

Maintaining a casual presence is sometimes a more effective way of blending in than trying to conceal that you are taking photographs.

People using consumer-level equipment at venues where photography is expected are less likely to face confrontations than those with professional-level gear.

They find something that interests them, quickly but calmly take a photograph, and move on. Others remain quietly in one location and wait for subjects to come to them.

Standing out is done by mannerisms that display an authoritative intent to take photographs. This approach tends to make people more comfortable because they feel assured that the photographer has some definite objective that does not pose a threat. This approach is often more suited than blending when a lower density of people makes it certain that the photographer will be noticed. Because the effectiveness of this technique depends on asserting one's visibility, photographers are in many cases better off using professional looking cameras, tripods, and lighting instead of lower profile equipment.

■ DEALING WITH CONFRONTATIONS

When a confrontation arises, you need to assess where it is likely to head and the best way to deal with the situation. Rather than use pat responses, it is better to analyze each confrontation using a framework that allows you to adapt to the unique aspects of the confrontation. The first question you should ask yourself is how important is the image and what is the purpose for taking it. In many cases you may find that you have no good reason for taking a photograph but were merely attracted to a scene and impulsively decided to photograph it. If the image is one that does not really interest you, it is senseless to engage in conflict over it. On the other hand, knowing why an image is important to you can help in defusing a confrontation. For example, if you are building a body of work documenting your community, being able to explain that objective to other residents can alleviate their concerns or objections.

The second question to ask yourself is what is the interest of the person objecting the photograph. Too often photographers get so engrossed in their own work that they fail to consider that others have legitimate interests as

draw less attention than single lens reflex and large format cameras. In fact, many people seem to mistake small point and shoot cameras for cellular telephones. Tripods and lighting equipment should be avoided when trying to blend in. Some photographers believe that cameras with waist level finders tend to be less obvious but this is open to debate because staring down into a box can attract attention from curious bystanders.

Blending in is easier to do in busy communal places where people tend to act less guarded towards people they do not know. For instance, most people are more comfortable about being photographed by a stranger amid the crowds at a state fair than they are in a nearly empty public park. Some photographers make it a practice to roam an area so as to minimize their presence in any one place.

well. A photographer who kneels down to photograph a child drinking from a water fountain may know that he intends no harm but parents who see atypical attention by a stranger are within their rights to be concerned. Likewise, a security guard who sees someone setting up a tripod to photograph an industrial facility is supposed to be alert to unusual activity and is not acting inappropriately by politely inquiring about the purpose for the photography. Just because someone expresses interest or concern is no reason to get your hackles up. A rational explanation of your intentions more often than not is sufficient to alleviate concerns and objections.

Viewing confrontations from the perspective of the parties' interests can also form the basis for resolution or compromise even when someone is not entirely comfortable about you taking photographs. Sometimes a willingness to compromise allows the objecting party to save face, which not only hastens the end of a confrontation but allows you to take the remaining images in peace. Common ways for photographers to compromise are to agree to move to a different vantage or to take photographs at a different time. An offer to compromise can sometimes be used to a photographer's advantage such as when a security guard agrees to allow you briefly onto a property in exchange for leaving the area once you are done taking photographs.

Reason and a willingness to accommodate other parties are not always effective and photographers should have a plan with regard to how they will proceed in the face of continued objections. If the confrontation is verbal and unlikely to escalate into violence, you can try to be more assertive with the person expressing the objection. In many cases, a polite but firm statement that you are acting within your rights may cause the person to back down. For example, if a doorman comes out and orders you not to photograph a hotel, a simple statement that you may legally photograph anything in view of your camera when standing on a public sidewalk will demonstrate that you understand the law better than the doorman does. When employees such as security guards and clerks persist in objecting, it is often fruitful to speak to someone higher in the organization. For instance, the public relations manager of a large hotel is unlikely to object to any photography outside the building and may very well be concerned that the doorman is unnecessarily damaging the hotel's reputation for courtesy.

One thing you should avoid when confronted about photography is to lie. Even when harmless, lying can reduce your credibility and enhance suspicions. Lying can also adversely affect your legal status. For example, someone who consents to an image after a stock photographer misrepresents himself as an amateur may claim the con-

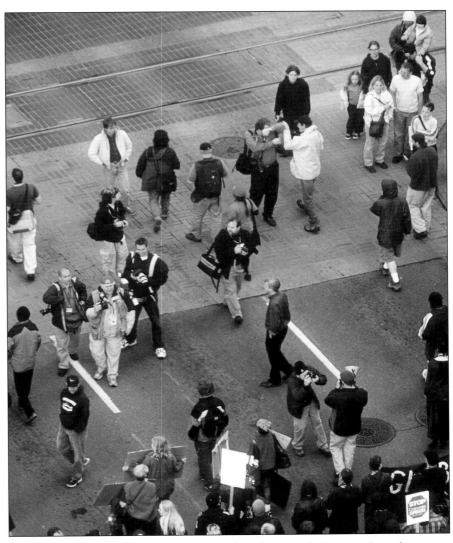

In situations where people expect to be photographed, assertive placements and using high-end equipment can establish credibility with the people being photographed.

sent was invalid after seeing the published image. In the worst cases, lying may unintentionally get you into more trouble. For instance, brushing off someone's query about why you were taking pictures in an alley by claiming you are an undercover police officer might not be a good response if the person and his nearby companions are concerned that you have photographed their most recent drug transaction. In addition, misrepresenting that you are affiliated with an organization such as a newspaper can lead to other problems. Not only will the organization be upset if it discovers your misrepresentation, in some cases impersonation might result in criminal charges.

If you are stopped and questioned, it is important to act appropriately.

If you are confronted by a law enforcement officer, you should be aware that he or she is probably responding to a complaint from someone who is concerned that you are doing something suspicious. In the event you are stopped and questioned, it is important to act appropriately. Typically, questioning officers will have no reason to believe that you have committed a crime and will be satisfied by answers that indicate that you are doing nothing wrong. It is best to respond candidly when questioned under circumstances when you know you have acted within your rights in taking photographs. For instance, if an officer asks whether you were at a specific location, be frank and admit it. Likewise, be honest regarding your reasons for taking photographs. Misrepresenting your whereabouts and motivations can make the officer more suspicious and may lead to further investigation. In some instances, lying to an officer is grounds for prosecution irrespective of whether you did anything else unlawful. In the event your activities have been unlawful, candor may work against you. How to respond to questioning in such situations is beyond the scope of this book.

In some cases, it will be apparent that the person making objections is not in a rational state of mind. When a situation escalates to continued interference or other irrational behavior, you may want to consider refraining from taking photographs until a more suitable time or place arises. Although no one likes to be intimidated, yielding in such circumstances is usually the best course, because few images are worth the risk of being assaulted. In some cases, it may be appropriate to summon help from a third party such as the property owner or law enforcement. When violence appears to be a substantial possibility, the better approach is usually to leave the area expeditiously, because standing one's ground in such circumstances can invite more trouble. In cases where forcible seizure or assault are implicitly or explicitly threatened, the photographer should summon the police to help defuse the situation. Often, the act of pulling out a cell phone to call the police will be sufficient to cause the harassing party to back down. Once summoned, law enforcement officials vary in how they treat photographers but in any case should be treated with respect. You should make your complaint calmly, objectively and maturely. In most cases, they will side with you and tell the other party to desist from further harassment. Occasionally, a law enforcement officer will try to avoid further conflict by telling both parties to leave the area and there have been some instances where officers have sided with the harassing party. While you technically do not have to obey an unlawful order from a peace officer, the potential consequences may not justify the risks associated with refusing to heed such directives. In some cases, it may be feasible to discuss the matter with the officer's supervisor.

If a party has actually assaulted you or taken film or equipment, you should call for assistance from law enforcement. In many jurisdictions you have the right to file criminal charges such as theft, harassment, and assault even if they agree to return your materials once the police appear. Sometimes law enforcement officials will decline to proceed with charges on the grounds that the conduct is a civil matter. In such cases, the photographer should at least request the officer to collect the names of the parties involved in the confrontation because knowing the identity of the parties will facilitate pursuing civil remedies. Furthermore, the photographer can independently request that the district attorney's office consider filing charges against the party that committed the crime.

There can be some benefits to filing criminal charges besides the social justice aspects. One benefit is that publicity given to such charges can make others in the community more sensitive to the rights of photographers. This kind of publicity is particularly effective to deterring violence or threats of violence by private security personnel. Another benefit is that many states have civil compro-

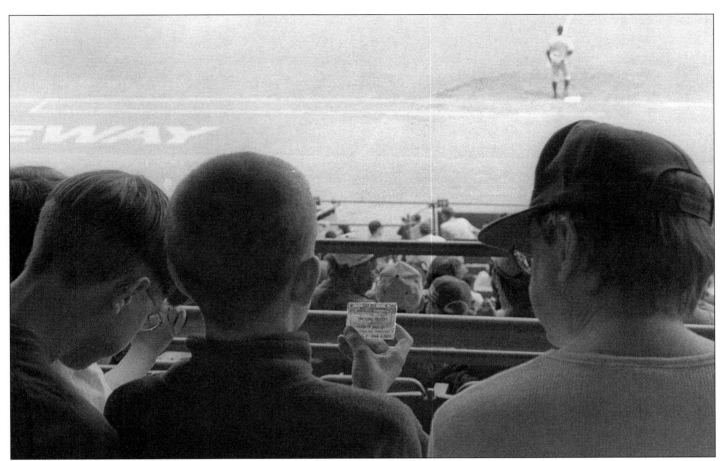

Admission tickets often contain restrictions on photography at concerts and sporting events. Because these restrictions are frequently expressed vaguely and untimely, photographers may want to get a clearer explanation from the facility or promoter beforehand to avoid problems.

mise statutes where criminal charges can be resolved by the defendant agreeing to provide suitable restitution to the victim. Although the damages encompassed by these statutes are often small, they can effect a resolution in less time than civil proceedings. Photographers should also be aware that filing criminal charges may have some detrimental aspects as well. First, the photographer will lose some control over how the matter is resolved because all decisions such as the terms of a plea agreement and timing will be made by government prosecutors. Second, if your film or equipment were seized, the government may retain it for use as evidence in a trial. Although this evidence will be returned after the trial or entry of a plea agreement, the photographer will be unable to use it until that time.

■ SEIZURE OF FILM, PHOTOGRAPHS, AND EQUIPMENT

There are very few instances where your film, images, or equipment may lawfully be taken from you. Even if you are caught trespassing, intruding on someone's privacy, or photographing against someone's rules, the most the wronged person may lawfully do is expel you from their property or sue for any damages they may have suffered. The instances where you may be required to surrender images, film, or equipment are mostly limited to legal proceedings such as lawsuits, law enforcement seizures where the materials constitute evidence of a crime, and where laws protecting military or nuclear secrecy have been violated.

■ PRIVATE SEIZURES

Private parties have no inherent right to seize your film or equipment but that does not mean they never try. People sometimes assert they have the right to seize film after they or their property have been photographed without permission. In most cases, they have no legal right to prevent you from taking photographs and certainly have no right to confiscate your property. The most common

instance where private parties do have the right to prohibit photography is when they bar cameras as a condition of entry onto their premises or participation in their events. In such cases, these conditions should be honored even if the photographer believes they are overbearing or irrational. However, the right to bar photographic equipment does not give parties the right to take your property even if you violate their conditions.

In some cases, parties may attempt to make you agree to surrender film or equipment before allowing you to enter their premises. The ability to enforce such conditions depends on whether they are imposed in conjunction with a conscionable contract. Important factors are whether the photographer had adequate notice of the condition and whether the balance between the damage to the interests of the property owner and the loss to the photographer is fair and reasonable. For instance, courts would give more credence to a consent form signed by a visitor that authorizes seizure inside a defense plant where photography is strictly controlled than they would to an illegible sign posted inside a dimly lit nightclub that stated the same.

Concerts and sporting events often prohibit or limit the use of photographic equipment. Legally, the facilities and promoters have no right to take your equipment but do have the right to bar your entry if you insist on bringing it. The promoters of some events provide the patrons with adequate notice ahead of time and occasionally provide facilities to check in equipment during the event. At

They can threaten to prosecute you but they cannot take your film.

the other extreme are facilities and promoters that give patrons the option of disposing of their cameras or foregoing the right to attend. Such practices are unconscionable and should be protested.

The limitations associated with attending an event are typically printed on admission tickets but are often expressed too vaguely to provide clear guidance to attendees. For example, text stating that "cameras, video recorders, and tape recorders are subject to promoter's authorization and may not be allowed into the facility" leave too much room for interpretation because "may" could be construed in several ways. If in doubt about a facility's policy regarding photography, it is sometimes helpful to call beforehand to get more information.

Processing laboratories concerned about obscenity or child pornography sometimes seize suspicious images and turn them over to law enforcement agencies. Many states have made it a crime for laboratories not to report images that depict sexually explicit conduct involving children or that show genitals in a lewd manner. Because laboratories and their employees not only face criminal fines and incarceration but also the forfeiture of their equipment, many will notify law enforcement upon the slightest suspicion that an image could be construed as child pornography. In some cases, laboratories have refused to return materials they considered obscene for fear of liability under statutes criminalizing obscenity. Courts have generally upheld this conduct. Photographers concerned about having lawful images seized by overzealous or fearful laboratories should inquire about a laboratory's policy before submitting materials for processing.

Private parties, particularly security guards, will sometimes justify an attempt to seize film or equipment on the grounds of making a citizen's arrest. Because the taking of photographs is rarely a crime, private parties cannot arrest you merely because you have taken photographs when they would have preferred otherwise. Similarly, while private citizens have some rights to arrest people, they have no analogous right to seize property. Most states limit the right of private parties to arrest others who have committed a crime in their presence when they reasonably and objectively believe that the particular person has committed a crime. In such cases, a person may use reasonable force to restrain the perpetrator until they can be turned over to a peace officer. Specific limitations on citizen's arrests vary widely among the states. For instance, some

states limit such arrests to felonies while others allow arrests for any crime if committed in the presence of the arresting party. Most states require that the arrested party be turned over to a law enforcement official as soon as possible. Citizens have been liable for restraining an arrested person for periods as short as an hour before calling the police. In the event someone detains you on the grounds of making a citizen's arrest, you should demand that they immediately summon a law enforcement official. If they fail to do so, they can be held liable for false imprisonment.

In theory, a photographer who has had his or her equipment seized has the right to arrest the person who took them provided that the seizure constitutes a felony or occurs in a state that allows arrests for any crime that occurs in the presence of the person performing the arrest. However, there are good reasons to refrain from this tactic. First, using force or the threat of force can lead to a dangerous altercation. Second, you run the risk of being liable for assault in the event you wrongly assessed that the conduct for which the arrest was made was a crime. Third, as discussed later in this chapter, there are better options such as techniques to defuse confrontations and the pursuit of legal remedies.

Likewise, a photographer has a qualified right to use force to resist someone who is attempting unlawfully to seize equipment or film but in many cases should refrain. As stated above, photographers in these situations generally have better and safer options. In addition, you could be legally liable if you use excessive force. When defending property, you may resort to force only if you reasonably believe it is necessary to prevent theft or destruction of the film or equipment. Many states require you to take reasonable measures such as requesting the person to desist before resorting to force. The use of deadly force is never authorized to defend personal property and weapons such as guns or knives cannot be used to prevent a seizure.

■ GOVERNMENT SEIZURES
The government may lawfully seize images, film, and equipment when they may constitute evidence of a crime. Because there are relatively few instances in which taking photographs is a crime, photographic equipment is rarely seized outside of cases involving counterfeiting, obscenity, or child pornography. However, the potent evidentiary value of images makes them a desirable target of seizure. Except in limited circumstances such as during the course of an arrest, law enforcement agents cannot seize someone's film or equipment without a warrant or subpoena authorizing them to do so. In the event you are arrested or ordered to hand over film or equipment, you should do so because there is no legal right to use force against law enforcement agents who are acting in good faith pursuant to their official authority. Doing so will subject one to being charged with resisting arrest. In such cases, your best alternative will be to try and resolve this matter with senior officials, or if that fails, to pursue legal action.

Using force or the threat of force can lead to a dangerous altercation.

Search warrants are judicially approved orders that authorize law enforcement agents to enter onto property without the owner's consent and seize materials that may constitute evidence of a crime. Although warrants grant much authority to law enforcement, they are also subject to strict constitutional limits. For instance, a court cannot issue a warrant unless an agent establishes probable cause that a crime has been committed and explains why evidence can probably be found at the place described in the warrant. A warrant must also describe the nature of the crime and identify the items or types of items that are intended to be seized. Theoretically, warrants cannot authorize indiscriminate searches although in practical effect they often do. In addition, evidence that is not described in a warrant but is incidentally discovered may lawfully be seized. In the event you are on premises subjected to the execution of a warrant, you should be careful not to interfere with the search. Removing or concealing materials described in a search warrant constitutes obstruction of justice and should be avoided. If agents want to search an area not described in a search warrant or seize items not specified, you may request they refrain but should otherwise not resist. Officers are supposed to supply an inventory of seized goods following the execution. Needless to say, if you or your property are the subjects of a search warrant, you should immediately seek legal counsel for assistance in protecting your interests.

Administrative agencies often have the power to require regulated parties to produce documents and images

for inspection and copying when necessary to carry out an agency function. These powers can be exercised in the form of an administrative order or during inspections and compliance visits. An agency's authority will be defined by the statutes that prescribe its authority to collect information. Few statutes give agencies the power to collect information from unregulated parties. For example, a pollution control agency might be able to require a wastewater discharger to provide information and images regarding its effluent but could not force an independent photographer to produce the same.

■ SUBPOENAS

Subpoenas should always be taken seriously because failure to comply can result in substantial sanctions. A subpoena is an order from a court issued on behalf of a party to a legal proceeding that requires someone to testify or produce documents or other items for inspection and copying. Photographers sometimes receive subpoenas when they have recorded something that interests a party to a lawsuit. Typical situations are accident scenes, riots, and filmed interviews. Many photographers resent subpoenas because they are inconvenient and require them to provide a valuable product at a fraction of its market value. Unfortunately, few remedies are available to alleviate this burden.

Subpoenas should always be taken seriously.

Subpoenas may be issued on behalf of private parties or the government in either civil or criminal actions. While technically issued under a court's jurisdiction, subpoenas are usually prepared by the parties to a legal proceeding without court supervision or approval. The subpoena must describe the materials with sufficient detail to allow the photographer to determine what materials are being sought and the time and place to produce them. If you have doubts about what is being sought, the party issuing the subpoena will usually be willing to clarify the request. In cases where someone has issued a subpoena for images that were prepared for a customer, it is a good practice to inform the customer prior to complying with the subpoena to give them an opportunity to challenge it. Work prepared for attorneys is frequently protected from disclosure

and it is imperative in such cases to contact the attorney before responding to the subpoena.

Subpoenas frequently request excessive materials or set an unreasonable schedule. Often, the parties to a litigation will draft overbroad requests out of fear that they may miss an important image if the material sought is described too specifically. Similarly, attorneys sometimes set unrealistic deadlines because they do not understand the amount of time needed to find and produce them.

When faced with an unreasonable subpoena, you should attempt to work out an accommodation with the party that issued the subpoena. Many times, the party requesting the images will be satisfied if you describe the materials you possess that seem relevant and produce them instead of everything that is technically demanded by the subpoena. This can sometimes save you a lengthy and burdensome search. However, you must obtain the party's consent before you can partially respond to a subpoena.

If you are unable to work out differences with the party that issued the subpoena, your only option is to file a motion with the court to modify or quash the subpoena or serve the parties with a formal objection. Because you will probably need to hire an attorney to do this, efforts to reach an amicable resolution directly with the issuing party should not be discounted. In general, one should not expect the courts to excuse you from complying with the subpoena unless it is grossly burdensome, imposes an unreasonable schedule, or requests privileged information. Privileges apply to information that is protected from discovery such as some kinds of work done for attorneys. In some cases, privileges are available to the news media to enable them to protect confidential sources. Courts will not require the parties to compensate you for the market value of the images. However, they will protect you from incurring significant expenses relating to inspection and copying. In any case, do not ignore a subpoena because the penalties for contempt can be severe.

An issue of concern to many photographers is the care and handling of the images they produce. Parties to litigation are usually content with copies and will usually agree to have reproductions made at their expense at a laboratory of the photographer's choice. While litigants have a broad right to discover relevant images, they are not allowed to damage them or appropriate them for purpos-

Police departments in large cities will have internal affairs or citizen's relations departments that can take complaints about inappropriate confrontations by law enforcement officers.

es outside the litigation. Because the parties will rarely have a compelling need to obtain negatives and original transparencies, you may have grounds to have such requests quashed by the court. In the event that original transparencies or negatives must be given to a party, be sure to protect yourself by providing a delivery memorandum describing each image. Although many law firms make reasonable efforts to minimize the burden on outside parties, some can be quite arrogant and fail to handle materials with the care they need. If you are forced to deal with such a firm, you want to take reasonable measures so you can sue them if necessary to be compensated for lost or damaged images. Registration of copyrights, as discussed in chapter six, is recommended.

■ REMEDIES FOR PHOTOGRAPHERS

Sometimes reasonable efforts to avoid or dispel confrontations fail and photographers are prevented from photographing or have their equipment or film confiscated. These situations are never pleasant and usually violate the photographer's rights. In such cases, a photographer may want to consider pursuing relief by filing a legal action. Understanding the practical aspects of how legal processes work can make obtaining relief quicker, less expensive, and more effective. Similarly, failing to understand how the system works can impair otherwise strong claims.

The first step when you have been unreasonably harassed or had film or equipment seized is to determine what you want in terms of relief. Keep in mind that legal

recourse is not always the best or even a practical means of resolving conflicts involving photography. In some cases, the degree of public or legal injury does not warrant seeking a remedy. For example, a press photographer who has been told by a minor school official that he cannot photograph a high school basketball game may not care enough about the matter to want relief. Even when the photographer or the newspaper wants recourse, options outside the legal system will make far more sense than filing a lawsuit to get access.

The first step in resolving a conflict is to assess the interests of the parties.

The first step in figuring out how one wishes to resolve a conflict is to assess the interests of the parties involved. The newspaper may want to cover high school sports to provide information desired by its readers. The school will most likely want only to ensure that the photography does not unduly interfere with the players and fans. Because the decision to limit photography was probably motivated by the poor judgment of a school employee, this kind of matter should be resolved quickly and amicably so long as the parties conduct themselves maturely. If a conversation between the photographer and the coach cannot resolve this matter, it is likely that a telephone call between the editor and the principal will.

If the matter cannot be worked out with the person or persons involved in the confrontation, there are other avenues that can be pursued short of taking legal action. There are no guarantees that you will get satisfaction by pursuing a complaint but many photographers have been surprised by the level of responsiveness after reporting an inappropriate confrontation to other people.

One approach is to pursue recourse by communicating with an appropriate person with a supervisory role over the persons involved in the confrontation. If the confrontation involved law enforcement officers, most large police and sheriffs departments have internal affairs departments or similar offices that investigate complaints filed by members of the public. In smaller organizations, this function is often handled personally by the chief of police or the sheriff. If the confrontation involved employees or agents of a private business or organization, it can be productive to complain to the public relations or legal departments. In such cases, it is best to make the complaint as objective as possible and rely on the facts to explain what happened. Providing details such as the time, date, location, and the content of conversations are more likely to be persuasive than general accusations or expressions of indignation.

Another way to address a confrontation is to contact the local media. Most journalists appreciate the value of the right to photograph public areas and events and are generally receptive to reports that police or private parties have overstepped their lawful bounds in dealing with photographers. It is also fairly easy to get in contact with journalists because most newspapers have websites that provide contact information of their reporters such as e-mail addresses. In fact, it is usually much easier to find out how to contact a journalist to report a confrontation than it is to find the appropriate person to file a complaint with a police department.

Sometimes a little thought given to where to file a complaint can lead to an effective resolution. Try to determine whether there is a party with an interest in the matter that can bring influence to bear. For example, a confrontation that occurs in a tourist area could be reported to the local chamber of commerce because such entities generally want to ensure that visitors to their locales are treated decently by police and local businesses.

In some cases, immediate recourse to legal action will be warranted. For example, if security guards seize a photojournalist's film after she photographs employees fleeing a burning building during an emergency at a chemical plant, the newspaper may feel it imperative to obtain the images before the story becomes stale. Because the newspaper's interest in prompt publication will conflict with the chemical company's interest in minimizing adverse publicity, the newspaper might want to retain an attorney to file for an emergency injunction to recover the film and not wait to see if informal efforts to resolve the conflict succeed. In other cases, it is usually best to wait a short period of time before filing a legal action. Being a party to a lawsuit is a sizable undertaking, usually entailing a significant expense. Therefore, allowing for a cooling-off period is generally wise. However, you should write down as much of the information about the event you can to ensure that nothing is lost as memory degrades. Also, many states require that notice of a possible lawsuit be provided within a short period following the event or you

will lose the right to pursue a claim against a government entity. Therefore, you should never wait more than a couple of weeks if you are interested in pursing the litigation option.

Once you know that you want to take legal measures, you have several options to pursue. The easiest and least expensive approach is to write the offending party a demand letter in which you state that you intend to file a lawsuit within a certain period if your demands are not met. The advantage to this approach is that the other party may take you more seriously and resolve the matter before you need to incur expenses such as court costs or attorney fees. The disadvantage is that you lose time if the other party does not respond acceptably.

Should it become necessary to file a lawsuit, the next question is whether small claims court is a reasonable option. The advantages of filing in small claims court are that you will not need an attorney and the process is faster than using the higher courts. However, you will give up procedural aspects such as the right to appeal a judgment or engage in pretrial discovery. Small claims courts also impose limitations on the amount you may recover but are often the only cost-effective means to resolve claims involving less than $5000.

For major losses, you will usually be better off hiring an attorney to prosecute your claim. Pursuing a claim in this way can be expensive, but the costs can be managed through careful planning. Relatively inexpensive options to consider before pursuing active litigation are a demand letter and mediation. Although demand letters prepared by attorneys serve the same purpose as ones drafted by the parties, such letters are often more effective because they indicate a strong resolve by the plaintiff and may better articulate the legal basis for the claim. Mediation is a settlement process overseen by a neutral party who assists the parties in working out their differences. When successful, mediation is faster and far less expensive than litigation. Although demand letters and mediation do not always succeed in resolving legal disputes, their low cost compared to trial advocacy make them important options to consider.

Your success with the legal process will generally depend on the merits of your claim and the attitude and abilities of your attorney. Because the attorney will be responsible for assessing the merits of your case and diligently prosecuting it, it is important to select suitable counsel. Unless you already know someone who is competent to handle the matter, it will be worth investing some effort in selecting an attorney. One way to get the names of potential counsel is to ask for recommendations from persons or entities associated with the photography industry such as other photographers, trade organizations, and the media. Civil rights organizations and the lawyer referral services operated by the state or local bar association can also provide good leads. Once you have some names, you should interview two or three candidates before making a final selection.

You need to hire an attorney who has a proper attitude towards clients. You do not need an attorney who lacks zeal and is unable to control costs. Issues to discuss before retaining an attorney include what you hope to achieve and how long it will take to resolve the matter. If you are in a hurry, then you probably will not want an attorney who procrastinates about starting the court proceeding. You should also be alert for faults such as poor listening skills and apathy about communicating with the client. If you feel an attorney does not really understand the facts underlying your claim because he or she is not paying attention to what you say, consider hiring someone else. You should ask questions about how services are rendered, such as how soon you can expect to have telephone calls returned and when the complaint will be filed.

Mediation is a settlement process overseen by a neutral party.

Other important topics to discuss when interviewing an attorney are the scope of services to be provided and the fee arrangements. The attorney should provide you with enough information about fees so that you understand what you may be spending and can make intelligent decisions about how to proceed during the case. Considering that the vast majority of cases settle before trial, it is important to understand how costs will vary depending on the stage at which the case is resolved. For instance, you should have a good idea of what the case will cost to prepare for trial, the costs associated with options such as mediation, and the cost to try the case and argue any subsequent appeals. If the attorney is willing to handle the matter on a contingent fee where he or she is paid a percentage of the recovery, make sure the agree-

ment is in writing and covers issues such as who advances the court costs and whether the recovery is divided before or after those costs are deducted.

Finally, it is important to be realistic about the prospects of recovery. The justice system is very much subject to human foibles, which means that litigation is risky. Challenges in presenting proof and the risk of aberrant verdicts cause most plaintiffs to settle cases for less than their perceived damages. You should carefully consider your attorney's appraisal of the case because this may be your best check on reality. However, keep in mind that while such appraisals are informed opinions, they are not guarantees and results at trial often vary substantially from predictions.

Writing a Demand Letter. The expense of retaining an attorney can make litigation uneconomical in many cases. One alternative available to photographers is to write their own demand letters. The purpose of these letters is to let another party know that you are serious about your legal rights and intend to take action if a suitable resolution cannot be reached outside of court. The advantage of presenting this information in a letter over verbal discussions is that you can control to whom it is addressed, describe the facts carefully and fully, and itemize the specific relief you desire.

Selecting the addressee is important and your goal should be to have the letter reach a representative who is intelligent, objective, and has the authority to resolve the matter. The facts should be described objectively, because it is probable that the other party will disagree with them to some extent. Because the tone of a demand letter will affect how it is perceived by the other party, effective letters will favor maturity and objectivity over insults and hyperbole.

For example, assume that Ima Plaintiff is photographing frogs in a roadside ditch that collects drainage from the local SlopCo chemical complex when a security guard appears and demands that she surrender her film. She politely tells the guard that she is on public property and does not want to be bothered. On hearing this, the guard gets into a rage and pushes her and her tripod-mounted camera into the ditch before driving off with her camera bag. She calls for the sheriff on her cellular phone, but the responding deputy tells her that SlopCo is important to the local economy which makes this a civil matter. He refuses to get involved. After returning to her studio, Ima

finds that her camera and lens are damaged beyond repair and that the camera bag taken by the guard contained three lenses, several accessories, and eight memory cards. She calls the management at the SlopCo plant several times but is given the cold shoulder. Ima decides to make one more attempt to resolve the matter before filing suit by writing a letter demanding the compensation and the return of her equipment. The question is how should she write the letter?

Considering that this matter involves a local facility that is part of a large corporation, Ima has several options regarding to whom she can send the letter. She could address it to the security department at the local plant, but because they have not treated her respectfully in the past there is little reason to expect a favorable response. A better approach might be to send the letter to the General Counsel of SlopCo because this person has experience at evaluating legal matters and is connected with the most senior management of the corporation.

Because she wants someone to evaluate the claim objectively, she should write the letter in a tone that reflects her credibility, maturity, and dignity. She should also describe the facts succinctly, spell out exactly what she wants in terms of relief, and support her analysis for compensation. Examples of a bad and good version of this letter are described below.

BAD VERSION

Head Goon
Security Department
Local SlopCo Plant

Re: DEMAND LETTER!!! for Thievery and Goonery

Dear Head Goon:
One of your guards assaulted me several weeks ago and took my valuable photo equipment and I intend to sue your pants off unless you immediately return what was stolen and pay me appropriate compensation. You and your filthy corporation will rot in prison for your environmental crimes!!!!!!

Sincerely,

Ima Plaintiff

GOOD VERSION

Walter Witty, Esq.
General Counsel
SlopCo International Corporation

Re: Request for Compensation

Dear Mr. Witty:

Three weeks ago on January 2, I was photographing frogs as part of my stock photography business. While standing on the shoulder of Highway 43 outside the local SlopCo facility, I was approached by a company security guard whose name tag read "Danny Vandal." After I refused to surrender my camera, he pushed me and my tripod-mounted camera into the ditch and drove away with my camera bag containing eight memory cards, three lenses, and my accessories. The camera and lens that were kicked into the ditch cannot be repaired and the tripod has deteriorated to the point where it is difficult to operate and should be replaced. The equipment that was seized by SlopCo has not been returned. I am writing to you to see if we can resolve this matter without resorting to court.

I am requesting that SlopCo compensate me for my losses and return the equipment and memory cards that were seized. The items that I know to be damaged and their fair market values are as follows:

Nikon Digital Camera Body — $1500.00
Nikkor 200mm f/4.0 Macro Lens — $900.00
Gitzo Reporter Tripod — $300.00
Arca Swiss Ballhead for Tripod — $300.00

I am also demanding that my equipment and memory cards be returned immediately and that SlopCo compensate me $650 dollars for each week that it has held the equipment (this amount represents the reasonable commercial rental rate of the equipment seized). If the equipment and memory cards have been damaged, please let me know so that I can provide you with an appropriate compensation value. Should you desire independent support for the reasonableness of the values I have provided, I suggest you contact the photographer who did the work for the most recent edition of the SlopCo Environmental Achievements Annual Report. My losses as of next Saturday, including compensation in the amount of $5000 for the assault by the security guard, will amount to $12,350.

As stated above, I would like to resolve this matter promptly. If you are not interested in settlement on these terms, please let me know by February 2 so that I may hand this matter over to an attorney.

Respectfully,

Ima Plaintiff

The bad version of the demand letter is unlikely to succeed because it fails to tell SlopCo the specific relief sought and is written in a manner that can only exacerbate already ill feelings. In contrast, the good version shows that the photographer has control over her emotions and will be a credible witness if the matter goes to trial. The demands for relief are reasonable and supportable. Even if SlopCo believes that parts of the claim are unreasonable, Ima has set a good foundation from which a settlement can be negotiated.

PROTECTING YOUR INTELLECTUAL PROPERTY

Information on how to avoid infringing copyrights is presented in chapter 4 so this chapter concentrates on how you can you protect the copyrights to your images. Copyright is the dominant form of intellectual property protection available to photographers because it offers the best legal means for controlling how your images are used and determining whether you can be compensated for their use. It protects against the copying of the images themselves but does not preclude others from using your concepts or photographing similar subject matter.

Copyright offers the best means for controlling how your images are used.

The other forms of intellectual property protection are patents, trade secrets, trademarks, and trade dress. These forms tend not to be as important to photographers as copyright but can be useful under certain circumstances. For instance, you might be able to obtain patent protection for new photographic techniques and methods you invent and you can rely on trade secret protection, trademarks, and trade dress to limit others from using your methods and concepts in some specific situations.

■ THE NATURE OF COPYRIGHT

Copyright law basically protects against others copying the expression of ideas and subject matter but does not prevent others from making their independent creations based on those ideas or subject matter. For example, if you photograph jellyfish at a public aquarium where they are backlit against a dark background, others are free to take their own photographs of jellyfish in the same setting even though their images may bear a strong resemblance to yours. However, they cannot lawfully scan your photographs and start selling the images as posters. If they do so, they are violating your copyright. In some cases, when the subject matter and arrangement of the dominant visual elements are deliberately selected with the intent to copy the look and feel of an image, courts will hold that the resulting images were not independently created. For example, if an advertising agency hires a photographer to make a replica of your image of a bowling ball sitting on top of a wine glass with a miniature elephant inside, the agency and photographer will likely have violated your copyright.

Another important thing to understand about copyright is that it is a property right. Although intangible, a copyright belongs to someone and can be licensed, loaned, sold, devised, and inherited. By statute, the owner of a copyright in a photograph has the exclusive right to reproduce, distribute, and publicly display the work. The owner also has the exclusive right to prepare derivative works such as using the photograph as the basis for a painting. Like other property, copyrights can be stolen, or in legal parlance, infringed. In such cases, the owner has several kinds of legal remedies to redress an infringement.

The basic elements of creating a copyrighted work are fixation into a tangible medium and the requisite level of creativity. The fixation requirement is almost never an issue for photographers. An image is considered fixed at the moment the light affects the film or is stored in digital memory. There is no need for the film to be developed or the image to be viewed on a screen before it is considered to be fixed into a media. The creativity requirement is a problem for photographers in only a few situations. Courts have consistently held that a work must have a

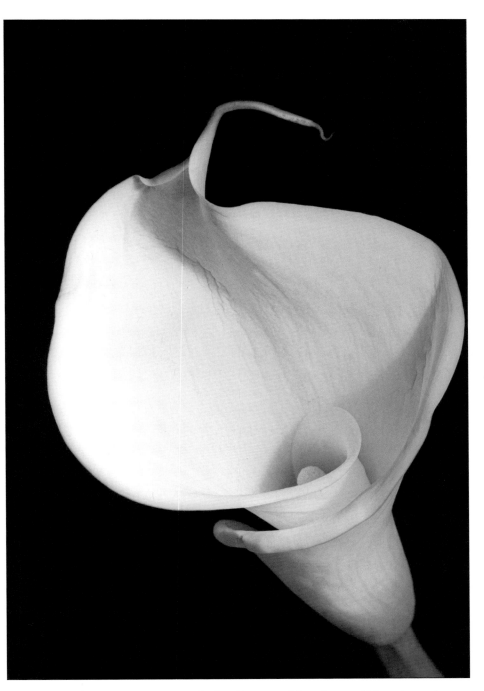

Copyright protects the expression but not the underlying idea of a subject. Callas are a popular subject for photographs and other artwork. Other photographers can independently create their own images of callas without infringing the copyrights of other images of callas.

minimal level of creativity. While the actual amount required to qualify for copyright protection is quite minimal, it must go beyond mere skill and labor. The typical factors assessed when examining the level of creativity in a photograph are selection of subject matter, posing the subjects, lighting, viewpoint, selection of film, and selection of equipment. Most photographs encompass such criteria and qualify for copyright protection. However, courts have stated that slavish copying, along the lines of making a photocopy, does not show sufficient creativity to be protectable. The most recognized examples are high-quality photographs that serve as reproductions of works of two-dimensional art. Although these images require substantial technical skill and great attention to detail, courts have stated that the objective of making an accurate reproduction is inimical to the creativity required under U.S. copyright laws. However, this is not an issue when photographing three-dimensional objects because factors such as angle of view and lighting necessarily require the photographer to exercise creative judgment, irrespective of whether it is conscious or unconscious.

Except when a work is made for hire, the photographer who creates the image is the "author" or the legal creator of the image. The most common form of "work-for-hire" is when the photographer is an employee whose job duties include taking photographs for an employer. A good example is a salaried photojournalist working for a newspaper publisher. The other way that a photograph can be-

come a work for hire outside of a traditional employee-employer relationship is when (1) it is specially commissioned for use in a collective work such as a magazine and (2) all the parties agree in a signed writing that the work will be for hire. Absent a written agreement, which must be signed before the images are created, there can be no work for hire. However, when a work is made for hire the employer is deemed the legal author of the image.

Another way that the ownership of a copyright can be transferred is by assignment. If the copyright is assigned, the photographer will remain the author but the person to

whom the copyright is assigned will be the claimant. Once the copyright is assigned, the claimant has sole control over how the copyright is used. Sometimes only part of the copyright is assigned, such as would be the case if a photographer assigns the right to publish the image in books to a publisher but keeps the right to sell individual prints. In such cases, that person becomes the claimant only for the rights that were assigned. When all or part of a copyright is assigned, the transfer must be in writing and signed by the photographer.

Most licenses granted by photographers are done on a nonexclusive basis.

When the author wants to retain ownership of the copyright but allow another party to exercise some of the rights, the permission to do so is called a license. Most licenses granted by photographers are done on a nonexclusive basis which means that the photographer is free to allow other people to use the licensed image in the same way. A nonexclusive license to use a copyright does not have to be in writing although the better practice is to memorialize such agreements.

■ AN ULTRA-BRIEF HISTORY OF COPYRIGHT LAW
Some of the nuances of copyright law may not make much sense unless you know the history of how they were developed. For example, concepts such as publication, registration, and notice, were once critical to determining whether works were entitled to any level of copyright protection in the United States and their vestiges continue to be relevant even though copyright vests at the moment of fixation under the current law. Knowing the roles that the concepts played historically makes many of the issues associated with copyright law easier to understand.

The first copyright laws in the United States were enacted in 1790 and covered maps, books, and charts. Foreign works were not protected and were often infringed until the United States signed treaties during the twentieth century that gave such works some degree of protection. One of the early hallmarks of American copyright law was that the period of protection lasted for a set time (initially fourteen years) but could be renewed for an additional period by filing the appropriate renewal document. Under federal copyright law, only published works

were protected and even then only if the copyright owner complied with formalities such as registration and copyright notice. During the nineteenth century, a doctrine of common law copyright was developed that protected unpublished works. The doctrine of fair use was also fashioned during this period to allow limited uses for socially beneficial purposes. Over time, copyright came to encompass more kinds of works. Photographs were first protected by copyright in 1865. Other visual arts, such as drawings and paintings, did not receive protection until 1870.

In 1886, the Berne Convention was signed by the first group of member nations although the United States abstained. This treaty required the signatories give foreign works the same level of protection as accorded to their own citizens. It also reflected the international norm that copyrights vest upon creation of the work and expressly prohibited prior registration with a government entity as a condition of copyright protection. The Berne Convention was further amended in 1908 to set the term of copyrights as the life of the author plus fifty years and to abolish other formalities such as requiring the display of a copyright notice. Following Berne, copyright protection within the United States was out of step with most of the industrialized world.

Some significant changes were made to United States copyright law during the first part of the twentieth century although rigid formalities made obtaining and maintaining copyright protection complex and sometimes precarious. A major revision of the copyright statute in 1909 extended the term of protection to twenty-eight years with an additional renewal term of twenty-eight years. The 1909 Act also granted protection to some classes of unpublished works provided that they were first registered with the U.S. Copyright Office. In 1914, United States signed the Buenos Aires Copyright Convention which established copyright protection between the United States and most Latin American nations. This treaty mandated use of the phrase "All Rights Reserved" as a precondition to granting copyright protection to foreign works. This phrase continues to pepper copyright notices even though its legal significance has long since diminished to nothing. The United States extended its protection of foreign works by signing the Universal Copyright Convention in 1952 which meant that citizens of most countries could enforce their copyrights in the United States after its provisions took effect in 1955. However, U.S. copy-

right law still imposed barriers to complete protection. For example, most works written in English had to be printed in the United States to qualify for copyright protection.

The next major overhaul of copyright law occurred when the Copyright Act of 1976 was enacted to facilitate the eventual membership of the United States to the Berne Convention. Works created after January 1, 1978 were deemed to be protected by copyright at the moment of fixation and the term of protection was made the life of the author plus 50 years. The Act also largely eliminated common-law copyright. The United States signed the Berne Convention in 1988 and finally joined the international mainstream with regard to copyright protection. One of the major changes forced by Berne was the elimination of the requirement of copyright notice as a condition of copyright protection. On March 1, 1989, the previously mandatory requirement to place copyright notices on published works became optional.

■ WHY YOU NEED TO REGISTER YOUR IMAGES

Although the Copyright Act of 1976 did away with the requirement to register images as a condition of copyright protection, registration of works with the U.S. Copyright Office is generally necessary to have effective remedies against the more common kinds of infringements. Unless a work is timely registered, the copyright owners will be precluded from being awarded statutory damages and be ineligible to recover the attorney fees incurred in pursuing an infringement action.

While there are occasions when the actual damages will be large enough to warrant the investment in legal services to recover them, in most cases the damages will be substantially less than the cost of proceeding with a lawsuit. For example, most copyright owners will not be willing to spend several thousand dollars to redress a infringement that is worth less than a thousand dollars.

However, the economics of filing a lawsuit change significantly when an image has been timely registered. In such cases, the court or jury may award damages within a specified range, usually $750 to $30,000 per image, and the court has the discretion to order that the infringing party pay your attorney fees. Ironically, the prospect of having to pay your attorney fees results in most infringers agreeing to settle without a lawsuit being filed because they want to avoid being on the hook for the legal expenses likely to follow. Although they may be unhappy about it, most infringers will pay a reasonable amount of damages to avoid being sued and risk having to reimburse your legal fees.

Another important reason to register your photographs prior to an infringement stems from the legal requirement that works made in the United States must be registered prior to filing an infringement action. Unless the work is registered within a reasonable time after creation, the photographer runs the risk that the original image might be lost and therefore make it impossible to provide a copy as required by the registration procedures. For example, assume that a famous sculptor prints one of your digital photographs off your website and makes a set of sculptures based on your photograph which he later sells for $500,000. Two years later, you see the sculptures while watching the news on television and immediately recognize that they are based on your photograph. These sculptures would be derivative works that violate your copyright and you would have a valid claim for infringement. But what happens if you had deleted the photograph off the web host's server while revamping your website and lost your remaining copy when your four-year old poured grape juice into the vents of your computer. In such a case, you no longer have a copy, cannot properly register the image, and are precluded from filing a suit.

■ HOW TO REGISTER YOUR IMAGES

Registering the copyrights for images is easy, not very expensive, and generally does not require an attorney. Preparing a registration application consists of filling out a simple form and providing copies of the images to be registered. Very little information is required beyond your name and address. Furthermore, the U.S. Copyright Office has prepared instructions on registering images that are fairly easy to follow and available for downloading at www.copyright.gov.

Registering the copyrights is easy and generally does not require an attorney.

My position, not adopted by many attorneys, is that photographers should learn how to prepare their own applications and be diligent about registering their images. Although attorneys can prepare and submit registration

applications on your behalf, they typically charge any-where from $200 to $350 to fill out a one or two page form. I have even seen a few cases where applications prepared by attorneys were seriously botched because the attorney did not fully understand the nature of the images or their past history. Although there are legal nuances associated with the registration of the various forms of works subject to copyright, it is not difficult to learn the ones associated with photographs. Furthermore, the photographer will usually be the person most qualified to evaluate how to apply those nuances because they will almost always have the best understanding of the circumstances under which the images were made and whether they have been published.

Publication is defined as the distribution of copies to the public.

Taking the short amount of time required to learn how to prepare a registration application is time well invested. Even if you have doubts about whether you are completing the application properly, it is much less expensive to have an attorney review a draft application than it is to retain one to prepare an entire one. The only legal knowledge you need to know to prepare the typical application is understanding the legal sense in which the terms "publication," "author," "work for hire," and "claimant" are used. These are terms of art used in the copyright laws that differ somewhat from their ordinary meanings.

"Author" and "work for hire" were explained earlier in this chapter. Publication is defined in the copyright statute as the distribution of copies to the public by sale or other transfer of ownership, or by rental, lease, or lending. The phrase "to the public" means that no restrictions are made with regard to how the purchaser can disclose the contents. Therefore, most ordinary sales of images will constitute publication even if made to an individual. Merely offering to sell images is not considered to be publication unless you are offering the images to an entity for further distribution such as to a stock agency or a commercial gallery. A public display such as a personal exhibit, or even having a photograph appear in a television program, is not considered a publication no matter how many people see the work. The issue of whether merely posting an image on a website, but not offering it for sale, constitutes pub-

lication is still a gray one. When in doubt, the safer approach is to assume that images have been published for registration purposes.

A "claimant" is either the author of the work or a person or entity who has obtained ownership of all the rights in a copyright that initially belonged to an author. Examples of parties who are claimants other than the author include the heirs of a deceased author and persons who have purchased all the exclusive rights to copyrights. The only people who can apply to register a copyright are authors, claimants, persons who have exclusive ownership of some rights in a copyright, or agents acting on their behalf (such as attorneys).

The first step in registering the copyright of images is to decide whether you want to register an individual image or several images with a single application. Because the fee is the same irrespective of the number of works to be registered, most photographers find it is far less expensive to register multiple images in a single application. The second step is to determine whether the images have been previously published as that term is used in copyright law. Whether an image has been published is important to registration because (1) the application requires that you provide the dates of first publication if the images have been published and (2) if the image was first published before March 1, 1989, the copyright notice must be included in the deposit for the images, and (3) two copies of each image may be required.

In any case, images must be registered using Form VA which comes in a short form version (one page) and a long form version (two pages). The short form can be used whenever you are the author and sole owner of the copyright, the work was not made for hire, and the work is completely new (i.e., does not contain a substantial amount of previously published or registered material). Otherwise, you are required to use the long version. Both forms have good instructions that are easy to follow.

Registering a single image is the most straightforward approach. If the image has been published, the application must state the date of first publication and provide two copies of the best edition of the image. Registering single images becomes prohibitively expensive if more than a few images must be registered, however. Therefore, most photographs are registered as sets of several images.

Technically speaking, when more than a single unpublished photograph is registered in a single application, the

grouping is called a collection. There is a huge advantage to registering photographs before they are published because you avoid having to state the publication dates. However, applications for such images must be received by the U.S. Copyright Office before publication which means in most cases before the first sale or before they are offered to a stock agency (and maybe even before posting on the Internet). The basic requirement for registering unpublished images as a collection is that all the photographs must have been made by the same author. There is no limit to the number of photographs that can be registered as a collection nor must they share a common subject or range of dates. However, you are required to identify the collection with a title. A good approach to selecting a title for a collection of photographs is to incorporate the name of the photographer, the number of photographs, and the ranges of dates over which the photographs were taken. An example would be "2,533 individual photographs taken by Joe Jones from January 2002 to March 2005."

The are several ways that the copies of the photographs can be made for submission with the application form. The options are:

1. Digital files on one or more CDs or DVDs and in JPEG, GIF, TIFF, or PCD format.
2. Unmounted prints measuring at least 3 inches by 3 inches but not exceeding 20 inches by 24 inches.
3. Contact sheets.
4. Slides, each with a single image.
5. A format in which the photograph has been published such as magazine clippings.
6. A photocopy of each photograph (if the photograph was published as a color photograph, the photocopy must be a color photocopy).
7. Slides, each containing up to 36 images.
8. A videotape clearly depicting each photograph.

A single copy is required to be submitted with the application when the photographs have not been published.

A registration of multiple photographs that have been published is called a group registration. The same application forms are used as for unpublished collections, although preparing an application for a group registration can take a little more effort because you have to identify the first date of publication for each photograph covered by the application. The requirements for what images may be encompassed by a single application are also more strict. For a group application, all the photographs must have been made by the same photographer whereas an application for registering a collection requires only that the author be the same (remember that when a photographer creates a work for hire, the employer is the author). In addition, all the photographs must have been published within the same calendar year and have the same copyright claimant.

You may list any appropriate title in the appropriate space for the title but must state "Group Registration/Photos" and describe the approximate number of photographs in the space provided for "Previous or Alternative Titles." For example, the primary title of the work might read "Joe Jones Published Photographs—2006" and the "previous or alternative title" might read "Group Registration/Photos; about 2500 photographs." The entire range of dates encompassed by the group are described on form VA. If the photographs were first published on different dates, then the dates of first publication must be described in one of the following ways:

1. On each deposited image.
2. In a text file on the CD-ROM or DVD that contains the deposited photographic images.
3. On a list that accompanies the deposit and provides the publication date for each image.
4. On the continuation sheet Form GR/PPh/CON (limited to no more than 50 continuation sheets identifying no more than 750 photographs).

However, there is a major exception to the requirement of having to list each date. This applies when each photograph within the group is first published within three months before the date the application is received by the U.S. Copyright Office. In such a case, you only need to state the range of dates in the appropriate space on Form VA and write "Group Registration/Photos" and the approximate number of images in the space provided for the alternate title (the regular form is better than the short form for this purpose). This can be an enormous time-saver for photographers who publish large numbers of images by submitting them to stock agencies or by

offering them for sale on the Internet. However, it is important that you comply with the associated time constraints.

As stated previously, photographs that were first published before March 1, 1989 were required by law to have contained a printed copyright notice that named the copyright owner and the year of first publication. In such cases, the copies provided with the application form must show the photograph as it actually appeared when it was first published along with proof of the copyright notice.

Otherwise, the copy requirements are the same as for collections.

Finally, keep in mind that while preparing the application for a registration should be taken seriously and done as carefully as possible, courts generally do not invalidate registrations for minor or inadvertent errors. Should the U.S. Copyright Office return an application or ask for corrections or supplementary material, you will need to respond diligently to ensure the validity of the registration. Likewise, if you discover an inaccuracy serious

USING PHOTOSHOP TO EXPEDITE REGISTRATION APPLICATIONS

The "Actions" palette of Photoshop can be used to expedite the creation of copies that can be deposited with registration applications. The action described below can be used to facilitate the preparation of the copies that are submitted as part of the application for the registration of copyrights. The action described below is intended to be applied as the last step of processing an image in Photoshop. It saves the file in the current directory, prepares a low-resolution copy, stores the low-resolution copy in a separate designated folder, and closes the image file. The action thus prepares a folder in which all the image files may be easily copied onto a CD or DVD to be included with the application. If you want, you can create separate actions to be used for published and unpublished images that copy the low-resolution files to different destination folders.

To create the action:

1. Create a directory folder called "Copyright Dump" or similar name. This is the directory in which you will store the low-resolution images produced by the action. When you are ready to submit the application to register the copyrights to the images, you can copy the images in the folder onto a CD or DVD.

2. Open an image for which you want to register the copyright.

3. Go to the View menu and click to make the "actions" palette appear on the monitor.

4. Click on the "New Action" symbol which is the square-within-a square icon at the bottom right of the palette.

5. Enter "Copyright Dump" in the space for "Name" and click on "Record."

6. Click onto the "File" menu and then click onto "Save." This will save the image in its current file folder.

7. Click on the "Image" menu and click on "Image Size."

8. Click on "Auto Resolution" and enter "75 lines per inch" in the space for "Screen."

9. Click OK. Then click OK to exit the Image Size palette. The image size should be smaller.

10. Click onto the "File" menu and then click onto "Save As." Change the folder to "Copyright Dump" and click "Save."

11. Click on the square at the bottom of the action palette to stop recording the action.

Thereafter, each time you are done processing an image in Photoshop, play the action to automatically save the file and store a low-resolution copy into the Copyright Dump folder. When you are ready to submit the registration application to the U.S. Copyright Office, you can copy the entire Copyright Dump folder onto a CD or DVD to prepare the required deposit. At the same time, you should prepare another CD or DVD for your records and either delete all the images from the folder or rename the directory to correspond to the title used on the registration application (e.g., Krages images, October–December 2005) if you want to keep the record of the registered images on your hard drive. If you choose the latter, create a new folder called "Copyright Dump" and start the process anew.

USING PHOTOSHOP TO ADD COPYRIGHT NOTICES TO IMAGES

This Photoshop action is used to place the proper copyright notice for unpublished images into the IPTC space of a digital image file. It will also cause Photoshop to display a copyright symbol on the title bar of the image. If you want, you can create a separate action to be used for published images. To do this, omit the phrase "unpublished work" in step 7. To create the action:

1. Open an image for which you want to register the copyright.
2. Go to the View menu and click on Actions to make the "Actions" palette appear on the monitor.
3. Click on the "New Action" symbol which is the square-within-a-square shaped icon second to the right at the bottom of the palette.
4. Enter "Copyright Notice" in the space for "Name" and click on "Record."
5. Click on the "File" menu and then click on "File Info."
6. Enter your name into the space for "Author," click on the space for "Copyright Status" and indicate "Copyrighted Work."

7. In the space for "Caption," enter "unpublished work Alt-0169" from the numbers keypad if using a PC or "unpublished work Option-g" if using a Mac. Append this phrase with your name and the year of creation so that the entire phrase reads something like this "unpublished work © Bert Krages 2006." Copy and paste this information into the space of "Copyright Notice" as well. You want to use the caption space because this is where other programs read the basic file information. If you want, you can add additional text in the caption space (such as a caption).
8. Click on "OK" and then click on the square at the bottom of the Action palette to stop recording the action.

Thereafter, you can insert a copyright notice into images by raising the action palette, selecting the Copyright Notice action, and clicking on play. Once you have done this, the copyright symbol should be displayed in the title bar above the image and a proper copyright notice is entered into the IPTC spaces of the image file.

enough that it might have influenced the Copyright Office's decision to issue a registration, such as misidentifying a photograph as an audiovisual work, you should file a supplementary registration to correct the error.

■ THE COPYRIGHT NOTICE

When the United States finally signed the Berne Convention in 1988, it was required to drop the prior formality that made copyright protection contingent on placing a copyright notice in a conspicuous place on or near a work. As of March 1, 1989, copyright owners are no longer required to use such notices to keep works from falling into the public domain. However, such notices are recommended because they will preclude infringers from raising the "innocent infringer" defense if they are sued. This defense allows a court the discretion to award as little as $200 in statutory damages if it finds that the infringer has proven that he or she had no reason to believe that his or her acts infringed the copyright.

The content requirements for a copyright notice are simple but it is critical to adhere to them. For photographs, the notice must contain the following:

1. The symbol ©, the word "Copyright," or the abbreviation "Copr."
2. The year of first publication of the work.
3. The name of the copyright owner or a recognizable abbreviation or alternative designation.

An example of a proper notice is "© 2006 Bert Krages." If the work is unpublished, the notice can be written as such "unpublished work © 2004 Bert Krages." If you are uncertain about the publication status, err on the side that the work has been published.

The U.S. Copyright Office has promulgated regulations that prescribe where the notice must be located. The general requirement is that the notice must be affixed so as to give reasonable notice of the claim of copyright.

Specific examples that are always acceptable for two-dimensional works are the front or back of the copies or on any backing, mounting, framing, or other material to which the copies are durably attached. For machine-readable works, such as digital image files, the current regulations state that the notice can be:

1. With or near the title or at the end of the work, on visually perceptible printouts.
2. At the user's terminal at sign-on.
3. On continuous display on the terminal.
4. Reproduced durably on a label securely affixed to the copies or to their permanent container.

Other than being visible as text on the image, the regulations are unclear about what other means of placing a notice are acceptable. If you want certainty, it is recommended that you use the text annotating function in almost any image editing software to place the notice on the image itself or within a border added to the image. However, a common means of embedding textual information into an image file is the protocol adopted by the International Press Telecommunications Council and the Newspaper Association of America (typically abbreviated as IPTC or IPTC-NAA), the groups responsible for developing standards for exchanging information between news operations, including information used to describe images. This standard controls how textual information is embedded into formats such as JPEG and TIFF so that it is writable and readable by commonly-used software such as Photoshop. Many digital cameras can also embed this information into files as they are created. At the present time, it is uncertain whether a copyright notice embedded as IPTC data meets the requirement of providing reasonable notice because many kinds of software used to view images cannot access the data. Nonetheless, it is a simple way to add copyright notices to images.

■ ENFORCING COPYRIGHTS

Despite the potentially harsh consequences, copyright infringement happens all the time. One reason is that many people do not respect the value of intellectual property. While few people would fail to see the point that skilled workers such as gardeners and auto mechanics deserve to be paid for their work and investment in capital, there are a lot of people who are oblivious that the same concept applies to creative artists whose work may require even greater levels of skill and investment. And although most people are capable of doing their own yard work or changing the oil in their vehicles, it never occurs to them to use this as an excuse not to pay when others do those services. In contrast, it is not unusual for someone to expect to be able to use a photograph for a pittance because they believe (usually mistakenly) that they could take a similar photograph with their own camera.

A contributory factor to these kinds of attitudes is the ease by which many kinds of intellectual property can be misappropriated. Digital technology has made it easy for just about anyone to download images off the Internet or to scan them from prints or publications. Some people are motivated by a blatant desire to avoid paying for usage and wilfully infringe when they believe they are unlikely to be caught. Other people are simply naive about how infringement can cost copyright owners their livelihood. There are even groups that advocate against copyright protection on the grounds that the transfer of information should not be inhibited by the impediment of having to pay the people that create the works by which the information is expressed.

Irrespective of the various intentions, the consequences to an infringer can be harsh because copyright

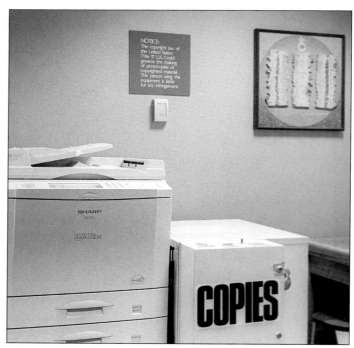

Public awareness of copyright is increasing due to prevalence of copyright warnings posted by copiers, in movie theaters, and on products such as videotapes and compact discs.

law gives the copyright owners powerful tools by which to protect their rights. At times, such owners can be downright vicious in using them. For example, recording companies have decimated companies that distributed file-sharing software that was used primarily to facilitate infringement of copyrighted music. In addition, there have been thousands of lawsuits filed against individuals who used the software to obtain digital music files without paying the copyright owners. Although these measures were taken by giant commercial interests, any copyright owner can avail themselves to the same legal remedies.

Copyright law in the United States has an interesting dichotomy in that the procedural formalities impose some technical impediments to bringing infringement actions but the substantive provisions offer the prospect of recovering large amounts of damages in appropriate cases. The most significant procedural impediments deal with registration. One such encumbrance restricts the kinds of damages that may be recovered unless images are promptly registered. When dealing with unpublished images, the images must be registered before the infringement occurs or the copyright owner cannot recover statutory damages (discussed in more detail below) or be eligible to recover the attorney fees incurred in bringing the lawsuit. Published images have a little bit more leeway in that the registration must be made either before the infringement occurs or within three months after the image is first published. Another incumbrance is that the copyright owner is required to register images made in the United States before an infringement action can be filed. This can present difficulties in situations where the statute of limitations is about to expire or when the information needed to complete the registration application is missing or has been forgotten. It is possible to expedite the registration process but the application fee for doing so is much more expensive than to obtain a registration in the ordinary course. In either case, the formalities associated with registration can make pursuing copyright remedies impractical. Of course, you can avoid these problems by habitually and promptly registering your images within a short time after their creation.

Another impediment to enforcement is that copyright infringement cases can be filed only in federal courts. Litigation in federal court is often more expensive than in state judicial systems and the courthouses are inconveniently located for many litigants. In addition, federal courts are not set up well for handling the smaller types of cases. For example, there is no federal equivalent to the small claims courts found in state courts, which makes bringing a copyright action without an attorney a serious challenge for most people.

Once the procedural formalities have been satisfied, copyright law becomes a daunting arsenal that can be used to pursue infringers. One remedy is to obtain a court order that bars an infringer from the future use, display, or sale of an infringed work. A related form of relief is the court's power to order the destruction of the infringing copies. In cases where the infringer has incurred a significant investment, such as making a large print run containing an infringed work, these remedies can be very costly. However, the remedies that the typical infringers of images tend to fear the most are the ability of courts to award damages and attorney fees to the copyright owner.

Copyright law becomes an arsenal that can be used to pursue infringers.

There are two kinds of damages that can be awarded in a copyright case. First, there are actual damages. This is the amount of income lost by the copyright owner and the profits that the infringer made that are directly attributable to the infringement and were not taken into account in computing the actual damages. Second, there are statutory damages, which need not be based on factual evidence of loss but are left to the discretion of court. As noted previously, a party can recover statutory damages only if an unpublished work was registered before the infringement occurred, or a published work was registered within three months of the date of first publication. Assuming the work was registered in time, the copyright owner is free to elect whether to recover actual or statutory damages at any time before the judgment is entered.

When photographs are infringed, the most common measure of actual damages is the fair market value of a reasonable license fee to use the photograph. For example, if the reasonable license fee to use an image on a shirt is $500 for a production run of 2500 shirts, the actual damages suffered would be $500 if an infringer used an image for this purpose. Added to this amount would be the profits from selling the shirts that can be attributed to the use of the image. In this regard, the copyright owner need

only prove the infringer's gross revenue was at least in part directly attributable to the image and the court will put the burden on the infringer to prove the deductible expenses and the elements of profit attributable to factors other than the copyrighted work. In the current example, the photographer would probably succeed in showing that the image directly contributed to the sales of the shirt and thus force the seller to prove whatever expenses it incurred in making the shirt and any other aspects of that contributed to the profit other than the image.

Some courts have allowed photographers to recover actual damages based on a multiplier factor for unauthorized uses when the evidence indicates that this is a customary practice in the industry. A multiplier of three times the normal license fee has traditionally been used in the stock photography business when unauthorized use is discovered although many agencies and photographers now use multipliers of five or ten times the normal fee. However, some courts have held that multipliers are inappropriate in actual damages cases or allow them in limited circumstances such as when the photographer's credit is omitted.

A potential problem with pursuing actual damages is that the situation does not always indicate what measure of damages is the most appropriate. For example, if a shirt manufacturer has the option of obtaining images from a royalty-free stock agency at relatively-low cost, or images from a rights-managed stock agency at a premium cost, it can be difficult to determine the appropriate level of damages when the photographer has no previous history of selling images on either a royalty-free or a rights-managed basis.

Most photographers elect for statutory damages in an infringement case.

Because actual damages can be uncertain or difficult to prove, most photographers prefer to elect for statutory damages in the typical infringement case. Courts generally approach the determination of statutory damages from the perspective that they are supposed to have a deterrent effect on infringers and therefore such awards are generally higher than is the case for actual damages. For ordinary infringements, the court may award any amount of statutory damages between $750 and $30,000 per infringed work. If the copyright owner proves that the infringer knew or reasonably should have known that the use was infringing, the court may award up to $150,000 per work. Conversely, if the infringer can prove it reasonably believed the use was not an infringement, the court has the discretion to award as little as $200 per work. It is important to understand that statutory damages are based on the number of works infringed and not the number of infringements. For example, if an infringer publishes one of your photographs in twenty different magazines, the ordinary range of damages available to be recovered will range from $750 to $30,000 because only a single work has been infringed. On the other hand, if the infringer published twenty of your images in a single magazine, the damages will range from $15,000 to $600,000 (i.e, 20 images times $750 and 20 images times $30,000) because the damages are assessed according to the number of works that have been infringed.

The attorney fees provision is very important to the effective enforcement of copyrights. By statute, copyright infringement actions must be filed in federal court where it is expensive to litigate. In many cases, the prospect of a low damages award would be a strong disincentive to pursue an infringement action but for the possibility of recovering attorney fees. Courts are not required to award attorney fees to the prevailing party but generally do so when the copyright owner wins a meritorious case. In addition to the filing costs and actual fees paid to the attorneys, courts will also order the losing party to pay most of the other costs charged by the attorneys such as postage and photocopying expenses. The notable exception is expert witness fees because a federal statute sharply limits the amount that courts may order the losing party to pay.

There are several kinds of infringement that are subject to enforcement. The most obvious are direct infringements in which the image is directly copied. A good example is someone taking a photograph and making it into a poster. Images can also be infringed by making derivative works from them. For example, many photographers have discovered that their images have been used by artists as the basis for drawings, paintings, and sculptures. When evaluating whether an infringement has occurred in a derivative work, courts look at what has been stolen and not at what has been added. For example, if an artist takes one of your landscape photographs and adds alien spacecraft to it, it still constitutes infringement

no matter how creative the additions are. Works can also be infringed vicariously, which means by a person who was not directly involved in the infringement but had the power to supervise and control the actions of another infringer. For example, the owner of a graphic design firm would normally be personally liable for infringements committed by individual employees.

Similarly, parties who are not directly involved in an infringement but encourage or facilitate infringements can be held liable as contributory infringers. An example would be a website that encourages its members to post or share images in violation of the owners' copyrights.

If you discover that an image has been infringed, there are several approaches you can take to get the infringer to stop using the image and compensate you for the previous usage. If the infringement is substantial (i.e., worth a lot a money) you will probably be better off immediately referring the matter to an attorney with experience handling copyright matters irrespective of your experience in collecting from infringers. Some photographers prefer to have attorneys handle even their routine infringement matters because they are not confident about their abilities to negotiate a reasonable settlement. However, there are many photographers who are comfortable about approaching infringers and attempting to resolve the matter without using an attorney.

Unless you are absolutely certain that the image is being used without permission, the first step should be to send a letter asking the potential infringer to explain how they obtained the image and whether they have permission to use it. This approach is particularly prudent for professionals who sell a lot of stock photography, either directly or through agencies, because it can be embarrassing to send an accusatory letter to someone who has appropriately licensed the image. A premature demand letter can be particularly problematic if it questions the ethics of the recipient or demands a payment that is less than the licensing fee actually paid by the party.

If you are satisfied that the use is unauthorized, sending a demand letter is appropriate. Effective demand letters will generally be mature, professional, and confident in tone. The letter should identify the image, the known usage, and request an appropriate amount of compensation. If the image has been registered with the U.S. Copyright Office, be sure to state this in the letter and provide the registration number. If you are unsure of what the usage is worth, there are several sources of stock photography prices available in the form of books, software, and Internet sites. There are also consultants who will work on a fee basis to provide an opinion on what a particular usage is worth. Many photographers will request compensation at several times the normal usage fee when the usage was unauthorized. More information about multiplier factors can be found in the next chapter. Factors commonly used in the industry range between three and ten times the normal fee for authorized use. The benefit to using a higher multiplier is that the damage amount is larger but it is often easier to collect for an unauthorized use without resorting to litigation is a smaller multiplier is used.

Send a letter asking the potential infringer how they obtained the image.

If the infringed image is being used on a website, you have the right under the Digital Millennium Copyright Act to request that the Internet service provider that hosts the website to either remove the image or block access to it. Under the Act, the service provider is protected against copyright liability if they promptly block access after receiving a notification from a copyright owner. The identity of the service provider can be found by conducting a WHOIS search of the domain name at a website such as www.dnsstuff.com. Specific information on how to make the request can usually be found on the service provider's website.

Infringers tend to respond to demand letters in different ways. If you are dealing with a sophisticated or decent person, they may very well agree to pay the fair value of the usage. In some cases, the infringement can actually lead into a sustained business relationship if the photographer is not too heavy-handed in the initial communications. On the other hand, it is not that uncommon for the infringer to fail to respond altogether. These types usually hope that you will go away if they ignore you. However, once you establish that you are serious (perhaps through a letter written by your attorney) they frequently claim they were merely waiting to complete their investigation before responding (your attorney may have doubts).

Many infringers will express surprise that they were doing anything wrong, or believe that as long as they

SAMPLE DEMAND LETTER

Stella Appropriation
Brilliant Green Bile Enterprises
2 Duct Lane
Coliform, OH

Re: Copyright Infringement Matter

Dear Ms. Appropriation:

I am writing about the image of the rotting oyster that appears on the home page of your corporate website under the file name of rottenoyster.jpg and that has also been used on a promotional tee-shirt sold by your company. This image was taken by me in January 2002 and is being used without my permission. I wish to emphasize that I am a professional photographer who expects to be compensated for the use of my images. Furthermore, copyright infringement is treated as a serious matter under federal law.

This image is registered with the U.S. Copyright Office under Certificate No. VAu-530-172. Because the image was registered with the U.S. Copyright Office prior to the infringement, I am entitled to recover statutory damages and am eligible to recover my attorney fees should I have to file an action in a federal court. The federal courts have a history of awarding significant statutory damages in copyright cases involving photographs. The damages that may be assessed for ordinary acts of infringement range from $750 to $30,000 per photograph and can go as high as $150,000 if the infringement is shown to be willful.

I am requesting that you discontinue use of the image until you have paid the licensing fees for the past use, with the customary multiplier and have agreed to a license for any future use you may want to make. The normal fee for past use, had you sought a license prior to using the images, would have been $1,950 per year for the website usage and $1,500 for the tee-shirt usage. Because I routinely use a multiplier factor of 5x to account for liquidated damages for unauthorized use, the total amount needed to resolve past usage will be $17,250.00. The fee for future use will depend on the nature and duration of your intended uses.

Federal law also provides copyright owners who discover infringing material on a website with the right to notify the Internet service provider and demand the removal or blocking of that material. Most providers comply with such notices because doing so will exempt them from liability to the copyright owner. If you are unwilling to negotiate an appropriate license fee for future use, I will be requesting that your Internet service provider block access to the infringed image on your website.

If you do not contact me within one week of the date this letter is mailed to discuss resolution of this matter, I will be turning this matter over to my intellectual property attorney and all future discussions will thereafter be conducted through him. Thank you for your consideration and please let me know if you have any questions.

Sincerely,

N. A. Flash

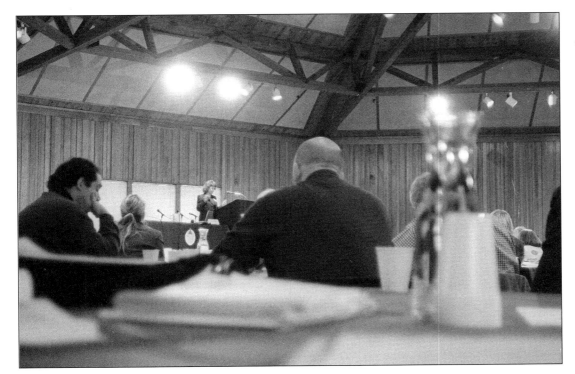

Intellectual property litigation is a complex and rapidly changing area of the law. Most attorneys who handle intellectual property cases are specialists that follow developments in the law, as are these attorneys at a continuing education seminar.

agree to stop using the image, they are off the hook for damages. Some will offer to pay a minimal amount but refuse to seriously consider paying the fair value of their usage. In many cases, the infringer will be genuinely shocked at the stated fair value of the image and will say something to the effect that they would have never stolen the image if they had known its value ahead of time. Such discussions typically proceed with proclamations that their use was trivial or caused no damage. When the copyright owner persists in seeking compensation, these discussions often deteriorate into pitiful appeals for mercy.

Sometimes infringers will be antagonistic in an attempt to persuade you to leave them alone. Claims of fair use are routine even in the face of clearly commercial use. Common claims include that the copy they infringed did not bear a copyright notice or that the copyright owner is to blame for not making the image more difficult to misappropriate. Infringers who use works as the basis for a derivative work frequently claim that their version is a "new original" or a transformative work and make frivolous arguments that they are free of your copyright. Probably the most offensive are the infringers who assert that your work is lousy or claim that they could have taken the photographs themselves. None of the issues diminish your substantive right to recovery and should not factor into your decision regarding how you will resolve the matter. The best way to deal with these contentions is usually to state that you disagree and to be persistent in seeking recovery.

How you handle the negotiations after first contact is up to you. Some photographers stick to their settlement demand irrespective of the response but some are willing to accept less than the offered amount if they feel the infringer is genuinely contrite. Do not expect that the matter will necessarily be resolved with a single round of correspondence. Infringers often request that you send a copy of the registration certificate or otherwise explain your ownership. Such requests are generally reasonable when you are asking for a substantial amount of compensation. At some point, the parties may reach an amount for which they are willing to settle the matter, even if grudgingly. If a settlement is reached, then draft a settlement agreement that specifies the amount of compensation, the payment schedule, and whether future use is authorized under the agreement.

If you cannot resolve the dispute despite a good-faith attempt, it will need to be resolved in the context of a lawsuit. Even when a lawsuit is filed, most copyright matters settle without a trial because the parties want to avoid the expense, risk, effort, and, at times, the frustration, associated with trying a matter in the federal court system. Many photographers have read about copyright cases in which photographers have been awarded large amounts of money against infringers. Such cases do happen and

reflect the high value that some judges and juries have accorded to intellectual property. However, it is also important to understand that copyright litigation is permeated with nuances that can unexpectedly derail a seemingly solid case. In addition, judges sometimes make implausible rulings that are not well supported by the copyright statutes. Similarly, not every judge or jury appreciates the value of intellectual property and there have been many plaintiffs who have been sorely disappointed by triers of fact who did not comprehend the serious nature of an infringement. Before a photographer commences a copyright action, he or she should understand that it usually takes far more than filing a complaint to see any money.

> It usually takes far more than filing a complaint to see any money.

In the event you do become the plaintiff in a lawsuit, keep in mind the need for patience as the matter winds itself through the court system. The defendant will likely have a month or more to file an answer and several more months will lapse as the parties and the court determine the schedule for hearings, discovery, and trial.

Most federal courts require the parties to participate in some sort of alternative dispute resolution process such as mediation or a settlement conference. You will likely have to respond to the defendant's discovery requests which may entail making copies of business documents and attending a deposition where the defendant's attorney will question you about the matter.

In most federal districts, it will likely be a year or more before your case goes to trial. In the event that you win a large judgment, or if the judge makes a legal error that seriously hurts your case, you may even have to go through the appeals process which will likely take at least another year to resolve. Finally, obtaining a judgment is no guarantee that the defendant will have the money to pay it.

In summary, lawsuits can be grueling experiences so it is important not to file a case without understanding the associated risks. On the other hand, it can be a rewarding experience to have a court vindicate your intellectual property rights and high awards are distinctly possible in appropriate cases.

■ TAKING CARE OF YOUR PROPERTY

Most property requires some level of maintenance and intellectual property is no different. The three issues associated with copyright are the term of the copyright, its role in your estate planning, and maximizing your opportunities to pursue infringers. The positive side with respect to copyrights is that they do not require very much work to maintain their effectiveness. The down side is that failing to give your copyrights adequate attention can render them nearly worthless when you need them the most.

There is very little that needs to be done to ensure copyright protection for works created after 1977 because there are no requirements to register works or apply for a renewal term as a condition of copyright protection. For these works, copyrights owned by natural persons will last for the life of the author plus an additional seventy years. In the event that a work was created for hire (or anonymously or pseudonymously), the duration of the copyright depends and the creation and publication date. The copyright will last for either 95 years from the year of its first publication, or for 120 years from the year of its creation, whichever expires first. However, the life plus seventy years rule will apply if the identity of one or more of the authors of an anonymous or pseudonymous work is revealed in a registration filed with the U.S. Copyright Office during the term of the copyright.

The practical implication for most photographers is the different terms for works owned by the photographer or owned by the person hiring the photographer. For example, photographers who have incorporated their photography businesses have the option of owning the copyright personally or having the business entity own it. Whether one form is advantageous depends on the individual circumstances of the photographer.

Another aspect of copyrights is that they are inheritable. A discussion of estate planning is outside the scope of this book but many photographers will want to take measures to ensure that their works are appropriately handled after their death. Among the issues that pertain to copyrights are whether and how the photographer devises the various rights such as the right to publication, display, and licensing. For example, a photographer may want to donate certain images to a museum pursuant to specific conditions or may want to ensure that his or collection is licensed by a competent agency. In addition to controlling the disposition of his or her works, a photographer's

estate plan can reduce the amount of estate tax paid at death. Because valuations of photographic works are a specialized area, estate taxes may be end up being significantly underestimated unless the estate planner is made aware of the value of the works prior to preparing a will or trust.

Insurance is another area to consider in taking care of your intellectual property. Persons who face significant risks with respect to intellectual property should consider obtaining insurance coverage specifically intended for intellectual property. Most general comprehensive liability (GCL) policies for businesses have a provision for advertising injury which encompasses copyright infringements when the infringement occurs in the course of advertising. Although insurance companies tend to initially deny infringement claims under such provisions, they often grant coverage when pressed to do so after the initial denial of coverage. Another kind of policy specifically provides for infringement defense coverage and usually pays for the defense costs associated with being sued for infringement. Unless added onto the policy, damage awards or settlement amounts are not usually covered.

Photographers who want to ensure being able to pursue infringers may want to consider obtaining enforcement insurance which helps to cover the cost of enforcing intellectual property rights. This kind of insurance typically applies to infringements that arise during the term of coverage and requires that some of the recovery be shared with the insurer. When evaluating an insurance policy, you need to check whether claims are made on a "claims made" or "occurrence" basis. With occurrence policies, all claims are covered if the event giving rise to the claim occurred during the term of the policy. In other words, coverage does not depend on when the claim is made. If the policy is a "claims made" policy, it will not cover claims that are made against you after the term of the policy expires. "Claims made" policies tend to offer poor protection because many claims are not asserted until well after the term of coverage has expired.

■ PATENTS

As stated previously in this chapter, copyright law does not protect against others using your ideas. This means that if you manage to come up with a unique and undiscovered way to photograph babies so they appear suspended in mid-air against a black background, copyright

Patent law can give more effective protection than copyright under some circumstances. Copyright law protects only design on this bag but patent law protects the concept of using a plastic garbage bag filled with leaves to emulate a Jack O'Lantern.

law will not prevent other people from using your method. However, patent law might. The key elements to patentability are that the invention must be novel and not obvious. Novelty means that no one else has come up with the invention before you did. Under federal law, an invention cannot be patented if it was known or used by others in the United States, or patented or described in a printed publication in any country before the invention by the patent applicant. In addition, the invention must not have been in public use or on sale in the United States for more than one year prior to the filing of the patent application. Obviousness means that a person having ordinary skill in the relevant field would know how to solve the problem at which the invention is directed by using exactly the same method or device.

The scope of a patent is evaluated by the claims which are a concise written description of the elements constituting the patentable part of the invention. To constitute infringement, each of the elements must be present in the allegedly infringing method or device. Federal law defines infringement as making, using, or selling any patented invention, within the United States during the term of the patent without the permission of the patent owner. Like copyrights, lawsuits to enforce patents must be filed in federal court. Unlike copyrights, there are no statutory damages and attorney fees can be awarded only if the infringement was proven to be willful. Damages in patent

Just because an invention is patentable does not mean that it is economically worth obtaining a patent. With the ascendency of digital photography, a daylight developing tank for sheet film (especially one that requires almost a liter of developer for two sheets) is of dubious economic viability.

cases are generally recovered as a royalty based on the usage or in some cases the profits the infringer made from using the invention.

Obtaining a patent is a complex process that requires filing an application with the U.S. Patent and Trademark Office (USPTO) and establishing your entitlement to be issued a patent. Once a patent has been issued, it can be enforced to prevent others from using the invention. You can license patent rights in a manner analogous to copyrights. A patent will ordinarily last for a term consisting of twenty years after the date the application was filed.

If you believe that you have a patentable invention, usually the first step is to have a patent search performed to ensure that someone else has not invented the matter before you or that your invention is not an obvious extension of the prior art. The next step is to prepare and submit a patent application to the USPTO. Patent applications can be difficult to prepare and are subject to numerous legal requirements and therefore are usually prepared by a patent attorney or agent. After the application is submitted, it will be examined by the USPTO and ordinarily some response or amendments will be required before the patent is deemed ready to issue. The process can be quite expensive and typically takes two to five years. Once the USPTO issues the notice of allowance, the patent owner must pay an issuance fee and thereafter pay periodic maintenance fees.

An important consideration is deciding whether or not to seek a patent is the prospect for benefitting economically. Just because an invention is patentable does not mean that it is economically viable. In fact, a high percentage of patent owners never recoup the money they spend in obtaining their patents. Another consideration is how the invention will be brought to market. While there are companies that will license patents from owners who do not have the capital or willingness to personally manufacture and market their inventions, it can be very difficult to get their attention and even more difficult to reach a licensing deal. Some other factors to consider when considering whether a patent is worth pursuing are whether the field of the invention is expanding, the cost and functionality of the competing products, and the likely price and demand for the invention. For example, an inventor who has figured out a way to manufacture a low-noise multi-megapixel digital camera sensor for under ten dollars has much better commercial prospects than someone who has invented a tank costing the same amount that enables a more convenient way to process a couple of sheets of large-format film.

■ TRADEMARKS

A trademark is a word, phrase, symbol or design that identifies and distinguishes the goods of the trademark owner from those of others. Examples of trademarks are brand names such as a Kodak, symbols such as a red dot on a camera, or a specific design such as the pattern of green, blue, and white on a film box. Trademarks help to establish a market identity for your goods and services and are valuable when you want to distinguish your business from that of your competitors. Trademarks can effect this identity in a number of ways including the name of your services, the look and feel of your website, and the way that you package products for your customers. If someone violates your trademark, you have the legal right to order them to stop and in some cases to recover damages.

A trademark is generally established through actual use in the marketplace, although it is possible to register a

mark when there is a legitimate expectation that it will be used in commerce in the near future. The main requirement for a trademark is that it have a distinctive character. There are different degrees of distinctiveness and the extent of protection will depend on how a particular mark is classified. Fanciful trademarks are considered the strongest marks and consist of entirely invented expressions. One of the most commonly cited examples is "Kodak" which is a word that was unknown before its use as a trademark. The next level is comprised of arbitrary trademarks which are common words used in a meaningless context (such as Fuji when used for photographic equipment). After that are suggestive trademarks which comprise descriptions that evoke the character of the goods or services but do not describe them completely. A example would be Blitz strobe units. Descriptive marks are the weakest trademarks and are terms commonly understood to relate to goods or services in ways that directly describe their characteristics. An example would be "Photo Net" when used in connection with a web site about photography. Finally, generic terms do not receive any legal protection as trademarks. For example, the word "photo" when used to describe film could not be defended as a trademark.

Trademarks do not need to be registered to be legally protectable but registration can greatly enhance your ability to protect a trademark. For example, registering a trademark provides legal notice to the public of your claim to the mark and creates a presumption that you have the exclusive right to use the mark in connection with your goods or services listed in the registration. Trademarks can be registered at the state and federal level depending on the geographic scope of usage. If the products or serv-

The strongest marks consist of entirely invented expressions.

ices are available in more than one state, you can register the mark with the USPTO in which case the registration entitles you to file lawsuits concerning the mark in federal court and to use the registration as a basis to obtain registration in foreign countries. While anyone can use the trademark symbols TM and SM in connection with their goods and service, the ® symbol may only be used for goods and services that have been registered with the USPTO.

PUBLISHING

The law associated with publishing photographs is more fully developed than the law associated with taking them because the media industry attracts more attention and has deeper pockets than most photographers. When it comes to publication issues, photographers tend to mostly be concerned about not violating the rights of the subjects they photograph and ensuring that publishers treat them with an appropriate degree of commercial respect. To avoid liability, it is important to understand how the law balances the rights of individuals against the rights of the public to be informed about matters in which they have a legitimate interest. To avoid being taken advantage of, it is important to understand the common business practices associated with publishing images and how to establish your rights when drafting terms and conditions.

In defamation law, publication means to communicate a false statement.

Publication is a broad term that generally encompasses all means of distributing reproductions of photographs. Photographs are published by means such as reproducing them in printed media, posting on websites, displaying in exhibitions, and showing prints to friends. While "publication" has a commonly-understood meaning, when used in a legal sense it can have different meanings depending on the context. For example, publication in the context of copyright law means the distribution of copies by sale, rental, lending, or other transfer of ownership. In the context of defamation law, publication means to communicate a false statement about a person to another person (or in legal prose: "to convey by some means to the mind of

another the defamatory sense embodied in the vehicle"). In most cases, the meaning of publication is easily understood but is important to understand that the term does not always mean the same thing.

When evaluating liability for published images, it is important to distinguish between the difference between the roles of a photographer and a publisher. The photographer is the creator of the content and is generally not liable for the harm associated with the dissemination of the content. Unless the actual act of photographing a particular subject violates a law or someone's right, or unless the photographer knows beforehand that a publisher intends to violate a law or someone's rights, a photographer is generally not liable for the acts of the publisher in disseminating an image. For example, a photographer who takes a photograph of a famous actress eating spaghetti at an outdoor café has not violated any laws because it is lawful to photograph people who are visible in public places. Nonetheless, a pasta manufacturer who uses the image without the permission of the actress to advertise its products would be liable for violating her right to control how her identity is used to market products. If the photographer licensed the image through a stock agency and had no reason to know how it would be used, he would not be liable to the actress although the pasta manufacturer would be. However, if the pasta manufacturer hired the photographer to photograph the famous actress eating spaghetti, and the photographer knew that the image was intended to be used in an advertisement, he could be liable as a joint tortfeasor.

■ THE PRIVACY TORTS
One of the most commonly used distinctions in describing the legalities associated with publishing images is that

between "commercial" and "editorial use." Although this distinction is supposed to help photographers and publishers determine when they need permission from the persons depicted in an image before they can publish them, it is mostly a lay description and not well rooted in the law. The problem with distinguishing between "commercial" and "editorial" uses is that the terms tend to be ambiguous and are often misunderstood. An editorial use is intended to provide information whereas a commercial use tends to assert sponsorship of a product or appropriate someone's reputation as the basis of a product. However, there are many commercial enterprises that make huge amounts of money by publishing images that provide information and there are many charities that use images to endorse humanitarian causes. Neither the amount of money involved nor the social worthiness of the usage determine whether a use is commercial or editorial. A better way to assess whether permission to pub-

lish an image is needed is to evaluate whether the proposed usage will violate one of the four privacy torts.

The privacy torts consist of (1) intrusion upon seclusion, (2) appropriation of name or likeness (and the closely related right to publicity), (3) publicity given to private life, and (4) placing a person in false light. The privacy right that has the most relevance to the taking of photographs is the intrusion upon seclusion tort since photographers can be liable for intentionally intruding on a person's private affairs irrespective of whether the photographs are published. That tort is explained in chapter 3 and does not require exposition in this chapter except to note that publishing a photograph made in violation of a person's legally-protectable privacy will increase the exposure to damages. The other three privacy torts require that a photograph be published to be actionable. Although these torts are generally recognized throughout the United States, there are substantial variations in how

Animals do not have privacy rights and therefore the owner has no legal claim against someone publishing an image of their animal so long as it does not imply an endorsement by the owner.

they are applied among the individual states. In risky situations, it is wise to obtain a legal opinion before publishing images that raise significant privacy issues.

■ MISAPPROPRIATION OF LIKENESS AND THE RIGHT TO PUBLICITY

Appropriation of name or likeness is the tort that most photographers are concerned about when images are published. The tort is also called the right to publicity. It basically addresses the right of an individual to choose whether or not to endorse a product or activity and also has been extended to the right to encompass the use of a person's identity on a commercial product without per-

mission to do so. Examples of the kinds of products that are subject to right to publicity claims are trading cards and tee-shirts in which the person's likeness is the primary adornment. In many respects, the tort treats a person's reputation as a property right and provides a remedy for the theft of a person's goodwill. This particular right was first developed as a common law doctrine in a few courts and has been adopted in a statutory form by legislatures in more than half of the states. Although the right was first created to protect famous celebrities, it is not necessarily restricted to such persons. Because there are variations among the states, and because the case law interpreting this potentially-broad right is variable and somewhat

limited, the line between permissible and impermissible uses of images can be difficult to discern.

The most common situation is the unauthorized use of an image of a person in an advertisement to promote a product or enterprise. This is why advertisers usually require model releases when identifiable people are portrayed in advertisements. The basic elements of the tort are that a defendant must have (1) used the plaintiff's name or likeness, (2) for the defendant's own purposes or benefit, (3) the plaintiff suffered damages, and (4) the defendant's conduct caused the damages. Generally, this tort does not apply when a person's name or picture is used to illustrate newsworthy material nor does it apply when the use of a person's name or likeness is merely incidental. For example, using an unauthorized photograph of a celebrity to illustrate a magazine article would not be considered an appropriation of identity since no endorsement of a product or service is implied. Likewise, some courts have held that showing a person engaged in an activity as a promotional trailer for a televised news feature about that activity does not constitute misappropriation even if that person is not depicted in the feature because the use is considered incidental.

Keep in mind that liability depends on the purpose of the use and not on the nature of the media. For example, distributing a free calendar that contains an unauthorized photograph of a mother and her baby would likely constitute the tort of misappropriation of likeness if the purpose of the calendar was to promote the goodwill of a company or advertise its products. However, selling the same

Liability for violating a person's right to publicity can depend on many factors including the person depicted and the nature of the use. Mass marketing of unauthorized posters of Elvis Presley could get you into big trouble but publishing a photograph of a local bluegrass band performing at a bookstore will not.

calendar would not likely constitute misappropriation of likeness if there is no intent to promote or advertise a product, service, or company.

However, this tort must be balanced against countervailing interests such as the right to free expression and freedom of the press. Although the basic form of the tort is reasonably well understood, states vary substantially in how they apply the tort. In addition, the boundaries are not always clear as to what kinds of publication do or do not violate an individual's rights.

A key issue when balancing the right to publicity against the First Amendment is whether the public's interest in information about celebrities or an artist's interest in expression will outweigh a celebrity's interest in being able to market their likenesses for profit. For example, courts have made several rulings against the manufacturers of tee-shirts, trading cards, and posters for using celebrity images on products in ways that did not have a newsworthy value. Conversely, courts have sometimes given great deference to uses that had some albeit minor news value. For example, one court ruled that a poster of the football player Joe Montana distributed by a newspaper after a major game did not violate his right to publicity because it was newsworthy. Another court ruled that an art print showing the golfer Tiger Woods in several poses at the Augusta National Golf Club did not violate his right to publicity because it portrayed an historic event in which Woods had participated.

Works that make social commentary are more likely to be protected.

The issues that the courts have grappled with in cases involving products is whether the artist had a goal or artistic message apart from merely representing the celebrity. Works that make social commentary or that depict a person in a nonrealistic style are more likely to be protected by the First Amendment.

In the context of photographic prints, a realistic image of a celebrity will likely be found to be unprotected if the court believes the dominant intent to capitalize on the celebrity status of a specific individual. However, given the current state of the law, the only certain aspect of right-to-publicity law in the product context is that it is muddled and poses uncertain risks.

States differ in whether plaintiffs are required to prove that their identities had commercial value prior to the association with the advertisement or the product as a critical element of a claim for misappropriation of likeness or right to publicity. In some states, the failure to show prior fame or other measure of commercial value will be grounds for dismissing a case. In other states, damages can be recovered for the mental anguish associated with the misappropriation and plaintiffs do not need to show that an economic injury was associated with the commercial exploitation.

■ PUBLICITY GIVEN TO PRIVATE LIFE

Under the tort of publicity given to private life, one can be held liable for widely publicizing the private affairs of a person that are not of legitimate concern to the public. Publicity, as the term is used in this tort, means the widespread dissemination of information so that it will likely become public knowledge. Showing an intimate photograph of another person to a few people would not be considered publicity given to private life, although publishing it in a newspaper or posting it on the Internet would be. The interests protected by this tort are limited to matters that the subject would reasonably expect to be kept from public view and the tort does not protect against publicity given to matters of legitimate public concern. This means that persons who become newsworthy by assuming a prominent social role or becoming enmeshed in newsworthy events may lose their right to privacy to the extent that their private affairs are relevant to legitimate news coverage.

A key element of this tort is that the content must be of a type that would be highly offensive to a reasonable person if disclosed. In one case, a couple consented to be photographed by a friend while showering together. The photographs were developed at a photo lab operated by a large discount retailer where some of the prints were appropriated by the employees and circulated in the couple's community. Even though the couple had given their friend permission to photograph them nude, the retailer and the employees were liable for revealing the photographs to the public. Something that is merely embarrassing will not suffice if it is not the kind of conduct that most people would consider genuinely private. For example, the fact that a person considers a photograph to be unflattering would not suffice to establish that their rights

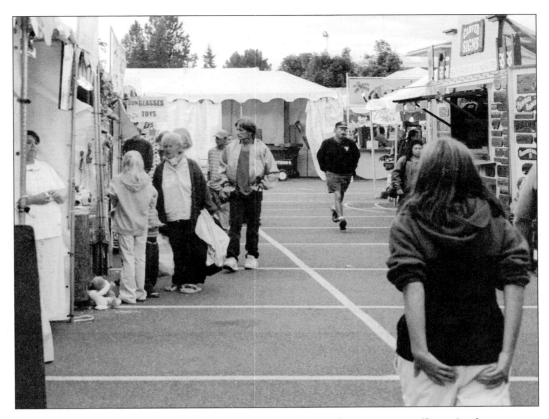

have been violated. Likewise, the activity must be one that the subject considers private. Publishing a photograph of the exterior of someone's house and describing it as "a bit weather-worn and unkempt" would not violate the owner's privacy rights if the house were open to public view and the property was in need of repairs.

■ FALSE LIGHT

A person can commit a tort by deliberately depicting another person in a false way that would be highly objectionable to a reasonable person. To be actionable, the person must either know or recklessly disregard that the facts that are being represented or implied are probably false. A key element of the tort is that the defendant must know or seriously suspect that the representations are untrue or misleading. Because photographs usually record straightforward depictions, liability in cases involving photographs usually occurs in contexts where the photographs are used to illustrate text in a way that falsely and offensively depicts the persons appearing in the photographs. For example, assume that a newspaper editor instructs a photojournalist to go out and photograph teenage prostitutes to illustrate a forthcoming feature on teen prostitution. After driving around the community, the photographer sees and photographs a man stopping his car next to

a street corner and picking up a racily-attired teenager. There is nothing unlawful about using the photograph to illustrate the feature article if the man is in fact picking up a prostitute since this would be an accurate portrayal. However, if the man is picking up his daughter after a rehearsal for a high-school play, the newspaper and the photographer risk being liable because portraying them as engaged in prostitution would be false and highly offensive. Whether they would actually be found liable would depend on the reasonableness of their assumption that the girl was a prostitute. Among the factors a jury might consider are the location, time of day, and other circumstances connected to the photograph. If the photograph were taken on a street known for the solicitation of prostitutes, a jury might well find the assumption was reasonable. If taken in front of a high school in a neighborhood with no history of prostitution, the newspaper and photographer are at serious risk of being held liable.

Photographs can portray somebody in a false light by falsely depicting them in an disreputable or highly-objectionable activity. Altering a photograph, such as by placing a person's head on a nude body to imply that they posed nude, will constitute a tort when it falsely depicts someone in an offensive or objectionable manner. Publishers can also be liable if they use someone's likenesses

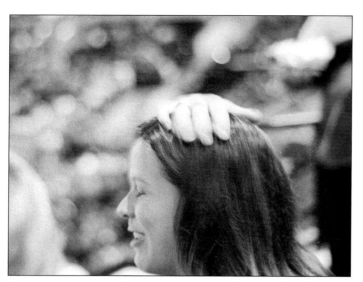

States vary in how they treat the use of photographs of generic subjects to illustrate text involving sensitive subject matter. A publisher could face liability if it used a photograph such as this one in the context of illustrating an article about a disreputable activity to which the person depicted had no connection.

to illustrate books or articles in a fictionalized and objectionable way. For example, broadcasting a videotape of a woman standing on a street in conjunction with narration about a potential treatment for herpes would create a valid false light claim if viewers inferred that the woman has herpes.

States vary in the manner in which they apply the false light tort in situations where images are used. For example, some jurisdictions such as New York, refuse to apply the false light tort when the photographs bear a real relationship to the written work they illustrate and the written work is not an advertisement in disguise. In one case, New York's highest court held that a teenage girl did not have a cause of action when a magazine used photographs depicting her in distraught poses to illustrate a letter written by another girl seeking advice after getting drunk and having sex with three young men. In many states, the boundaries of the tort have not been well established by judicial opinions. Several states do not recognize the tort at all on the grounds that aggrieved persons should pursue remedies under the law of defamation.

Courts generally have not held publishers liable for depicting incidental bystanders in scenes even if viewers might infer something negative by their presence. For example, publishing an image that incidentally shows an interpreter standing in an unemployment line while help-

ing her client pick up a check would not incur liability if the photograph truthful depicted her presence and the associated article was newsworthy. However, nonincidental uses can expose a publisher to liability when they implicitly depict a person in a false light. For example, publishing a photograph of an actor on the cover of a sexually-explicit magazine would not by itself be grounds for liability because actors do not have the right to control editorial uses of their images. However, if the headline on the cover suggests that nude images of the actor can be found inside the magazine, the publisher could be liable for placing the actor in a false light by implying that he poses nude for such magazines when he actually does not.

■ DEFAMATION

Defamation is the damaging of a person's reputation by publishing a statement that was known or should have been known to be false. Publication when used in the context of defamation law means that the statement was made to someone other than the subject of the statement. The torts of placing a person in a false light and defamation are closely related and the primary differences between them is that the latter vindicates the damage to a person's reputation and where the former tort addresses the mental anguish caused by the false publication. As is the case with false light, liability in most defamation cases arises from how the photographs are used in association with a printed work. For example, a drug company was found liable for using a fictitious biography and photograph of a woman in a brochure advertising an AIDS drug. The company's brochure described the woman as an unmarried 19-year-old, and suggested that she had contracted AIDS and herpes through sexual promiscuity. In fact she was a suburban housewife in her mid-30s who did not have herpes and had contracted HIV from her husband. The brochure did not use the woman's real name but she could be identified by the photograph.

It is possible for a photograph to be defamatory by itself. For example, a court ruled in a 1930s case that a jockey could sue for defamation after a photograph of him was published in which the girth on a saddle he was carrying created the impression that he was exposing a huge and deformed endowment. The court held that the image was defamatory because it depicted a man of stature and dignity as a fool. Although more recent defamation cases suggest that literal depictions such as this one are far less

likely to be actionable, photographs that subject people to extreme ridicule by demeaning their character may still run the risk of exposing publishers and photographers to defamation claims. Needless to say, the widespread availability of image editing software has increased the potential to create untruthful and defamatory photographs.

In cases where the parties alleging defamation are public figures, they must prove that the defendants knew that the statements were false or were made with reckless disregard of their truth or falsity (i.e., with malice). A person is considered to be a public figure when their stature is such as to invite public scrutiny entirely apart from the scrutiny occasioned by a particular controversy. Celebrities and politicians certainly qualify as public figures but people can become "involuntary public figures" as the result of widespread publicity given to events such as high-notoriety crimes. More often, a person can become a "limited public figure" by engaging in actions which cause them publicity within a narrow field of interest. In such cases, they are required to prove malice if the defamatory statement falls within the scope of the field of interest at issue.

Because of the importance of information to society, there are exceptions to liability that are called privileges. One such privilege exempts anyone from liability for defamation for statements made in the course of a legislative or judicial proceeding. For example, one is protected against liability for defamation when the image is presented in court or at a legislative session as an exhibit. Another privilege protects good faith statements made by a person with a significant interest in the subject matter provided that such statements are not made with malice. For instance, a photographer who gives copies of photographs of a riot scene to the police would not be responsible to the innocent bystanders depicted in the images provided he did not intend to falsely represent them as rioters. In addition, many states recognize a neutral reportage privilege in which statements made in the course of journalism are protected if they contain accurate and disinterested reporting of the information contained in the record, even if the record itself contains false information.

■ LICENSING PHOTOGRAPHS

The commercial media have a huge need for images, and despite the large number of photographers that supply them, many buyers routinely have difficulty finding images that meet their particular needs. This does not mean that photography is an easy business; in fact, it can be very competitive. Nonetheless, any photographer who is interested in professional photography on either a full time or part time basis should realize that commercial-quality images are valuable intellectual property and understand that it is the creative talent that usually has the superior bargaining power when it comes to licensing images to publishers who are interested in using them. This book is not intended to address the business aspects of professional photography. However, it is worth noting that the photographers who are able to say no when prospective customers want images at cut-rate prices are also the ones who are able to sustain a comfortable standard of living.

■ LICENSING OPTIONS

Photographs are licensed on either an assignment or a stock basis. Assignment photography consists of being hired by a specific customer to photograph a specific subject. The general practice in assignment photography is that the photographer is compensated based on a day rate and the expenses incurred, retains the copyright to the images, and is able to market them to other users after giving the customer the first right of publication. Stock photography consists of licensing the use of existing images to customers and is sold under either a "rights managed" or a "royalty free" model of compensation. Under the rights-managed approach, the license fee is based on the nature and length of the usage. For example, the license for an advertising use in a magazine with a circulation of 500,000 copies per issue will generally be

> Photographs are licensed on either an assignment or a stock basis.

priced higher than an editorial use in the same magazine or for an advertising use in a magazine with a significantly smaller circulation. Under the "royalty-free" approach, the photographs are licensed for a flat fee irrespective of the type of use or its duration.

There are proponents and opponents of both systems and the debate between them has become quite heated. Many people are concerned that royalty-free pricing strategies may have caused the overall revenues in the

stock industry to decline. There are some people who believe that the contentiousness is not rooted in the nature of the business model but rather the effect that royalty-free images have had on the overall perception of the value of images on the part of buyers. While many photographers and agencies have suffered declines in revenues as royalty-free licensing becomes more popular, it is unclear what role that factors such as the increasing dominance of digital photography and the advent of the Internet have played in the abundance of images being sold for stock. However, it does appear that this is an area of rapidly evolving economics. For example, royalty-free providers seem to be moving away from licensing based on subscriptions which allow buyers to download a large number of images over specific periods toward charging for single images at fixed prices. As the pricing strategies in the royalty-free market adjust to reflect economic sustainability, it is possible that the controversy over how best to market images will subside.

The royalty-free model tends to be oriented toward smaller publishers.

The royalty-free model tends to be oriented toward smaller publishers who need inexpensive generic-type images to illustrate publications such as newsletters, business cards, and websites. However, buyers for large media users are perfectly willing to license images on a royalty-free basis when they are suited to a particular application. Being successful at licensing on a royalty-free basis generally requires a large library of images that have a broad appeal. Just about all royalty-free images are sold via a website or CD disc which means that a photographer must set up a website or be able to distribute discs into commerce. One of the benefits of licensing on a royalty-free basis is that the photographer avoids having to determine a license fee for every prospective customer. The downside is that the photographer receives the same license fee irrespective of the nature of the use.

Images that involve specialized subject matter are often better marketed on a rights-managed basis because the smaller number of potential publishers means that licensing such images is unlikely to bring an adequate economic return unless licensed at fees that reflect the nature of the usage. Another aspect of rights-managed licensing is

that the photographer retains more control over how the image is used. This can be important when gaining access to subject matter depends on the images not being used in ways that offend or disparage the persons or entities who provide the access.

■ TERMS AND CONDITIONS

Irrespective of whether photographs are licensed on an assignment or stock basis, it is important to negotiate a legal agreement with the customer either before the images are created (in the case of assignment photography) or before they are given to the customer (in the case of stock photography).

The prevailing industry practice is that the legal aspects of a licensing deal are described in a document referred to as terms and conditions. Some photographers choose to include their terms and conditions in the form of a delivery memorandum that accompanies the images and some provide them with the invoice. However, the better practice is to provide them prior to delivery or invoicing to avoid situations where a client raises a disagreement after receipt or publication. For example, many photographers attach terms and conditions whenever they quote a price for a particular usage. Another problem with using delivery memoranda as the sole vehicle to express terms and conditions is that an assignment contract may contain a clause that precludes either party from later claiming that there were contract terms in addition to those stated in the written agreement. Such "integration" clauses can prevent the photographer from enforcing terms and conditions unless they are incorporated into or explicitly referenced by the contract.

Sometimes prospective licensees will try to negotiate terms and conditions, or even insist that the licensing agreement will be governed by their standard terms and conditions. It is very important to be attentive to these issues because they can have enormous effects on your legal rights with regard to the license or even your continued ownership of the copyright. Many photographers make it a standard business not to accept client terms and conditions. Some are willing to negotiate reasonable changes that reflect a client's particular needs when such changes are reasonably reflected by the license fee. For example, a buyer who wants exclusive use of an image should expect to pay significantly more than a buyer who does not require exclusivity. However, a photographer

should never grant exclusive use merely because a prospective licensee wants or demands it.

In many cases, the terms and conditions proposed by buyers are drafted by attorneys whose objective is to see that their clients get the most possible out of a transaction, irrespective of the nature of the deal or whether it is commercially reasonable. For example, one large advertising agency uses the following provision in its terms and conditions:

> Unless otherwise specifically set forth above, Supplier hereby sells, transfers, and assigns to Buyer sole ownership rights, including the copyright in the Material. If for any reason the Company has purchased less than full rights to the Materials, it is agreed that no portion of the Material may be sold, transferred, or licensed for use on behalf of any product or service competitive to Client.

The effect of this provision is that, unless specifically stated otherwise, the photographer has transferred the entire copyright to the buyer. This means that the agency would obtain the right to license the image to other users and prevent the photographer from using or licensing the image. Even if the photographer establishes elsewhere in the licensing documents that the copyright has not been transferred, he has agreed to limit his licensing activities for that image. This kind of provision is clearly unreasonable and should almost always be stricken.

Another trick used by some photo buyers is to insert text into a purchase order or similar document that asserts that the images are works for hire or have been assigned to the buyer. This kind of provision can have enormous repercussions from a copyright perspective because if the work is made for hire, then the party employing the photographer or ordering the work is the owner of the copyright and the only party who can register the work. Some licensees use a highly unethical practice of placing a statement on the back of the payment check stating that endorsing the check constitutes acceptance of their terms and conditions. Court cases have not indicated whether such a practice is legally binding but from a practical perspective, some photographers have made it their practice to cross out the offending language and initial it, without subsequent objections from the licensee. Another possible way to address questionable attempts by a photo buyer to surreptitiously grab rights after a deal has been negotiated is to place a rescission provision in your terms and conditions. Such a provision would basically nullify the license if the attempt was made and render any subsequent usage into copyright infringement. A provision of this type might read:

> Any attempt by the licensee to circumvent or diminish the rights of the owner in the copyright of the proffered image subsequent to the execution of this agreement shall constitute an automatic and immediate rescission of this license and licensor shall cease all usage subsequent to the attempt.

Such a provision is a heavy-handed approach to this problem and might offend some buyers. A rescission would also require that you forgo or return any payment of a licensing fee. However, if the buyer went forward with the publication, the provision could provide the photographer with a great deal of negotiating leverage provided that the images have been registered with the U.S. Copyright Office.

Irrespective of your approach to handling unreasonable conditions proffered by prospective licensees, it is important to review purchase orders and like documents for boilerplate terms that may adversely affect your end of a licensing deal. When you find such terms, it is equally important that you register your objections with the prospective licensee. One way to do this is to cross out the offending text, initial it, and send it back by facsimile. Another way is to require that the client sign or initial a line on your terms and conditions indicating acceptance. The specific means available to note an objection are quite flexible, provided that they clearly express your rejection of the proffered conditions and are in writing.

Terms and conditions should describe the basic legal expectations.

Terms and conditions do not need to be inordinately long or drafted in obtuse legal prose, but they should be comprehensive enough to describe the basic legal expectations associated with a license. In other words, terms

and conditions should make it clear how the images may be used and set forth the consequences of misuse. Although there are many nuances that can be suitably addressed by terms and conditions, the major ones that should be covered are the grant of rights, the payment schedule, unauthorized use, return of images, lost images, and use in violation of law.

It is important to describe accurately the image being licensed.

The grant of rights clause works in conjunction with the description of the image and the specific usage to address the major issues regarding the scope of the license to the licensee. It is important to describe accurately the image being licensed in the quotation or invoice document as well as the intended usage. Many photographers describe the image with text that summarizes the content of the image but printing a thumbnail image is a better approach. The usage should describe the nature, magnitude, and duration of the use. For example, a license to use an image in a magazine advertisement might describe the use as "one-half page, 1 to 4 million print run, 4 insertions." The grant of rights clause should address whether the rights provided to the licensee are nonexclusive and nontransferable, as is normally the case. It should also clearly state the licensee agrees to limit its use to the ones specified in the invoice.

The time of payment is important to address because many publications are notorious for being extraordinarily lax when it comes to making payments. A fairly common practice is to pay after the publication date and this issue can be a deal killer for some small publications if the photographer insists on prior payment. On the other hand, most publications are able to pay prior to the usage, if sometimes grudgingly, and it is not unreasonable to require payment before publication. Furthermore, the kinds of publications that refuse to budge on time of payment tend to be problematic in other areas such as credit lines and payment amounts. Your terms and conditions should make it clear that you do not permit self-billing by clients who send notices when they engage in uses beyond those stated in the grant of rights and request that you bill them. The problem with such a practice is that if the licensee fails to process the notice, you will not get paid.

Similarly, if the client does not process its notices diligently, you will not be paid in a reasonably timely manner. This practice can also lead to the unpleasant situation where the client engages in a certain use with an erroneous understanding of how much it is worth. This issue can be suitably addressed by making it clear that the license is granted only after the fee has been agreed on and fully paid.

One of the risks in licensing images on a rights-managed basis is that licensees will extend their use beyond the term of the license or to non-licensed uses. Considering the prevalence of unauthorized usage, the unauthorized use clause is very important and deserves a lot of contemplation on the part of the photographer because it will affect the manner in which he or she can obtain compensation from clients who fail to keep their usage within the confines of the license. Generally speaking, a use that extends outside the scope of the license will constitute copyright infringement. If the terms and conditions are properly drafted, unauthorized use can also constitute a breach of contract. The distinction between copyright and contract law is important because the remedies and the procedural aspects of prosecuting a claim are different. For example, copyright infringement cases must always be filed in federal court and most breach of contract cases must be filed in state courts. Because federal court does not have a small claims alternative, it can be unwieldy for addressing matters that involve relatively small damages. Under a contract theory, you can only recover the actual damages unless there is a liquidated damages provision in the terms and conditions. Under copyright law, you can recover statutory damages if the images were timely registered with the U.S. Copyright Office which means that you do not have to show what your actual damages were.

It is common for terms and conditions to contain a liquidated damages provision that charges for unauthorized uses by multiplying the normal fee for such uses by a predefined multiplier factor. From the legal perspective, liquidated damages provisions are intended to save the parties the burden and expense of having to prove or disprove the actual damage incurred by the photographer. Because common law prohibits the use of contracts to impose penalties on parties who breach them, it is important that the unauthorized use clause reflect a reasonable measure of the presumed damages and not constitute a

penalty. Courts handle liquidated damages issues in different ways depending on the jurisdiction, but a common rule is that for a liquidated damages provision to be upheld as valid, the actual damages must be difficult to determine and the stipulated amount must not be plainly disproportionate to the possible loss. Unless the provision satisfies both requirements, courts will not enforce them on the grounds that the provision constitutes a penalty.

In the past, a multiplier of three times the normal price was customary among photographers and agencies who licensed images. Following the advent of the Internet, along with the greatly enhanced potential for unauthorized use, many agencies now use multipliers that range up to ten times the normal price. Examples of multipliers used by large stock agencies are Getty Images' factor of five times the normal price and Corbis's factor of ten times the normal use. However, there is very little case law that addresses the issue of what constitutes an enforceable multiplier and there is no assurance that a court would necessarily uphold these multipliers.

Photographers who license their images should give considerable thought to how they want to structure a liquidated damages provision. One approach is to make the failure to pay the liquidated damages a precondition to filing a copyright claim. In other words, a licensee who uses an image outside the scope of the license will be given a specified number of days following the invoice to pay the liquidated damages. If the licensee fails to pay, the photographer may them treat the matter as one of copyright infringement and pursue the remedies provided under the copyright statutes.

Another approach is to keep the entire claim contractual in which the photographer's remedy will be to sue for the liquidated damages on a contract theory. Breach of contract claims can be filed in state courts which can be significantly less expensive than filing in federal courts, especially for smaller claims. However, breach of contract claims in cases involving liquidated damages are often contested over the issue of what constitutes a reasonable "normal price" for the unauthorized use and whether liquidated damages might constitute an unenforceable penalty.

In some cases, the liquidated damages approach would enable a better recovery for individual images than a copyright infringement approach because the photographer will not be limited to the maximum award for statutory damages of $30,000 per work. This cap could pose a problem in cases where a single image is infringed by several kinds of unauthorized uses because under a statutory damages approach, the damages are assessed by the number of works and not the number of uses. Likewise, a breach of contract approach avoids the problem of not being able to recover attorney fees if the images were not timely registered with the U.S. Copyright Office, provided that your terms and conditions have a provision that the prevailing party is entitled to recover attorney fees. However, the copyright approach to obtaining a remedy offers the advantages of injunctive relief and a well developed body of case law involving photographs.

The clauses for return of images and lost images address the issue of having clients return images within a reasonable amount of time. This issue is far more important for photographers who provide images in the physical form of transparencies and prints than it is for those who provide digital files. If you transact business by providing licensees with the sole copy of an image, it is

A GOOD WAY TO REDUCE UNAUTHORIZED USE PROBLEMS

A fairly frequent occurrence is to have a customer extend their use of an image beyond the licensed period. To reduce this problem, one suggestion (devised by the wife of a stock photographer) is to maintain a tickler file that notes forthcoming expiration dates. When a date approaches, the photographer sends the customer a postcard or letter reminding them that the license is about to expire and offering to renew the license if the customer pays before the expiration date. This practice should benefit the photographer's business standing by alerting customers to a potential problem area and providing an opportunity to generate additional income should they decide to extend or renew a license. In the event that the customer fails to renew, but continues to use the image past the expiration date, sending out such letters will also benefit the photographer's legal status because the postcard will tend to establish that the copyright was infringed wilfully instead of inadvertently.

A BARE-BONES VERSION OF TERMS AND CONDITIONS

Many photographers use stock versions of terms and conditions. While these documents often serve their purpose admirably, they will not necessarily reflect the business practices nor effect the means of enforcement preferred by the photographer. The terms and conditions set forth below are very generic and cover the basic issues that should be addressed when licensing rights to use photographs. Photographers who derive a significant amount of income from licensing should consider having an attorney review their terms and conditions and modify them according to the photographer's business needs and preferences. Some additional provisions that you may want to add to terms and conditions include clauses that address credit lines, tear sheets, and dispute resolution.

1. Photographer agrees to license the use of the image described above upon Client's written acknowledgment of the scope and duration of the license and these terms and conditions. The license is nonexclusive and nontransferable to third parties. Photographer retains ownership of image and reserves all rights not explicitly licensed.

2. Payment of the licensing fee is required before publication or other exercise of the license.

3. If the image is provided in the form of physical media, Client is responsible to ensure that the image is not lost or damaged, and agrees to return the media in its original condition within 30 days of receipt or the first publication date, unless another period is stated in writing. The parties agree that the reasonable value for loss or damage of each image as liquidated damages is $2000 per image and that compensation shall be rendered on that basis.

4. If the image is provided in the form of digital files, Client agrees to destroy such files at the end of the license period. Files delivered in the form of digital media such as CDs must be returned in their original condition within thirty days of receipt.

5. A holding fee of $5.50 per item per day shall be paid for all images and digital media that are not returned before the appropriate due date.

(Three options are presented for clause 6, which covers Unauthorized Use. The photographer should select only one for inclusion in the terms and conditions.)

important that the terms and conditions require that the image be returned within a reasonable period such as ninety days of receipt by or by the first publication date. Otherwise, you will likely encounter licensees who hang onto images for several months or even longer. Many photographers like to specify that a holding fee applies for images that are not timely returned. For photographers who transact business digitally, it is a good practice to require the licensee to return any digital media and to destroy their copies of files after use. In the event a licensee misplaces, loses, or damages an image that exists in a physical form, the terms and conditions should require the payment of liquidated damages. A commonly-used amount for liquidated damages is $2000 per image.

Because the photographer should not be responsible for the legal consequences of how a publisher decides to use an image, the terms and conditions should state that

the licensee agrees not to use the images in ways that violate the law or the rights of individuals. This provision should also require that the licensee indemnify the photographers against any claims, including attorney fees, that arise from licensee's use of the images.

There are other provisions that may be worthwhile to address in your terms and conditions. Examples including attorney fees, dispute resolution, attribution (such as credit lines), copyright notice, and copies of tear sheets. Many photographers use terms and conditions that are provided in standard forms available from several sources. However, these forms do not always conform well to the nature of a photographer's business and should be used with caution. In most cases, photographers can have a stock form modified by an attorney at a reasonable fee to specifically reflect their business practices.

Option 1—Breach treated as copyright infringement.

6. Unauthorized Usage: In the event Client uses the image outside the scope of this license, Photographer agrees to forego the right to pursue remedies for copyright infringement provided Client purchases a retroactive license equal to five times the normal fees associated with the unauthorized use within 30 days of mailing of such invoice.

Option 2—Breach treated as breach of contract.

6. Unauthorized Usage: In the event Client uses the image outside the scope of this license, Photographer will calculate the normal fee associated with the unauthorized usage by relying in good faith on the information known to Photographer after seeking input from Client regarding the scope of unauthorized uses. Because it is difficult to quantify the damage incurred by unauthorized use, the parties agree that liquidated damages in an amount equal to five times the normal fee is an appropriate measure of liquidated damages.

Option 3—Breach treated as infringement or breach.

6. Unauthorized Usage: In the event Client uses the image outside the scope of this license, Photographer agrees to forego the right to pursue remedies for copyright infringement provided Client purchases a retroactive license equal to five times the normal fees associated with the unauthorized use within 30 days of mailing of an invoice. If Client fails to make payment within that time period, Photographer shall have the right to sue for compensation for copyright infringement or breach of contract, at Photographer's discretion.

7. Client agrees not to use images in violation of law or the rights of third parties including their rights to privacy and publicity. Photographer has not provided model releases or other forms of subject-matter permission associated with any of the licensed images unless specifically stated above. Client further agrees to indemnify and hold Photographer harmless against any and all liabilities, claims, and expenses, including reasonable attorney fees, arising from Client's use of Photographer's work.

■ **WORKING WITH STOCK AGENCIES**

Many photographers license their work through stock agencies. This removes them from the daily routine of administering the business and sometimes gives them access to particular markets. The downside to working with agencies is that the photographers must share the revenues and are somewhat at the mercy of the agency's honesty and promotional efforts. The basic purpose of stock agency agreements is to set forth the business relationship between the agency and the photographer. Although the general practice is to divide the revenues equally between the parties, agencies vary widely in how they treat issues such as licensing authority, exclusivity, payment schedules, charge backs, return of images, and enforcement for lost images or copyright infringement.

Most agencies do not abuse their licensing authority but it is nonetheless important that the agency agreement spell out what the agency is entitled to do with your images. A critical issue for most photographers is whether the agency is authorized to license images on a buy-out or exclusive use basis. Under a buy-out, the agency basically sells your copyright to the buyer and thus you are precluded from using that image again. Licensing the exclusive use of an image is almost as egregious because the image cannot be licensed to other licensees during the term of the exclusivity. Of course, there may be times when the remuneration offered for a buy-out or exclusive license will make the deal attractive. However, it is in the photographer's interest that the agreement require his or her prior consent before the agency licenses an image under those conditions. Some agencies use agreements that have consent clauses but qualify them with text stating that the consent cannot be withheld unreasonably. Such clauses can be problematic when the agency and photographer

have different opinions on whether a particular licensing offer is reasonable.

Exclusivity with regard to representation is an important issue to consider because it affects the extent to which you can license your images. The best form of exclusivity for the photographer is none at all. In other words, the photographer is free to market images on their own, work with other agencies, and place identical images with other agencies. At the other extreme is complete exclusivity where the photographer is required to have all their work represented solely by that agency, In such cases, the photographer is legally required to share licensing revenues even when the photographer places an image with a licensee without the involvement of the agency. There are agencies that work at both extremes so it is important to understand the restrictions that an exclusivity can place on your business. Keep in mind that exclusivity provision can be a serious problem if for some reason the agency fails to market images effectively or engages in misconduct such as delaying payments.

Timely payment can be a major issue when working with an agency.

Timely payment can be a major issue when working with an agency and it is best if the agency agreement reflects when and how you are paid. A common practice is for agencies to pay the photographer's share within a month of receiving payment from the licensee. Some agencies prefer to pay on a quarterly basis. Furthermore, it is not unheard of for agencies to stall on paying their contributors when they run into cash flow problems. In effect, this constitutes using photographers as involuntary banks from whom the agency obtains interest-free loans. One benefit to having a payment schedule clause is that breaches are easy to determine and thus become a more readily-enforceable grounds to terminate a contract in the event of sustained nonpayment.

Some agencies charge photographers for services such as inclusion of images into printed catalogs, duplicating transparencies, and writing the checks used to pay the photographer. Some kinds of charges may appear superficially small but can become significant when accumulated over time. For example, a monthly storage fee of 10¢ per image will amount to a annual charge of $1200 if you have placed 1000 images with the agency. Whether such charges are tolerable depends in part on the net revenues earned by the photographer. Nonetheless, it is important that the agency agreement address any such charges.

Stock agencies can be notoriously slow when it comes to returning images at the request of the photographer. This is not a major issue when the images are digital copies but a delay of two years or more following termination of an agency relationship can entail forgoing a lot of income when the images are in physical form such as transparencies. A clause that specifies the period in which images are supposed to be returned is particularly beneficial in a situation where the ownership of an agency changes hands or in the event that the agency declares bankruptcy. Such a clause will not only establish that the duty of the new owner, trustee, or receiver is to return the images within a set period of time, it also provides a factual basis for determining what constitutes the period for which the agency or its successors should be held liable for the photographer's lost income from being unable to use the image.

Enforcement is a major issue that should be addressed in an agreement because diligence, costs, and recovery become substantial concerns in the event that an image is lost, destroyed, or infringed by a customer of the agency. Note that the standard agreements used by agencies agreements often fail to address this issue. In addition, many agreements address only the issue of lost images and are silent as to how copyright infringement or unauthorized use will be handled. Many photographers like the idea of the agency handling enforcement matters because it frees them from the effort and stress of having to do so. However, many photographers have been dissatisfied after granting agencies control over these matters and then standing by while an agency ignores or slothfully pursues a matter. Agencies vary significantly in the zealousness of their enforcement and it can be extremely frustrating to suffer a major loss or infringement and have the agency decline to pursue the matter. By retaining control, or setting up a mechanism where you obtain the right to pursue enforcement if the agency fails to act within a reasonable amount of time, the photographer can take charge of enforcement matters and ensure they are handled to his or her satisfaction.

The agency agreement should also specify how the costs of enforcement and recoveries shall be shared.

Typically they are split equally but this may seem unfair to photographers when the agency uses in-house staff to obtain the recovery and bills this to the photographer as a cost. Another issue is whether the agency retains the sole discretion to settle an enforcement issue. If so, the photographer will have no say even if the agency chooses to settle a matter for much less than its reasonable value. This can be a problem for a photographer when the agency is more interested in appeasing a major customer than in seeing that an individual photographer is fairly compensated.

Photographers need to understand that business practicalities mean that an agency's ability to succeed often depends in part on maintaining the graces of its major customers. Legally speaking, agencies cannot put a customer's interests above those of the photographer, irrespective of temptations to do so. Even though some agencies treat photographers as if they were unimportant, stock agencies are fiduciaries and thus owe a duty of loyalty and good faith to their photographers. Should an agency act in such a way that interferes with the photographer's best interests, it may be liable for breach of the fiduciary duty. For example, the agency's duty in negoti-

Stock agencies owe a duty of loyalty and good faith to their photographers.

ating a license agreement will normally be to get the best deal possible without unduly alienating the customer. Should an agency cross the line in order to ingratiate themselves with a customer by giving them a better deal at the expense of the photographer, the agency would be liable to the photographer. Fortunately, this is rare and most agencies have good reputations for advocating the interests of their photographers.

FORMULATING YOUR ETHICS

Photographs can powerfully portray subject matter and therefore the taking and publication of photographs necessarily presents ethical issues. One reason for the power of photographs is that they allow a broader audience to witness a scene than the people who were actually there. This can be used to good effect such as showing the beauty of a scene that many people would otherwise never see or to bad effect by increasing the suffering or humiliation of people depicted in situations that are embarrassing, painful, or private. The temporal aspects of photographs also make them a powerful means of communication because they record things that would otherwise be forgotten. This can be good when it preserves history and bad when it reminds people of things they would rather not remember. We live in a complex society where photographs can have good and bad effects simultaneously. A photograph that causes some viewers pain can, at the same time, cause people to change their conduct for the better. Because photographs can affect individuals and even societies, photographers need to be aware of the ethical issues associated with taking photographs.

Photographs record things that would otherwise be forgotten.

Whether a photograph will be morally good or bad largely depends on how you balance the ethical considerations associated with taking a photograph. Furthermore, opinions vary widely about when it is ethically appropriate to take a photograph. Likewise, a decision on whether or how to publish a photograph has ethical implications. The intent of this chapter is not to dictate rigid ethical standards but rather to encourage photographers to under-stand the issues so they can make reasoned decisions regarding their ethics. The personal choices regarding material and the manner of execution not only reflect how a photographer sees the world, they also reflect how the world sees the photographer as an ethical being.

■ ARTICULATING YOUR ETHICAL CODE

Most people consider themselves ethical although many have never tangibly defined what their ethics are. The problem with not defining your personal ethic is that an unarticulated ethical philosophy often amounts to no ethics at all. Articulating your ethical code is not only essential to handling ethical issues effectively, it can also help define your sense of vision with regard to what you record and how you record it. A good starting point is to ask yourself what is the purpose of your photography. Is it to document the world that you see or to express some inner vision? Is it done solely for private expression or to show others what you feel they need to see? What kind of satisfaction do you seek from making images and what aspects make them succeed in this regard? These questions are important because the answers will provide a foundation for making decisions that reflect your personal ethics.

Another issue to consider is what level of personal control do you need to have over taking photographs and who makes the moral decisions? If you were a commercial photographer, would you make an image that could emotionally harm or severely embarrass a child to satisfy a parent's request? As a photojournalist, would you photograph the unintentionally exposed bust of a mother bending over while serving food at a school picnic to satisfy an editor who thinks using the image as a humor piece would sell more newspapers? While insisting on complete control

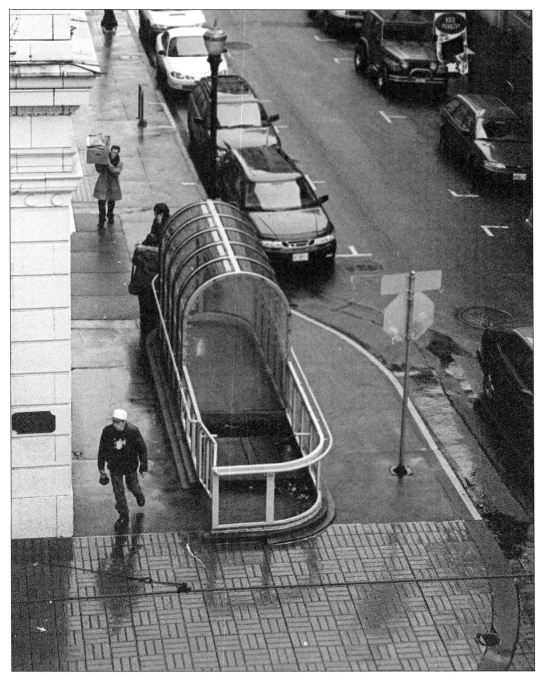

Although some photographers debate the ethics of candid photography, the infeasibility of getting permission from people in public settings makes candid depictions essential for recording scenes that reflect everyday activities.

over subject matter would be unrealistic and even disrespectful to customers, friends, and family, photographers should understand they are not absolved of moral responsibility by letting other people make decisions for them.

Another issue to consider is what makes your photography stand apart from that of other photographers. Are there particular things that you strive to accomplish? Do you attempt to make scenes look better, the same, or worse than what you perceive them to be? The art of photography can and does encompass many viewpoints. While no single viewpoint is inherently better than anoth-

er, personal awareness of how you try to portray things can provide insight into what ethical considerations may be important to you.

Ethics necessarily involves choices, and choices mean setting limits. What are the boundaries to your photography? Are there subjects you will not photograph? Some photographers express their compassion by not photographing private suffering or intentionally making unflattering images of people. Other photographers, such as the Farm Security Administration photographers who documented the Great Depression during the 1930s, acted on

their compassion by doing just that. Determining what limits to set depends largely on the purpose of your photography and the effect you want to have on your viewers.

Another issue to consider is how you want to be perceived by others. Most people need at least some degree of acceptance from others and should consider this when taking photographs. For instance, do you want people to think of you as kind, adventurous, or insightful? Do you care if you are perceived as insensitive, exploitive, or ghoulish? Your photography will necessarily be an expression of your character, so you should be conscious about what your images communicate about you.

Would you be embarrassed if others found out you took such photographs?

Having formulated your ethical philosophy, it is important to execute it when you are taking photographs. One way to do this is to train yourself to ask why you want to take a particular photograph before doing so. Is the attraction merely because the subject is unusual or somehow exciting? How will you feel about yourself after you take the photograph? Would you be proud or ashamed to show the image to others and to what kind of people? Would you be embarrassed if others found out you took such photographs? Contemplation about what you are trying to achieve reflects personal maturity and adds strength to your images. Understanding the purpose in recording an image can also give a photographer useful insight into how to record it. It also can facilitate a fresh viewpoint to photographing subjects that would otherwise be depicted as cliches.

■ ETHICAL ISSUES ASSOCIATED
WITH CANDID PHOTOGRAPHY
The ethical propriety of capturing images of people in their unguarded moments depends on the circumstances. The key issues associated are the degree of respect that should be given to the subjects and the purpose in taking the photograph. Irrespective of purpose, photographers need to be aware that some people are uncomfortable about being photographed without their knowledge and factor this issue when formulating their ethical code. However, the fact that people may object to being photographed does not make candid photography unethical.

Not only do photographers have a legal right to photograph most subjects in public view, most people do not have strong feelings about being photographed as long as their personal space is not invaded.

How photographers deal with the prospect of candidly photographing those people who prefer not to be photographed is a personal decision. Some photographers feel strongly that people should not be photographed without their consent. Other photographers feel just as strongly that no one has the right to control what they photograph in a publicly accessible place. From a practical perspective, it is often impossible to obtain consent from everyone who will appear in an image and in some cases a rigid requirement for consent may prevent photographers from making images that reflect certain truths.

Another issue associated with candid photography is how subjects are portrayed. One factor that distinguishes candid photography from forms such as portrait photography is the degree to which the subject may be portrayed in a demeaning or unflattering way. While opinions differ regarding the boundaries of appropriate conduct, every photographer should contemplate this issue and decide on their personal ethic. Some photographers maintain that the most flattering photographs portray people as they really are but others feel that the probable opinion of their subjects is what merits consideration. While photographers need not refrain from potentially unflattering shots, they should ask themselves why they want to take them. Sadly, the practice of taking unflattering photographs is often used for unfair and abusive purposes. Examples of these kinds of photographs appear with some regularity in the news media where disfavored politicians and celebrities are shown in ways that accentuate features such as crooked teeth or disheveled grooming.

Another factor to consider is how to balance the photographer's right to take photographs in public places against a subject's ability to control over how he or she acts and appears in public. A person who engages in voluntary conduct or dresses in a suggestive manner way has less moral authority to object to being photographed than someone who has no control over their situation. While it would be generally acceptable to photograph Ms. Graham while she was attending the Cullman County Fair (see chapter three), it was unkind to photograph her when the air jet blew her dress above her waist and then publish the image in the local newspaper.

Although respect for subjects should be the norm for most photography, there are times when it is *per se* ethical to take demeaning or unflattering photographs. Many important photographs involve situations where violence or immoral behavior make it impossible to show everyone in a positive light. For instance, photographers who covered civil rights rallies during the 1960s had no ethical obligation to depict the police officers who directed attack dogs against demonstrators as kind and sensitive dog lovers. Likewise, a woman who publically taunts a child walking to a newly desegregated school is part of history than can be legitimately recorded. Nonetheless, photographers should recognize that they do not need to photograph everything they see that is negative or reflects poorly on an individual.

■ ETHICAL ISSUES ASSOCIATED WITH PRIVACY

The term privacy is subject to many definitions but basically comes down to an individual's right to be left alone. The law does little to protect individuals from being photographed when they are in public places, but this does not mean that all such photography is ethical. In other words, one can distinguish between legal and moral rights to privacy.

Societal attitudes towards privacy vary and it is difficult to determine the boundaries regarding when it is ethical to take photographs. Furthermore, attitudes towards privacy seem to be shifting. As the ability of computers to gather and assimilate information about individuals and their habits chips away at personal privacy, people are becoming more sensitive about privacy issues. This may account for part of the trend observed by some photographers that people are increasingly uncomfortable about being photographed by strangers.

Although some people are hypersensitive regarding privacy, refraining from photographing people is neither feasible for most photographers nor can it be justified on purely ethical grounds. Photography is an important aspect of society and the interests of photographers are entitled to some measure of respect. In this regard, the ethical propriety of taking photographs when people might prefer to be left alone depends in part on whether the subject is morally entitled to privacy. For example, most people expect to be able to take photographs of family members when attending amusement parks and someone who would prefer not to be photographed has no legitimate right to object merely because they will appear in the background of a photograph.

Nonetheless, there are situations where you should consider giving people some measure of privacy by not photographing them. An example would be photographing celebrities while they engage in the personal kinds of activities that are routinely enjoyed by those who are not in the public light. It is legal to take such photographs even when the person objects and some people assert this practice is ethical based on the premise that celebrities covet attention and profit from any resulting publicity. It has also been asserted that such photographs are needed in an egalitarian society to show that celebrities have an ordinary side. The contrary positions are that everyone wants to be left alone at least some of the time and that no one can truly have an ordinary side if he or she cannot escape from being stressed and badgered when in public. In addition, pursuing an otherwise mundane image merely because it involves a well known person can show a lack of respect that reflects poorly on the photographer.

The ethics of photographing people who are suffering or grieving is more difficult to resolve. While such photographs may add to someone's pain, they can also provide social benefits, such as making others aware that people need assistance or that dangerous situations need to be rectified. They can also serve as record of history. One question to ask before photographing such scenes is

> The interests of photographers are entitled to some measure of respect.

whether the potential benefit outweighs the harm. Photographing a pedestrian who has been killed by a hit-and-run driver is ethical if it is done to aid a criminal investigation that might result in justice and compensation for the victim's family. Taking such a photograph for your personal pleasure is questionable because the offense suffered by the victim's family and bystanders is unlikely to be offset by whatever satisfaction the image provides you.

■ ETHICS OF PORTRAYING THINGS TRUTHFULLY

Truth is not necessarily an ethical requirement although it has been a traditional hallmark of photography. As an artistic medium, photographers are entitled to some degree of license to depart from the reality of the scene as

It has become more common for nature publications to disclose when subjects have been photographed in captive settings such as this Marbled Murrelet at a public aquarium.

they saw it. On the other hand, photographs should not be used to perpetrate frauds. The balance between the artistic capabilities of photography and its potential to record objective facts presents an issue that photographers should consider when formulating their ethic.

A primary consideration when evaluating the ethics of departing from reality is the expectations of the viewer. In cases where viewers reasonably expect images to represent matters much as they actually appeared, ethical photographers should disclose when the photographs do not substantially express reality. Examples include photographs used to illustrate editorial journalism and scientific writings. One the other hand, viewers in contexts such as advertising or fine art generally do not have high expectations regarding reality. Photographers should be aware that viewers sometimes expect disclosures when an image tends to represent something it is not. For example, readers of nature magazines often feel they have been lied to after learning that an animal was photographed at a zoo

and not in a wild place. However, viewers rarely object to the reasonable use of traditional techniques such as filters, burning, and dodging so long as they do not grossly alter the essence of the subject matter. Furthermore, express disclosures are unnecessary when the nature of the photograph indicates an obvious manipulation, such as a composite photograph that shows a mouse lifting up a house.

Recording a scene truthfully involves ethical issues similar to manipulating images. Constructing a scene that is obviously staged or posed is ethical if viewers are likely to understand it as such. Likewise, photographers are not unethical when the inherent limitations of photography prevent recording all relevant information. For instance, 36 exposures taken at a shutter speed of $1/250$ second over a two-minute period can record about 0.12 percent of action. So long as the liberties necessitated by these limitations are not abused to misrepresent a scene, viewers tend to tolerate reasonable choices regarding composition and equipment. However, the widespread adoption of

digital photographic techniques has made it very easy for photographers to alter what an image depicts. While there is a strong professional consensus that images used in the context of journalism should not have the substantive content altered, opinions vary widely over the use of digital manipulation in other contexts.

Intentionally staging a scene to reflect something that did not happen becomes unethical if the photograph is likely to be construed as representing an actual scene or event. For example, Arthur Rothstein was accused of moving a cow's skull from a grassy field and photographing it on parched ground when he worked for the Farm Security Administration during the 1930's. Politicians opposed to legislation that was intended to aid drought victims used the image to support arguments that the Roosevelt administration was overstating the environmental conditions faced by farmers and ranchers in the West. Although Rothstein's motive was to help people, the controversy over the image made it more difficult to achieve this objective.

The other risk to staging photographs that falsely represent events is that you can irreparably damage your credibility. Viewers who learn that a photographer has fabricated a scene represented to depict actual conditions will doubt the veracity of other images made by that photographer. If truth is a tenet of your ethical philosophy, you need to know when to inform viewers that a photograph does not represent reality.

Creating a bad situation or making one worse to enhance the effect of an

Digital photography has made it easier to alter images and correct defects. Few people take issue with traditional manipulations such as dodging, cropping, and spotting (as seen here). However, not everyone is comfortable about using techniques such as removing extraneous or distracting elements in photographs used for editorial purposes.

image on viewers is morally reprehensible. Doing so to increase sales is clearly unethical because any profits will be at the expense of increasing the suffering inflicted on other people. However, profit is not always the motive behind such behavior. Photographers who champion social or political causes are sometimes tempted to create and photograph shocking scenes in an effort to garner support or sympathy from the public. Ironically, people who engage in this behavior demean themselves by adding to the harm they want to ameliorate. Although

The ability of digital photography to alter the depiction of reality has somewhat damaged the expressive power of photography. When it comes to images of unusual or transient scenes (such as these rabbit-shaped clouds), people have an increasing tendency to perceive them as digitally created.

some may rationalize that the ends are justified by the means, proponents of change almost always have alternatives to deceitful photography to express their views.

■ EFFECT OF IMAGES ON NATURAL SUBJECTS

The ethical issue of whether taking photographs can adversely affect the subjects is another area where opinions vary widely and there are no set answers. For instance, some argue that scenic photographs of Yosemite have harmed the area by increasing visitation while others

maintain these photographs have increased support for its conservation. Although the issue of how photography affects subjects can rarely be evaluated with certainty, photographers should at least consider whether and when their photography could have effects they would prefer to avoid.

Nature photographers in recent decades have actively grappled with the issue of whether their activities affect the environment. Most modern nature photographers avoid disrupting habitats but before the "do no harm"

philosophy became prevalent, wildlife photographers were often willing to engage in conduct that harmed their subjects. For instance, some photographers trimmed branches around birds nests not realizing that this practice increased the risk of predation. Some photographers even killed animals with firearms to make them stay still. There is now widespread consensus among nature photographers that such practices are unethical.

Another ethical debate concerns whether photography can lead to the degradation of habitat and scenic areas by attracting more visitors. In reality, many nature and landscape photographs are taken in heavily visited areas or from well known viewpoints and are unlikely to increase the number of visitors or further degrade natural areas. Nonetheless, most photographers will want to be careful about publicizing sensitive locations if the attention is likely to cause them to be damaged or destroyed.

A more tangible risk associated with nature photography is that the act of photographing sensitive animal and plant populations can alert curious but less sensitive people to their presence and result in damage to habitats that otherwise would have remained undiscovered. Whereas a responsible nature photographer will avoid disrupting habitats and cease photographing if it stresses animals, casual observers often do not care about the damage they cause or downplay their effect on the environment. Those

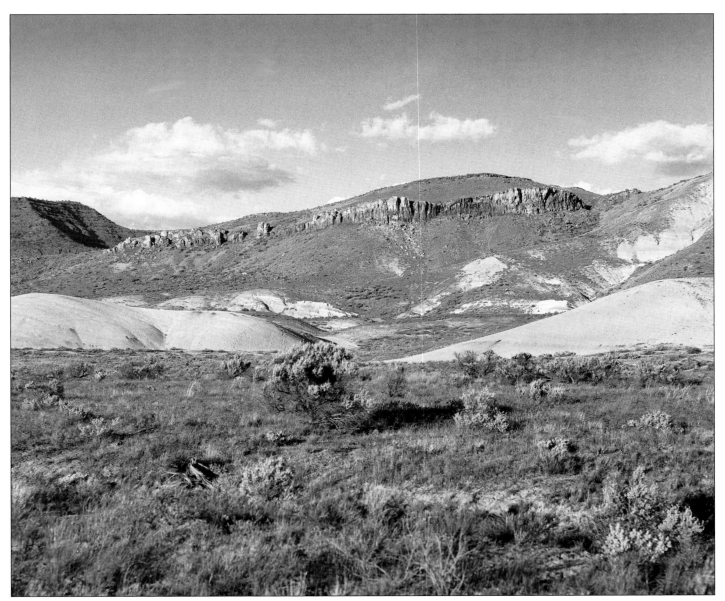

Another ethical issue for which there is no consensus is whether photography of natural areas tends to promote public support for their protection or attracts more visitation which tends to degrade them.

who wish to ensure they do not damage the environment will not only consider the stress they may cause but also the potential to reveal sensitive areas to those who may act inappropriately.

■ EFFECTS ON PEOPLE

Photographers should also consider the effect that photographs may have on human subjects, although the moral aspect of holding people accountable for their actions makes photographing people different than for wildlife and natural areas. While photographers should avoid taking photographs for the sole reason of harming someone, it is ethical to photograph people who will suffer as a result when those consequences are morally appropriate considering their conduct. For instance, the videotapes of the Rodney King beating in Los Angeles in 1991 radically changed the lives of the police officers involved but were ethical because the officers were committing acts for which they should have reasonably expected consequences. Nonetheless, photographers should consider whether they want a person to suffer, even when the conduct is intentional. This is particularly true when the probable consequences exceed what the photographer considers fair and reasonable under the circumstances. For example, a high school student who falls asleep while working a summer job may present a humorous scene to a photojournalist looking for a human interest image, but it may not be worth getting the student fired.

Evaluate whether making an image is worth causing pain and embarrassment.

Sometimes, it is not reasonable to hold people accountable for their experiences. Accident and crime victims are rarely morally responsible for their circumstances and should not be photographed without good reason. Similarly, people show different degrees of judgment at various stages of their lives and this should be considered when evaluating the ethics of taking photographs. For instance, a teenager who foolishly decides to skinny dip in public view may deeply regret being photographed. While it is legal to photograph people engaged in conduct resulting from ill-advised decisions, photographers should evaluate whether making an image is worth causing pain and embarrassment to the subject.

■ ETHICS OF MISREPRESENTING FACTS TO TAKE A PHOTOGRAPH

Photographers have a long history of deceitful practices intended to gain them access to subjects that otherwise would be denied. Sometimes the motives have been good such, as when Lewis Hines lied to local managers about being employed by companies to gain entry into their factories to photograph abuses of child labor. At other times, motives have been quite questionable, such as misrepresenting that nude photographs were being taken for educational purposes when the intent was to market them as pornography. Regardless of whether lying brings about good or evil outcomes, photographers need to understand they undermine their moral authority by resorting to misrepresentations.

A major problem with misrepresenting one's purpose that many photographers fail to consider is that it can backfire, even when motivated by the desire to reveal fraud and unhealthy conditions. A case in point was the undercover reporting in 1992 by journalists employed by the American Broadcasting Corporation (ABC) that revealed unhealthy meat handling practices by the Food Lion supermarket chain. Two of these journalists filed job applications and were hired by separate supermarkets operated by Food Lion. While thus employed, they witnessed and secretly photographed improper food handling which ABC later televised. However, the public furor over ABC's tactics far exceeded concerns about Food Lion selling bad meat. Food Lion sued ABC and the journalists and won a hefty verdict that was reduced to $2.00 on appeal. However, the use of deceit to gain access to the stores fostered a reputation for sleazy reporting that overshadowed the newsworthy nature of the story.

Even minor misrepresentations can adversely affect photography. A common lie by photographers is that they are taking a photography course and need images to fulfill an assignment. While the motives behind such misrepresentations vary, they rarely are intended to harm the subject. Some amateur photographers misrepresent their reasons for taking a photograph because they are self-conscious about photography as a hobby and making up some purpose makes them feel more comfortable. Some professionals misrepresent themselves as amateurs or tourists out of fear that the subject will deny access or will request money in exchange for being photographed. Although these practices do not harm the subjects, they sel-

dom result in any great benefit to the photographer. Being candid about why you are taking photographs is often easier when you can articulate the purpose of your photography. For instance, stating that you are documenting your neighborhood sounds more serious than "I like to take pictures" and is usually more believable than "I'm taking a photography class." Misrepresenting why you want to take photographs is more serious when done to obtain permission that would probably be denied if you disclosed your true reasons. This kind of deceit is such a serious ethical infraction that it can expose one to legal liability. In addition, such practices may irreparably damage one's credibility.

Another consideration when one feels that photographing a particular subject will be impossible without misrepresentation is whether taking photographs is the best way to accomplish your objective. In most cases, there are alternatives that can express a message more effectively than photography obtained through deceit. For instance, the ABC journalists might have exposed the Food Lion meat handling practices by interviewing former employees and confronting store managers with evi-

Such practices may irreparably damage one's credibility.

dence. Although the footage may not have been as graphic, the primary message ABC was trying to convey would not have been drowned by the media attention given to the questionable tactics.

CONCLUSION

Photography at its best would ideally not require that photographers ever have to worry about the legalities of their actions or that their intellectual property and commercial interests would ever be at risk. However, the role of photography in modern society is so pervasive that entanglements with legal issues cannot be entirely avoided. Fortunately, we live in a society that largely favors the rights of photographers and it is not that difficult for most photographers to avoid legal problems.

Ethics require photographers to think about more than legal requirements when making images. In a large sense, having a sound and considerate ethic about one's photography will go a long way toward avoiding legal problems. Photographers should also be mindful that the law does more to protect photography than it does to restrict it. By knowing the legal and ethical issues, photographers can increase their confidence in making images and derive more satisfaction from doing so.

GLOSSARY

Administrative rule: A regulation drafted by a government agency to control regulated parties or establish procedures to be followed by the agency.

Appeal: A proceeding in which the decision by a trial court or government agency is reviewed by a senior court for correctness.

Appellate: Associated with an appeal.

Citizen's arrest: An arrest made by a private citizen as opposed to a law enforcement officer.

Civil: Matters that pertain to private rights and remedies as opposed to matters that pertain to criminal or administrative law.

Civil compromise statute: A statute that allows for someone accused of a minor crime to avoid prosecution by agreeing to compensate the victim.

Claim: An assertion that one has a right to compensation or other action due to a wrong committed by another person.

Classified material: Government documents and information which may be viewed by a limited number of designated individuals.

Clause: A sentence or paragraph that makes up part of a legal document.

Common law: The body of law that is derived from ancient customs as modified and enforced by the courts.

Compensation: Payment or remuneration made to repay someone for a loss.

Confrontation: A face to face exchange in which one party objects to the conduct of the other.

Consent: A voluntary act of granting permission.

Consideration: The items of value exchanged for each other in a contract. Examples of consideration include money, services, and the waiver of legal rights.

Contempt: A deliberate act of disobedience to an order from a court.

Contract: A legally enforceable agreement between at least two parties in which they agree to exchange things of value such as services for money.

Copyright: A right accorded to visual artists, writers, and others that protects against the unauthorized copying of their works.

Counsel: An attorney who advises clients of their legal rights or represents them in court or business matters.

Counterclaim: A claim filed by defendant in a court action seeking compensation from or an injunction against the plaintiff.

Defamation: The making of false statements that damage the reputation of another.

Defendant: A person against whom a court action is filed.

Demand letter: A letter which notifies someone that they will be sued unless they make compensation for an alleged loss within a specified period.

De minimis: Very slight or trifling.

Discovery: Legal procedures that allow parties to obtain facts, information, and documents from other parties to a lawsuit.

Doctrines: See legal doctrine.

Evidence: Proof that may be presented at trial.

Evidentiary ruling: A decision by a court to allow or prohibit a party from presenting certain evidence during a trial.

Fair use: An exception to copyright which allows the unauthorized copying of another's work for a limited purpose.

Federal government: The system of government administered on the national level as opposed to the state or local level.

Felony: A serious crime typically punishable by incarceration for more than one year.

Indemnify: To restore someone for a loss.

Indemnity: An agreement where one person agrees to restore another in the event a loss occurs.

Injunction: An order from a court which requires or prohibits the performance of a specific act.

Invasion of privacy: The violation of a legal right to privacy.

Judgment: The final decision of a court resolving a dispute.

Judicial precedent: A court decision used as authority for determining how the law should be applied in later cases involving similar issues.

Lawsuit: An action filed in court in which someone claims they are entitled to compensation or an injunction as a result of their rights being violated.

Legal doctrine: A rule or principle of law.

Legislative law: Laws enacted by legislative bodies such as the United States Congress.

Liability: Exposure to an obligation to pay compensation or a penalty because of the failure to meet a legal duty.

License: In the context of copyright law, the permission granted by a copyright owner for the use of images.

Licensing fee: A fee paid to a copyright owner for the use of images.

Litigation: The process of contesting claims in a lawsuit.

Loitering: To spend time idly at a specific area or property.

Market value: The price that goods or services would command in the open market.

Mediation: A process where a neutral third party assists others in an attempt to resolve a dispute.

Model release: A document in which a model or legal representative thereof agrees to waive privacy rights with respect to being photographed and published.

Nudity: A state of undress.

Nuisance: An activity that unreasonably interferes with the right of nearby property owners to enjoy their property.

Obscenity: Material that appeals to a morbid sexual interest in a patently offensive way.

Ordinance: A rule or regulation enacted by a city or county.

Permit: A document issued by a government agency that allows someone to engage in an otherwise restricted activity.

Plaintiff: A person who files a court action against another.

Plea agreement: An agreement in which a person agrees to admit guilt to a crime in exchange for a specified punishment.

Pornography: Material intended to appeal to a person's sexual desire.

Privacy right: See right to privacy.

Privilege: (1) A exemption from tort liability in the face of special or unusual circumstances, (2) A exemption from having to provide information, documents or testimony to a party engaged in a lawsuit.

Probable cause: A reasonable ground to believe that a crime has been committed.

Publication *(literal definition)*: To display or make known to people in general.

Publication *(copyright definition)*: To distribute by sale or other transfer of ownership, or by rental, lease, or lending, without restrictions on the further disclosure of content.

Recitals: Statements of fact, law, or reasons in a legal document such as a contract.

Recovery: The compensation obtained as a result of a judgment entered by a court.

Release form: A document where a person agrees to consent to an act or give up a legal right.

Relief: Redress provided by a court such as an injunction.

Remedy: The means by which a legal right may be enforced.

Restitution: See compensation.

Right to privacy: A legally recognized right that protects against the unwanted intrusion into private spaces, unauthorized use of another's reputation for commercial gain, or the public portrayal of a person in a false light.

Sanction: A court order punishing someone for improper behavior.

Search warrant: An order issued by a court authorizing law enforcement officials to search for and seize property that is evidence of a crime.

Securities: A document that evidences an interest in an enterprise or a debt. Examples include stock certificates, notes, and bonds.

Security obligation: See securities.

Settlement: An agreement between the parties that resolves or avoids the need for a lawsuit.

Small claims court: A court in which minor matters are heard.

Stalking: Behavior consisting of following or waiting for a person in a manner that causes a reasonable fear of harm.

Statutes: Laws enacted by legislatures.

Statutory: Pertaining to a statute.

Subpoena: An order issued under the authority of a court that requires a person to provide evidence to a party in a lawsuit.

Terms and Conditions: Provisions of a contract, commonly used by photographers who license their images for publication.

Tort: A private wrong or injury that is not a breach of contract. Examples include trespass, nuisance, and assault.

Trademark: A distinctive mark or phrase used to distinguish the goods and services provided by one person from the goods and services provided by others.

Trespass (criminal): The unauthorized entry or remaining on a person's property in defiance of instructions prohibiting one's presence such as a verbal request or a posted warning.

Trespass (common law or private): The unauthorized entry onto another's property.

Trial: A proceeding at which the parties present evidence and have a judge or jury resolve their dispute.

Verdict: An award issued by a judge or jury before the official entry as a judgment.

Whistleblower: An insider who reports wrongdoing to government authorities or the media.

ABOUT THE AUTHOR

Bert Krages is an attorney who has been practicing law in Portland, Oregon, since 1987. He obtained his undergraduate degree from Northwestern University and his law degree from the University of Oregon.

In addition to representing clients in intellectual property matters, he is nationally recognized as a public advocate for the rights of photographers to document what they see in public places. You can download his flyer, "The Photographer's Right," from his website at www.krages .com/phoright .htm.

He is also the author of a number of books, including *Heavenly Bodies: The Photographer's Guide to Astrophotography* (Amherst Media, 2004).

INDEX

A

Access to property, 10–11, 12–24
 photography in public places,
 12–18
Accidents, photographing, 58
Administrative rules, 8–9
 enforcement, 10
 issues covered, 8–9
 researching, 9
Aerial photography, 45
Airports, photographing in, 14
Animals, photographing, 55–56
 protected species, 56
Assault, 11
Audio recordings, 33
Auditoriums, photographing in,
 14–15

B

Bathrooms, photography in, 32,
 34–35
Buildings, photographing, 58

C

Candid photography, ethical issues,
 110–11
Civil vs. criminal law enforcement,
 10
Common law, 9–10
 application in court, 10
 enforcement, 10
 issues covered, 9–10
 researching, 9–10

Concert halls, photographing in,
 14–15
Confrontations, 59–73
 avoiding, 60–62
 dealing with, 62–64
 remedies, legal, 69–73
 seizure of equipment, 22, 65–68
Copyrighted material,
 photographing, 46–50
 amount and substantiality of
 work copied, 50
 de minimis use doctrine, 49
 effect of use on market value of
 copied work, 50
 fair use doctrine, 49
 nature of the copyrighted work,
 50
 purpose of the use, 49–50
 types of work protected, 47
 what constitutes a copy, 48
Copyrighting images, 74–89
 assigning copyrights, 75–76
 copyright notices, 81–82
 enforcing copyrights, 82–88
 estate planning for copyrighted
 images, 88–89
 history of copyright law, 76–77
 how to register, 77–81
 term of copyright, 88–89
 why it is necessary, 77
 work for hire, 75
Courtrooms, photographing in, 14
Crime scenes, photographing, 58
Currency, photographing, 41–42

D

Defamation, 98–99
Disorderly conduct, 16–17
Dressing rooms, photography in, 32,
 34

E

Economic espionage, 45–46
Embarrassing photos, *see* Privacy
 issues, intentional infliction of
 emotional distress
Emergency technicians,
 authority of, 17–18
Ethics, 21, 37, 55–56, 108–17
 articulating your code, 108–10
 candid photography, 110–11
 effects of photography on people,
 116
 misrepresenting facts to take a
 photograph, 21, 37, 117–18
 natural subjects, protecting,
 55–56, 114–16
 privacy issues, 111
 truthful portrayals, 111–14

F

Federal
 insignia, photographing, 42–43
 seals, photographing, 42–43
 trademarks, photographing,
 42–43
Firefighters, authority of, 17–18

G

Government agencies, restrictions on photography, 15–16

Government-owned property, photographing on, 10, 13–16, 43–45, 58

H

Homeland Security Act, 57–58

I

Intellectual property, protecting, 74–91
 copyrights, 74–89
 patents, 89–90
 trademarks, 90–91
Invasion of privacy, 10–11

L

Law-enforcement facilities, photographing, 58
Legislative process, 8–9
Licensing photographs, 98–107
 assignment basis, 99–100
 royalty-free images, 100
 stock basis, 99–100, 105–7
 terms and conditions, 100–104
 unauthorized uses, 103–4
Locker rooms, photography in, 32, 33
Loitering, 16–17, 18

M

Medical patients, photographing, 10, 28
Military installations, photographing, 10, 13–15, 43–45
Minors, photographing, 36, 39, 53–54, 58
Motion pictures, 14

N

National security, 18, 43–45, 57–58

Nudity, 32–33, 34–35, 53–54
 bathrooms, photography in, 32, 34–35
 distribution of nude images, 53
 dressing rooms, photography in, 32, 34
 locker rooms, photography in, 32, 33
 minors, 53–54
 pornography, 53–54
 public places, 53

P

Parks, photographing in, 12–18
Patents, 89–90
 obtaining, 90
 protecting, 89–90
 purpose of, 89
 scope of, 89
Patriot Act, 57–58
Permission to photograph, 14, 18–22, 36–39
 authority to consent/object, 21–22
 consent by owner to photograph, 20–22
 consent by public official to photograph, 22
 implied consent, 36
 limits set by owners, 20–21
 misrepresentation of purpose for photography, 21, 37, 117–18
 permits, 14
 releases, 36–39
 written consent, 36
Permits, 14
Police, authority of, 17–18
Pornography, see Nudity
Power plants, photographing, 58
Prisons, photographing, 13, 14, 28
Privacy issues, 25–39, 92–107
 bathrooms, photography in, 32, 34–35
 covert photography, 32–33, 35
 dressing rooms, photography in, 32, 34

(*Privacy issues, cont'd*)
 ethics, 111
 expectation of privacy, 26
 inmates, 28
 intentional infliction of emotional distress, 28–30
 intrusions on privacy, 25–28
 locker rooms, photography in, 32, 33
 looking into dwellings, 31–32, 36
 medical patients, 10, 28
 newsworthy events, 27–28
 publication of images, 26, 92–107
 security monitoring, 34–35
 stalking, 34
 tort of intrusion upon seclusion, 26
 workplace monitoring, 35–36
Private property, photographing 18–22
 authority to consent/object, 21–22
 consent by owner to photograph, 20–22
 consent by public official to photograph, 22
 limits set by owners, 20–21
 misrepresentation of purpose for photography, 21
 privacy torts, 92–94
 publicity given to private life, 96–97
 seizure of equipment, 22
 trespassing, 19–22
 undeveloped properties, 19
Private property, photography from your own, 23–24
 zoning, 23
Publication of images, 26, 92–107
 artistic intent, 96
 commercial vs. editorial publication, 92–94
 defamation, 98–99
 false depictions, 97–98
 licensing photographs, 98–107

(*Publication of images, cont'd*)
 misappropriation of likeness, 94–96
 privacy torts, 92–94
 public interest, 96
 publicity given to private life, 96–97
 purpose of use, 95–96
 right to publicity, 94–96
 unauthorized, 26
Public places, definition of, 12–13

R
Recording conversations, 33
Releases, 36–39
 authority to sign, 36–37, 39
 consideration clauses, 37–38
 misrepresentation, 21, 37
Restrictions on subject matter, 40–58

S
Schooling, photography at, 16
Search warrants, 67
Securities, photographing, 41–42
Seizure of equipment, 22, 65–68
 administrative orders, 67–68
 by government agents, 67–68
 by law enforcement, 65
 by private parties, 22, 65–67
 in the course of arrest, 67
 resisting seizure, 67
 search warrants, 67
 subpoenas, 68

Shopping malls, photographing in, 12–13
Sidewalks, photographing people on, 12, 14
Stalking, 34
Stamps, photographing, 41–42
Statutes, 8–9, 10
 enforcement, 10
 issues covered, 8–9
 researching, 9
Stock photography, 99–100, 105–7
Streets, photography on, 16
Subpoenas, 68
Subway systems, photographing, 14
Superfund sites, photographing, 58

T
Tanning booths, photography in, 32
Trademarks, 90–91
 protecting, 91
 purpose of, 90
 registering, 90–91
 symbols, 91
Trademarks, photographing, 42–43, 50–52
 diminishment of value, 52
 government, 42–43
 infringement, 51–52
 licensing fees, 51
Trade secrets, 45–46
Train stations, photographing in, 14
Trespassing, 10–11, 19–22
 justifications, 20

Tribal lands, photography on, 22–23
 bans on, 23
 fees, 22–23
 permits, 22

W
Water treatment plants, photographing, 58
Waterways, navigable, 19–20
Workplaces, photography in, 10, 13–15, 35–36, 43–45, 45–46
 bathrooms, 35
 covert, 35
 economic espionage, 45–46
 employees, photography by, 36
 government, 10, 13–15, 43–45
 trade secrets, 45–46
 union activities, 35–36
 whistleblower statutes, 36

HEAVENLY BODIES
THE PHOTOGRAPHER'S GUIDE TO ASTROPHOTOGRAPHY

Bert P. Krages, Esq.

Learn to capture the beauty of the night sky with a 35mm camera. Tracking and telescope techniques are also covered. $29.95 list, 8½x11, 128p, 100 color photos, index, order no. 1769.

WEDDING AND PORTRAIT PHOTOGRAPHERS' LEGAL HANDBOOK

N. Phillips and C. Nudo, Esq.

Don't leave yourself exposed! Sample forms and practical discussions help you protect yourself and your business. $29.95 list, 8½x11, 128p, 25 sample forms, index, order no. 1796.

OUTDOOR AND LOCATION PORTRAIT PHOTOGRAPHY, 2nd Ed.

Jeff Smith

Learn to work with natural light, select locations, and make clients look their best. Packed with step-by-step discussions and illustrations to help you shoot like a pro! $29.95 list, 8½x11, 128p, 80 color photos, index, order no. 1632.

CORRECTIVE LIGHTING, POSING & RETOUCHING FOR DIGITAL PORTRAIT PHOTOGRAPHERS, 2nd Ed.

Jeff Smith

Learn to make every client look his or her best by using lighting and posing to conceal real or imagined flaws—from baldness, to acne, to figure flaws. $34.95 list, 8½x11, 120p, 150 color photos, order no. 1711.

PORTRAIT PHOTOGRAPHER'S HANDBOOK, 2nd Ed.

Bill Hurter

Bill Hurter has compiled a step-by-step guide to portraiture that easily leads the reader through all phases of portrait photography. This book will be an asset to experienced photographers and beginners alike. $29.95 list, 8½x11, 128p, 175 color photos, order no. 1708.

DIGITAL IMAGING FOR THE UNDERWATER PHOTOGRAPHER, 2nd Ed.

Jack and Sue Drafahl

This book will teach readers how to improve their underwater images with digital image-enhancement techniques. This book covers all the bases—from color balancing your monitor, to scanning, to output and storage. $39.95 list, 6x9, 224p, 240 color photos, order no. 1727.

MASTER POSING GUIDE FOR PORTRAIT PHOTOGRAPHERS

J. D. Wacker

Learn the techniques you need to pose single portrait subjects, couples, and groups for studio or location portraits. Includes techniques for photographing weddings, teams, children, special events, and much more. $29.95 list, 8½x11, 128p, 80 photos, order no. 1722.

THE ART OF COLOR INFRARED PHOTOGRAPHY

Steven H. Begleiter

Color infrared photography will open the doors to a new and exciting photographic world. This book shows readers how to previsualize the scene and get the results they want. $29.95 list, 8½x11, 128p, 80 color photos, order no. 1728.

THE ART OF PHOTOGRAPHING WATER

Cub Kahn

Learn to capture the dazzling interplay of light and water with this beautiful, compelling, and comprehensive book. Packed with practical information you can use right away to improve your images! $29.95 list, 8½x11, 128p, 70 color photos, order no. 1724.

THE BEST OF NATURE PHOTOGRAPHY

Jenni Bidner and Meleda Wegner

Ever wondered how legendary nature photographers like Jim Zuckerman and John Sexton create their images? Follow in their footsteps as top photographers capture the beauty and drama of nature on film. $29.95 list, 8½x11, 128p, 150 color photos, order no. 1744.

PROFESSIONAL TECHNIQUES FOR
DIGITAL WEDDING PHOTOGRAPHY, 2nd Ed.

Jeff Hawkins and Kathleen Hawkins

From selecting equipment, to marketing, to building a digital workflow, this book teaches how to make digital work for you. $29.95 list, 8½x11, 128p, 85 color images, order no. 1735.

THE ART OF BLACK & WHITE PORTRAIT PHOTOGRAPHY

Oscar Lozoya

Learn how master photographer Oscar Lozoya uses unique sets and engaging poses to create black & white portraits that are infused with drama. Includes lighting strategies, special shooting techniques, and more. $29.95 list, 8½x11, 128p, 100 duotone photos, order no. 1746.

THE BEST OF WEDDING PHOTOGRAPHY, 2nd Ed.

Bill Hurter

Learn how the top wedding photographers in the industry transform special moments into lasting romantic treasures with the posing, lighting, album design, and customer service pointers found in this book. $34.95 list, 8½x11, 128p, 150 color photos, order no. 1747.

SUCCESS IN PORTRAIT PHOTOGRAPHY

Jeff Smith

Many photographers realize too late that camera skills alone do not ensure success. This book will teach photographers how to run savvy marketing campaigns, attract clients, and provide top-notch customer service. $29.95 list, 8½x11, 128p, 100 color photos, order no. 1748.

THE BEST OF CHILDREN'S PORTRAIT PHOTOGRAPHY

Bill Hurter

Rangefinder editor Bill Hurter draws upon the experience and work of top professional photographers, uncovering the creative and technical skills they use to create their magical portraits of these young subejcts. $29.95 list, 8½x11, 128p, 150 color photos, order no. 1752.

WEDDING PHOTOGRAPHY WITH ADOBE® PHOTOSHOP®

Rick Ferro and Deborah Lynn Ferro

Get the skills you need to make your images look their best, add artistic effects, and boost your wedding photography sales with savvy marketing ideas. $29.95 list, 8½x11, 128p, 100 color images, index, order no. 1753.

WEB SITE DESIGN FOR PROFESSIONAL PHOTOGRAPHERS

Paul Rose and Jean Holland-Rose

Learn how to design, maintain, and update your own photography web site—attracting new clients and boosting your sales. $29.95 list, 8½x11, 128p, 100 color images, index, order no. 1756.

PHOTOGRAPHER'S GUIDE TO
WEDDING ALBUM DESIGN AND SALES

Bob Coates

Enhance your income and creativity with these techniques from top wedding photographers. $29.95 list, 8½x11, 128p, 150 color photos, index, order no. 1757.

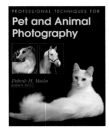

PROFESSIONAL TECHNIQUES FOR
PET AND ANIMAL PHOTOGRAPHY

Debrah H. Muska

Adapt your portrait skills to meet the challenges of pet photography, creating images for both owners and breeders. $29.95 list, 8½x11, 128p, 110 color photos, index, order no. 1759.

THE BEST OF PORTRAIT PHOTOGRAPHY

Bill Hurter

View outstanding images from top professionals and learn how they create their masterful images. Includes techniques for classic and contemporary portraits. $29.95 list, 8½x11, 128p, 200 color photos, index, order no. 1760.

THE ART AND TECHNIQUES OF
BUSINESS PORTRAIT PHOTOGRAPHY

Andre Amyot

Learn the business and creative skills photographers need to compete successfully in this challenging field. $29.95 list, 8½x11, 128p, 100 color photos, index, order no. 1762.

THE MASTER GUIDE FOR WILDLIFE PHOTOGRAPHERS

Bill Silliker, Jr.

Discover how photographers can employ the techniques used by hunters to call, track, and approach animal subjects. Includes safety tips for wildlife photo shoots. $29.95 list, 8½x11, 128p, 100 color photos, index, order no. 1768.

THE BEST OF WEDDING PHOTOJOURNALISM

Bill Hurter

Learn how top professionals capture these fleeting moments of laughter, tears, and romance. Features images from over twenty renowned wedding photographers. $29.95 list, 8½x11, 128p, 150 color photos, index, order no. 1774.

POWER MARKETING FOR WEDDING AND PORTRAIT PHOTOGRAPHERS

Mitche Graf

Set your business apart and create clients for life with this comprehensive guide to achieving your professional goals. $29.95 list, 8½x11, 128p, 100 color images, index, order no. 1788.

BEGINNER'S GUIDE TO PHOTOGRAPHIC LIGHTING

Don Marr

Create high-impact photographs of any subject with Marr's simple techniques. From edgy and dynamic to subdued and natural, this book will show you how to get the myriad effects you're after. $29.95 list, 8½x11, 128p, 150 color photos, index, order no. 1785.

THE BEST OF ADOBE® PHOTOSHOP®

Bill Hurter

Rangefinder editor Bill Hurter calls on the industry's top photographers to share their strategies for using Photoshop to intensify and sculpt their images. No matter your specialty, you'll find inspiration here. $34.95 list, 8½x11, 128p, 170 color photos, 10 screen shots, index, order no. 1818.

HOW TO CREATE A **HIGH PROFIT** PHOTOGRAPHY BUSINESS

IN ANY MARKET

James Williams

Whether your studio is located in a rural or urban area, you'll learn to identify your ideal client type, create the images they want, and watch your financial and artistic dreams spring to life! $34.95 list, 8½x11, 128p, 200 color photos, index, order no. 1819.

THE BEST OF PHOTOGRAPHIC LIGHTING

Bill Hurter

Top professionals reveal the secrets behind their successful strategies for studio, location, and outdoor lighting. Packed with tips for portraits, still lifes, and more. $34.95 list, 8½x11, 128p, 150 color photos, index, order no. 1808.

MARKETING & SELLING TECHNIQUES

FOR DIGITAL PORTRAIT PHOTOGRAPHY

Kathleen Hawkins

Great portraits aren't enough to ensure the success of your business! Learn how to attract clients and boost your sales. $34.95 list, 8½x11, 128p, 150 color photos, index, order no. 1804.

PROFESSIONAL PORTRAIT LIGHTING

TECHNIQUES AND IMAGES FROM MASTER PHOTOGRAPHERS

Michelle Perkins

Get a behind-the-scenes look at the lighting techniques employed by the world's top portrait photographers. $34.95 list, 8½x11, 128p, 200 color photos, index, order no. 2000.

BEGINNER'S GUIDE TO ADOBE® PHOTOSHOP®, 3rd Ed.

Michelle Perkins

Enhance your photos, create original artwork, or add unique effects to any image. Topics are presented in short, easy-to-digest sections that will boost confidence and ensure outstanding images. $34.95 list, 8½x11, 128p, 80 color images, 120 screen shots, order no. 1823.